Marketing for Cultural Organizations

D0162458

Marketing for Cultural Organizations presents traditional marketing theory with a focus on the aspects most relevant to arts or cultural organizations. The book explains how to overcome the division between the concepts of high art and popular culture by targeting the new tech savvy cultural consumer.

As arts patronage has declined, and given new technological advances, arts organizations have had to adapt to a new environment and compete for an audience. This edition emphasizes visitor or audience participation, as well as the use of social media in attracting and maintaining an audience. Learning to harness social media and technology in order to encourage a dialogue with its audience is of primary importance for arts organizations. This book covers:

- Cost effective methods of researching the audience using technology
- Developing a consistent, branded online message
- Using social media to increase audience engagement, and involve them in the creative process

With an approach that is jargon-free and focused on practical application, this book is designed for both undergraduate and graduate students of arts marketing and cultural management.

Bonita M. Kolb is an Associate Professor of Business Administration at Lycoming College, USA. She has published in a number of leading journals and is the author of several books on marketing and non-profit management.

Marketing for Cultural Organizations

New Strategies for Attracting and Engaging Audiences

Third Edition

Bonita M. Kolb

Routledge
Taylor & Francis Group

NEW YORK AND LONDON

First published 2013
by Routledge
711 Third Avenue, New York, NY 10017

Simultaneously published in the UK
by Routledge
2 Park Square, Milton Park, Abingdon, Oxon OX14 4RN

Routledge is an imprint of the Taylor & Francis Group, an informa business

Library of Congress Cataloging in Publication Data
Kolb, Bonita M.
 [Marketing cultural organisations]
 Marketing for cultural organizations : new strategies for attracting and engaging audiences / Bonita M. Kolb. — 3rd edition.
 pages cm
 Revision of the author's Marketing cultural organisations.
 Includes bibliographical references and index.
 Performing arts—Marketing. 2. Museums—Marketing. I. Title.
 PN1590.M27K65 2013
 658.8—dc23
 2012046141

ISBN: 978-0-415-62695-8
ISBN: 978-0-415-62697-2
ISBN: 978-0-203-10236-7

Typeset in Garamond
by EvS Communication Networx, Inc.

Contents

Preface

Why a third edition of a book on marketing for cultural organizations? After all, haven't cultural organizations already learned all they need to know about marketing? In the past cultural organizations have been somewhat protected from the harsh realities of the marketplace by public subsidies. As a result they were able rely on simple promotional techniques to attract enough of an audience to keep the doors open. However as these subsidies have decreased due to governments cutbacks, cultural organizations have found that they need to become more sophisticated in their approach to marketing.

Over the past two decades, significant research has been conducted on the issue of arts attendance by factors such as age, gender, education level, and ethnicity. As a result of this research, cultural organizations have developed promotional campaigns using welcoming messages that communicate benefits thought attractive to specific demographic groups. However, the latest data show that the attendance problem is not specific to single demographic groups as the percentage of the population attending traditional cultural events is now declining overall.

It is now time to rethink the emphasis that has been placed on traditional promotional methods alone as the solution to the attendance problem. Instead, the attendance decline should be understood to be the result of a fundamental change in how people choose, consume and, now, create products, including cultural products. These changes have resulted from new communications technology, often classified together under the term *social media*, and a resulting change in how people purchase and consume cultural products. As a result, cultural organizations must now use marketing to build a relationship between the organization and the customer. This relationship must be built between equals and involve listening and responding to customer needs.

Social media use has resulted in a new type of consumer, the cultural participant. Social media technology allows one individual to easily communicate to the public his or her own opinion about cultural products. As a result, consumers can market the product more effectively, either positively or negatively, than the cultural organization. Social media

technology also allows people to create and share their own art creations, whether a photograph, a video clip, or a blog posting. This has changed the public's view of cultural hierarchy because it allows everyone to be an artist.

The widespread use of communication technology presents cultural organizations with two broad challenges: how to use social media to build a relationship with the public so as to communicate their message and how to allow consumers to participate in the creation of the cultural product. These challenges will be addressed throughout the book.

This book will be helpful for practitioners in both large and small cultural organizations to apply marketing techniques in their organizations. It is the basis of this book that this can be done while still remaining true to their mission. The book focuses on those aspects of marketing most related to the challenges currently facing cultural organizations, including determining their market segment and the positioning of their cultural product and using social media to engage the audience in the cultural experience.

The book will also be valuable, used alone or as a supplemental text, for students who are studying arts management. It could also be used in the teaching of standard marketing classes, as the blurring of the distinction between the non-profit and for-profit worlds makes it increasingly likely that the challenges discussed in the book will be faced by a wide range of students.

Throughout the book examples are provided of how cultural organizations have successfully applied marketing strategy. It is hoped that those in marketing and management in cultural organizations will be inspired to also meet the new challenges with creative ideas. The worksheets at the end of the book can be used by students or practitioners to develop their own marketing plan.

The first chapter examines the current marketing challenges facing cultural organizations, including their history and development. Emphasis is placed on the changing environment in which cultural organizations must function. These changes have resulted in new challenges that all cultural organizations must face.

The second chapter examines in detail how the manner in which the public views culture has changed. The blurring of the distinction between high and popular culture, the demand by the audience to be entertained, and the increase in social media use has dramatically changed the ability of the cultural organization to dictate to their audience their own definition of art and the appropriate manner in which it should be presented. The views of Adorno, Gans, and Bourdieu are discussed.

Chapter 3 discusses the media audience models including the development of the cultural consumer. Particular attention is given to the new concept of the culture participant. This chapter also discusses how attendance patterns are affected by generational and value shifts.

 Chapter 3 focuses on the internal, external, and customer forces that affect the creation of a marketing plan. It also introductions the components of marketing and the difference between the production, sales and market approach to the marketing function.

 Chapter 5 examines consumer motivation and how knowledge of the purchase process and the benefits sought by consumers can help cultural organizations design a marketing strategy. Using market segmentation in audience development is the core of Chapter 6. A special focus is given in this chapter to targeting cultural tourists. Audience research is discussed in Chapter 7 with emphasis on how small cultural organizations can use qualitative techniques.

 Chapter 8 discusses the cultural product, its features, benefits, and distribution. It explains how culture can be considered a product that the cultural organization can then package so that it provides multiple benefits to consumers. Chapter 9 examines the impact nonprofit status and the resulting pressure to raise funds has on cultural organizations. Different pricing concepts and their use by nonprofits is considered. The final chapter provides information on promoting the cultural product using social media, advertising, sales incentives, personal selling, public relations, and direct marketing.

1 Cultural Marketing Challenges

Cultural organizations have been using marketing since the 1970s to inform potential customers of upcoming events. This was a very simplified use—marketing as promotion—but it was all that was needed at the time. Everyone understood that art was somehow better than popular forms of entertainment and, therefore, deserved support by attendance and donations. While marketing to consumers was used by cultural organizations, it was one way communication that merely provided factual information.

Technological and social changes have made this simplified form of marketing obsolete. Cultural organizations must now develop a new marketing strategy that allows for two-way communication to build a relationship with their customers. Creating a marketing plan will help guide the cultural organization as it meets these new marketing challenges.

The New Reality

In the last decade, there have been fundamental changes in communication technology that have altered more than just the way people communicate. Instant access to unlimited factual information and also an unlimited supply of the opinions of others have also changed the way people purchase and consume products. As a result, the relationship between the consumer and the cultural organization needs to be rethought. The cultural organization can no longer present the art product as a passive experience where artists communicate their vision to an uninvolved audience, but must develop a means through which the audience is able to communicate ideas and even to engage in the creative process.

This change in perspective by the cultural organization is necessary because there has been a fundamental change in the public's attitude toward culture and art. There has been a growing disregard for the historical distinction between types of cultural products that started with the rise of commercial popular culture (DiMaggio 2000). As a result, how people view the distinction between high art and popular cultural has radically altered the relationship between the organization and the audience. Now, much of the public no longer believes in a cultural hierarchy where high

art has an intrinsic worth that popular culture does not have (Johnson 2006). Instead, the public considers themselves to be the equal of artists. Because of technological and social changes the only hierarchy that remains is between culture that the consumer does or does not enjoy.

Technological Changes

Technology has resulted in the establishment of new forms of community that were not imaginable in the past. Because of the ease of communication with words and images over distances, today a cyber-community is just as "real" and, therefore, as valid as a physical community. People have always shared their opinions on organizations and products except that the opinions in online communities spread more rapidly and widely (Dreyer and Grant 2010). This has created the need for cultural organizations to develop specific marketing messages that communicates to these communities.

The organization needs to do more than just communicate; it also needs to develop a means for these communities to be actively involved with the organization. Art used to be something that was done by artists and then delivered to the audience. Technology today allows everyone to create. While the audience may still acknowledge that the artist has a higher level of skill or a more interesting message, this is a degree of difference rather than an absolute difference. Because of the ability to create using technology, passively viewing the artistic creations produced by cultural organizations is of little interest (Simon 2010). Therefore, the organization now needs to use technology to allow their audience to be part of the creative

Using Your Phone to Connect Crosses Age and Ethnic Boundaries

Who has a smartphone? In the US the ownership of smartphones has grown from 35 percent of adults in 2011 to 46 percent of adults in 2012. (Another 41% have basic cell phones.) What do they do with their phones that might be of interest to cultural organizations? Seventy-four percent get location-based information, such as what is nearby and what nearby is recommended. Eighteen percent of smartphone users use their phone to access geosocial services (Foursquare, Gowalla, or others). What is most interesting is the identity of the users. It may not be surprising that 23 percent of smartphone users aged 18–29 use the services. But adults aged 30–49 at 17 percent and adults aged 50+ at 14 percent are not that far behind. African Americans (21%) and Hispanics (23%) use the services more than white, non-Hispanic smartphone owners (17%). So, cultural organizations should consider making sure that when these groups are accessing the geosocial sites they will be finding them.

Pew Research Center (2012)

process. To do so the organization must create its own cyber-community focused on the particular art form. This should not be difficult as the arts have always formed a community of likeminded people.

Social Changes

The social changes that have resulted from technological changes have also been profound. The blurring of the distinction between high art and popular culture has been going on for some time. With the advent of social networking it can be said that this blurring is now complete. Consumers of culture now only make distinctions between types of culture, which they no longer view as hierarchical. Cultural organizations that were the traditional gatekeepers and informed the public of what was good art versus bad have been replaced by anonymous bloggers who share their opinions whether informed or uninformed (Keen 2007).

The traditional hierarchy of the distinction between "high" art and "popular" culture was disappearing by the end of the twentieth century because more people, unconcerned with value judgments regarding the relative worth of each, consumed both (Staniszewski 1995). The view of today's consumer of culture is that life is enriched by more and varied experiences of any type, which they want to share with others. They believe that the social act of sharing an experience with an online community is as of much importance as the experience itself. In fact, many consumers do not see the difference, as social sharing is part of any experience.

This social sharing can take three forms (Hollman and Young 2012). People want to share their excitement or disappointment about products with other current or potential users. People also want to share with the organization their ideas on how products can be improved. Finally, they want to help other users with problems or questions about the product. Cultural organizations must develop a means for this sharing to take place.

Cultural Organizations

This book uses the term *cultural organization* instead of *art institution* for a reason. Cultural organizations should think of themselves as members of their communities. They should view their art as something they wish to share, rather than impose from above. For this reason instead of the word *art*, the word *culture* is used as it applies in a broad sense to all events or objects created by a society to communicate cultural values. Instead of the word *institution*, the word *organization* is used. An institution is a place, but organizations are groups of people. Although the people who make up the organization may work in a building, it should not confine or define them. In fact an organization may not have their own space, but instead work out of another public or private institution, or have no physical location at all and work out of cyberspace.

While the management and purpose of cultural organizations tends to vary to some extent in different countries, there is still an immediately recognizable similarity across national borders as to purpose of the product and the intended audience (Hudson 1987). The ambience of a museum may vary from the United States to Japan, but there is no confusion as to the fact that both are museums. The same can be said of theatre, classical music, opera, and dance. Likewise, the technological and cultural changes are happening on a global scale. For this reason, the marketing information in this book can be applied across national boundaries.

Development of Cultural Organizations

If the urge to communicate and create is innate to the human spirit, then there have always been artists. However, the freedom for an individual to create unencumbered by the need to sell the work to provide for everyday existence is a modern development. Through most of history, the necessity to provide the basics of survival was paramount, and the art that was created needed to have some social purpose to justify its existence. There were simply no resources or energy to spare for art for art's sake.

When society organized itself into the ruled and the rulers, the rulers then had the money and time to have artistic objects created just for them. Many of these objects had spiritual significance and were used for religious purposes. For much of history, only royalty and the church had the wealth to patronize the arts. During the Middle Ages, artists created objects of worship for the church and objects of pleasure for royal houses. Besides being of use, the art for both groups was also a symbol of status.

As the wealth of society developed in Europe during the Renaissance, the patronage of the arts began to expand and the great merchant families had the wealth to join royalty and the church in playing a critical role in supporting individual artists. The newly wealthy merchants began to patronize artists (Sweetman 1998). The art performance or object was purchased to fill the increasing leisure time or as possessions to adorn the home. These merchants were not individually wealthy enough to support an artist, but, through many of them purchasing art, artists were now able to survive. Patronage by a royal individual, church, or merchants provided the artist with economic support. In exchange, it was considered the artist's duty to provide art that appealed to the taste of the patron. The artist's individual artistic vision was considered of secondary importance, if it was considered at all.

The Industrial Revolution in Europe resulted in growth in the wealth and power of towns and cities, and civil governments started to take on the burden of supporting the artist, which was formerly the responsibility of the court, church, and merchant family. In fact, cities often competed with each other to obtain the services of the most famous artist in a manner similar to the way modern cities court sports teams. Rather than be

seen merely as a craftsman whose skill was used as a means to glorify others, European society began to treat artists as a special category of people entitled to create art based on their own personal vision.

Rather than support the artist directly, the city and wealthy business people now funded the organization sponsoring the artist or presenting the art form. Instead of artists being supported by religious or royal patrons, or being dependent upon the whims of merchants, the idea of a professionally managed institution that supports the artist was invented (Björkegren 1996).

These cultural organizations have supplanted the patrons of the past. Cultural organizations have a unique role in the marketplace because they provide goods/services that for profit firms cannot, or will not, provide. Since cultural organizations could count on subsidies, they often did not even attempt to cover costs with revenue.

The modern arrangement is for the cultural organization to be supported by public funding and staffed by people who are not artists, but closely believe in the vision of the artist. It is often the managers of these organizations who act as gatekeepers by determining the value of culture. Since only work of value will be presented, then the fact that work is presented by a cultural organization gives value to the work (Bourdieu 1993).

Now the role of the organization itself is being called into question because people using technology can view, create, and share art and culture on their own. The organization's traditional role to educate, advocate, and share art and culture still remains. However the educating, advocating, and sharing will also be done between members of the public without the influence of the organization. Cultural organizations will no longer be leading; they will just be joining the conversation. However, through this joint conversation with the public, the organization can better communicate its message and meet its mission (Notter and Grant 2011).

Where Pianos Go to Die

Not just artists and arts organizations, but even musical instruments, are struggling to survive. The golden age of pianos refers to the millions of pianos that were produced in the US starting at the beginning of the twentieth century. While 365,000 were sold in 1910, only 41,000 were sold in 2011. It isn't just that new pianos are not being sold; no one wants the old ones, which are now routinely dumped in landfills because they can't even be given away. Why? Pianos are no longer the focus of home entertainment. In addition, people are not taking piano lessons, there are cuts in music education programs in schools, and the depressed housing market means that people are not buying pianos for new homes. When a YouTube video was posted of pianos being dumped at the landfill, people were outraged. A piano adoption website was created but to no avail, as no one was willing to adopt.

Wakin (2012)

Current Challenges

According to a Rand Corporation study, the strict separation of nonprofit organizations creating high culture and for profit businesses creating popular culture passed with the end of the last century (McCarthy et al. 2001). Today, it is difficult to even know from outside the organization whether it is a nonprofit cultural organization or a for profit creative business.

The Rand report predicted a future of cultural production where for profit and nonprofit organizations would compete in providing cultural products. The difference would be that for profits would aim for a mass audience while the nonprofit would target a specific audience interested in a high quality cultural experience. On the other side of the size spectrum, small for profit firms would target niche audiences for cultural products, while small nonprofit organizations would focus on local and ethno-cultural markets.

The familiar distinction between the nonprofit world of high culture and the for profit world of popular culture has now broken down. While nonprofit cultural organizations now must worry about marketing a product, and therefore hire marketing professionals, for profit companies which produce popular culture are now able to attract talented artists to work for them. For profit multimedia, design and entertainment companies are particularly seen as legitimate users of artistic talent.

Current funding cuts and the resulting pressure to generate revenue is helping to further break down the strict demarcation between nonprofit and profit marketing. Nonprofit organizations increasingly have revenue-producing activities they must market to compete with business. For example, a nonprofit cultural organization may have a gift shop or café or even a parking garage which competes with local firms by providing similar goods and services. While gift shops and cafés are now common, some cultural organizations also have very sophisticated business enterprises including mail-order operations, video production, rental of premises, and even renting/selling their product, all of which must be marketed.

However, there remains an important distinction between these two types of organizations. A popular culture company in the for profit world can, if necessary, change the artist's product to the point where it is unrecognizable to the original creation. The company can even drop the product it was originally producing and produce an entirely new form of popular culture, if that is what the marketplace wants. Because the creator or artist is in the employment of the profit-making company, the company can use and alter the product in any way that is necessary to attract customers and make money.

The nonprofit cultural organization cannot change the artist's product to fit the marketplace. The organization starts with a mission to present the art produced by an individual artist and it must remain true to the artist's

vision. However, the cultural organization can remain true to the art form and artist while at the same time it markets the product in a manner more attractive to the consumer.

The unique challenge faced by cultural organizations is to remain mission-driven, while at the same time using marketing strategies developed for for profit businesses. In fact marketing strategies from the fields of broadcasting, publishing/recording, multimedia, sport/leisure, and tourism can be very useful. Such companies are closely related to nonprofit cultural organizations as they also use creative talent to create products that provide the benefits of both enrichment and entertainment. In fact such profit and nonprofit cultural organizations often compete to provide their product to many of the same customers.

One Museum Closes But a New One Opens

In Manchester, in the United Kingdom, the Museum of Urban Life closed its doors but two years later the new National Football Museum opened in the same space. The museum is not just designed for young, hard core football fans. It is also designed for those with just a passing knowledge of the game and those who worship football's past glory. How does it keep all these different audience segments engaged? It does so by offering a variety of exhibits. A visitor can enjoy interactive exhibits and activities including the ability to be the commentator at a match. Or, a visitor can view the curated artifacts. Other visitors might enjoy the temporary exhibits that tie an interest in football with other art forms. The museum is designed to have something of interest no matter the visitor's level of involvement in football.

Feld (2012)

Cultural Marketing

The field of arts management as a distinct profession became popular in the 1970s. It developed out of the old role of the arts promoter whose job was to find a public audience for the artist since the artist could no longer depend on individual patronage. It was not a partnership between artist and promoter; rather, it was the function of the promoter to serve the needs of the artist.

The growth of cultural organizations filled the need for a new type of intermediary. The new art administrators worked for the cultural organization rather than directly for the artist, but their role was similar to that of the arts promoter: to serve the needs of the artist. For the arts administrator, the criterion for success was helping the artist to achieve artistic goals, and financial rewards were considered to be of secondary importance. Therefore, art administration was seen as an appropriate area

for women who had artistic interests because the field was thought to lack the cut-throat competitive atmosphere of business management.

Rather than compete for profit, the role of the arts administrator was to allocate the financial resources received from the state and donors, to supervise the organization, and to ensure there was an audience for the artist. The primary focus was on the production of art, with the expectation there would be an audience willing to attend. Because the organization's reason for existence was first for the artistic product, second for the larger good of society, and only third for the consumer, there was not surprisingly little emphasis on marketing. Scant attention was given to the desires of the consumer beyond considering how to arrange the art in a pleasing program or exhibit. In fact the word "marketing" was rarely used.

Traditionally, the management of cultural organizations has been viewed as safely separate and distinct from other types of business organizations. As a result of this belief, those working in cultural organizations did not feel they needed to manage their organizations as businesses. It was assumed that different rules would apply to the management of cultural organizations—just as different rules applied to artists. Both would be protected from the distasteful business of making a living, justifying what they were doing, and providing a product pleasing to the public.

It was only during the 1970s that cultural organizations came to the widespread realization that if there was to be sufficient attendance, it would be necessary to market their art to the public (Heilbrun and Gray 2001). As a result, cultural organizations created marketing departments. At first the marketing strategy created by these departments was to adopt standard business promotional practices. They simply placed advertisements that communicated a broad marketing message on the availability of the art that was being provided.

They could hardly do more. Cultural organizations have always had an artistic strategy which includes the type of art and the specific artists which they would present. The new marketing departments were kept carefully separate from the development of the cultural organization's artistic strategy so that the cultural product would not be influenced by demands from the marketing department. As a result, it was impossible for them to develop a marketing strategy that included considering the public's needs and desires.

However, it is critical that the marketing department's knowledge of the external environment, including technological and social changes, be considered when defining the organization's internal artistic strategy. This does not mean that marketing will, or should, control the cultural organization or the art product. It does mean that some compromises to the demands of consumers must be made if the organization is to survive to present its art.

Cultural organizations have traditionally taken a negative view of marketing. The reasons include the belief that marketing is an inappropriate

Funding Cuts Are Everywhere

In the Netherlands, the International Danstheatre had expected a cut in funding. What it didn't expect was to have its government funding cut off entirely. The company had cut its funding request from €2,800,000 down to €900,000, but instead received €0. The theatre, which has attendance of around 80,000 a year, has been in existence for half a century. As part of their lower funding request, they had already cut their staff from 54 employees to three. However, this effort to show that they could run a leaner organization did not save them. The Dutch government did not just single out the dance company. The funding for arts and culture had been cut by 25 percent, so numerous other organizations saw their funding cut or even eliminated. The International Danstheatre will continue in existence at least for a while because of partnerships with other companies. For those arts organizations that do not have other means of support, the future looks grim.

Dowling 2012

use of money and an unnecessary addition to overhead for cultural organizations that already have limited resources. There is also the negative preconception that marketing is both intrusive and manipulative and that using marketing strategy is a sell-out which makes them no better than the profit-making businesses that sell popular culture. This view may result from the fact that the people who work in cultural organizations have specifically chosen not to work in the for profit world. Fortunately, this view is becoming outdated.

Now it is understood that marketing is the key to survival. However, the cultural organization's knowledge of marketing may be limited. Indeed the word *marketing* may even be interchangeably used with the word *promotion*. However, the two words have very different meanings. Promotion is the part of marketing where the benefits of the product are communicated to potential consumers. Marketing has a much broader meaning. It is the process of analyzing the external environment to look for an opportunity to develop a product for a particular group of consumers and then deciding on a price, a means of distribution for the product, and a promotional campaign that will build a relationship with the consumer.

New View of Marketing

Marketing's function was limited to informing the public of the organization's product, persuading the public to attend, and reminding them to come back again. Now instead of only being one way communication between the organization and the public, marketing is seen as a means of building a community around the art form. To do so it must provide a means of two-way communication with the public but also be involved with

the development of the art product. Marketing cannot help to create mean-
ing if it is kept separate from the other departments of the organization.

This is a radical view as before the cultural organization has been
viewed as a hierarchy with the art product and its message being a given
and marketing's only role to ensure that the product and its message had
an audience.

It did occur to cultural organizations that a significant portion of the
population did not desire their product. But it was also believed that
this portion could be educated to understand and appreciate the arts. In
an effort to educate everyone to appreciate the arts, outreach programs
became an increasingly important focus for cultural organizations. While
these programs were good public relations, there was no evidence that
they were the answer to attendance problems (Kolb 2002).

This concern about the future continues as cultural organizations are
faced with an aging audience (National Endowment for the Arts 2008).
Not only is the audience aging, but older attenders are attending less.
What is surprising is the sharp drop in attendance even among the most
educated adults. As the concern over declining attendance continues, pro-
fessionally managed marketing departments have gained a stronger voice
within cultural organizations. Also, funding and political pressures from
the external environment have made the internal split between artistic and
marketing strategy no longer sustainable. The need to increase attendance
while coping with reduced funding is forcing many cultural organizations
to break down the wall between artistic and marketing departments.

Cooperation between the artistic department, which is concerned with
the internal mission of the organization, and the marketing department,
which is knowledgeable about the external environment in which the
organization exists, is at the heart of a successful marketing strategy for
cultural organizations. The marketing plan is a detailed roadmap of how
the strategy will be implemented.

The Brooklyn Orchestra is Now Really Brooklyn's Orchestra

The Brooklyn Orchestra faced such daunting financial difficulties it was
thought the end was near. Instead, they changed from being the Brooklyn
Orchestra to Brooklyn's Orchestra. How can the addition of the possessive
apostrophe change everything? The orchestra redesigned their performance
model. They took input from the residents of the city's three main neighbor-
hoods, Brighton Beach, Bedford-Stuyvesant, and Downtown. The program-
ming now includes collaboration with hip-hop legends and Russian cartoon
music. Where do the programming ideas come from? The orchestra works
with a host committee from each community to develop the programming
and decide on the performance venue.

VanderMeulen (2012)

Developing a Marketing Plan

The marketing plan is a roadmap for the cultural organization to follow in order to implement a new marketing strategy. There are eight components to a marketing plan, the first of which is a statement of the cultural organization's mission. Any marketing strategy must fit this mission or it should not be implemented.

A cultural organization may wish to immediately create a new marketing strategy, but it is critical that this not be done until after a situational analysis has been completed. The situational analysis consists of researching, or scanning, the internal, customer and external environments in which the organization exists. The internal factors that need to be analyzed include the organization's financial resources. However, it also includes the skills and talents of its staff and artists. The type of organization, whether conservatively managed or risk taking, also needs to be assessed. The internal analysis is complete when the current marketing strategy and its effectiveness are analyzed.

The customer environment of the cultural organization must also be researched. Of course, the organization must understand the current customer who purchases their product. They must also understand when the customer purchases and why they purchase. In addition they must also understand who does not purchase their product and why they do not do so.

The cultural organization must also analyze the external environment that includes the competition, economic conditions, political and legal trends, technological advancements, and sociocultural trends that may affect them. The main competitors in both the nonprofit and for profit world must be identified. These competitors must then be analyzed to determine their strengths and weaknesses. The other components of the external world that must be understood include economic trends that may affect the public's willingness to pay for the cultural product and the ability to fundraise. Political trends and legal trends can affect how the organization operates. In addition the cultural organization's funding might depend on who is in political office.

Technological changes need to be understood because customers expect technology to be adapted by the organization to make communication with the organization and purchase of tickets easier. Sociocultural changes may be the factor that is most affecting cultural organizations. Changes in the age of the population, immigration, and the status of the family are just a few of the factors that affect cultural organizations. In addition changes in lifestyle and values must be understood if customers are to be attracted to the cultural product.

After this analysis, the organization should have a clear understanding of their competitive advantage that makes them unique from their competition. The competitive advantage should explain to the consumer why the organization is better able to meet their needs then competitors.

The organization should then be able to state their marketing goal, which might be to launch a new program, create a new promotional campaign, or target a new customer segment. Whatever the goal, the organization must also write objectives, which are the tasks that will implement the goal.

The cultural organization then must target an appropriate audience segment. They might choose to increase the number of customers from their current base. Or, they might decide to target a new segment. This segment might be defined by demographic factors such as age or ethnicity. It might also be defined by lifestyle such as the young and trendy. Or, it might be defined by values such as those who are interested in cutting edge art or traditional culture.

An important step that is often ignored by cultural organizations is to plan the research needed to determine the accuracy and viability of the marketing goal. Is anyone interested in the new program? Will the new promotional campaign motivate its intending audience to attend? What benefits does the new customer segment desire? These questions should be researched before additional time and money is spent implementing the marketing goal.

The cultural organization therefore must consider how they can adapt their product, its distribution and pricing to provide these benefits, while at the same time remaining true to their own unique organizational mission. The final task is to develop a promotional plan.

Components of a Marketing Plan

1. Statement of Organizational Mission
2. Environmental Analysis: Internal Resources, External Factors, Customers
3. Competitive Advantage and Marketing Goal
4. Segmentation
5. Research Plan
6. Product and Distribution
7. Pricing Options
8. Promotion Plan

The New Marketing Relationship

Cultural organizations today face economic challenges that are likely to remain for years to come. At the very time when they need to spend money on marketing to attract more customers to make up for declining government funds, they have fewer resources to do so. Adding to this difficulty is the fact that they are competing for the same customers as many other organizations, both nonprofit and commercial.

It's Not Just Arts Organizations that Struggle Financially

While much attention has been paid to the financial struggles of cultural organizations, the artists that supply the artistic product are also hurting financially. Few artists make worldwide names for themselves. For most artists it is a struggle just to make ends meet. Artists, of course, don't have job security. They also do not have company benefits or pension plans. When you add in the global financial crisis, times are even more difficult. Of visual and applied artists, a third make less than £5,000 (less than $8,000), which is not enough to live on. How do they survive? Fifty-seven percent make more than three quarters of their income from other jobs. The story is similar for musicians, 90 percent of whom make less than £15,000 (less than $24,000). Songwriters and composers have it worse because the same percentage makes only £5,000. The cuts to cultural organizations are also affecting artists as there will be fewer performances and exhibits. So, when you are bemoaning hard times, don't forget a little pity for the artist.

Day (2012)

Marketing can benefit nonprofits by introducing accountability in achieving their mission, which is to enrich people' lives in some way. The development of a marketing plan forces the cultural organization to understand who the organization is serving, how these individuals are being served, and what will be the result (Burnett 2007). This introduces business terminology into the cultural organization, such as calling the individual served a customer, and processes, such as writing a marketing plan. By doing so it reminds the organization that all products purchased involve exchanges in which the consumer either has to part with money, time, effort, or all three.

Therefore, a new emphasis on marketing is needed where it is seen as an integral part of the organization and not an afterthought. Cultural organizations must not just view marketing as promotion to get people in the organization's doors but also understand that successful marketing builds a relationship with customers. Cultural organizations will need to find a way to communicate with their customers by using a combination of traditional and social media. However, to do so successfully they must now understand that the external environment presents them with new realities that they must face.

- Art is not perceived as having a sacred right to public support and as a result cultural organization must take into account the desires of the public.
- Consumers want a direct communication link with the organization that allows them to participate in the marketing and creation of the cultural product.

The new consumers have sometimes been called "free agents" (Notter 2011). They will not be dictated to by organizations, and even more, they expect to converse with the organization, collaborate with the organization, and then, together with the organization, take action. The cultural organization needs to build a partnership with their customers as a way to both spread their message and improve their cultural product.

Because the new culture consumer wishes to participate in a partnership with the organization while experiencing culture, it is important for organizations to include in their marketing plan not just new creative marketing strategies. They need to also use technology to give their customers a sense of belonging to a community focused on the art/culture product (Notter 2011). These strategies include packaging a cultural product as an event that combines both culture and entertainment. Such packaged events may involve collaboration between different cultural organizations, combine high and popular culture or use new distribution systems for delivering culture to customers. In addition, the packaged events might be promoted by both cultural organizations and businesses as a means of building community or attracting tourists. These events will still meet the mission of enriching lives by increasing exposure to the arts but at the same time will provide a complete package of benefits that will motivate consumers to attend.

It is now accepted that marketing strategy can be of use to those involved in presenting all types of culture including high, popular, local, ethnic, and world. However, it is necessary for cultural organizations to do more than just learn marketing techniques. Basic to marketing theory is the concept that the customer is an equal partner in the exchange of money for goods. Cultural organizations have historically had a top down approach of we know what is best for you. Now they will need to learn that not only can they not dictate, but they must welcome their audience as equals.

Everyone Loves a Good Deal, But Is It a Good Deal for the Organization?

Many museums are offering financial deals to get people in the door. While free days have been a staple of the pricing strategy for years, daily deals are new. Deals offered by Groupon and Living Social have caught on with the public. Museums are now also offering these deals with varying success.

A research study found that almost 50 percent of museums had offered such deals. Those who loved the results believed the offers brought in new visitors who would not have ordinarily attended. Others believed the impact of the deals was negative because the people attracted by the deals will not visit again if they must pay the regular price; daily deals, some feel, are training consumers to wait for the offer.

Museum Audience Insight (2012)

Meeting the Audience as Equals

Nonprofits understand that they have a mission to educate, enlighten, and change their audience. They traditionally have fulfilled this mission by engaging the audience through attendance at events and by providing knowledge of the art form. Now the goal must be to expand how they fulfill their mission to allow the public to participate in the organization and the creation of its art product. The education and enlightenment will come through active participation with the organization rather than through top down information. The message that the organization now welcomes the participation of their audience must be communicated by creating a community both physical and cyber. The organization can use social media to engage their audience in the creation and interaction of the cultural product. Then, the physical attendance at the event will be to meet and experience both the art and the community. Without the interaction that started online, the attendance would not have happened.

There are creative thinkers working in marketing departments at cultural organizations who have developed strategies on how these challenges can be met while still being true to the artistic vision of the organization. It is important that others learn of these successes so that cultural organizations can survive to enrich the lives of individuals while serving the community at large.

Therefore, to survive, cultural organizations must change the way they interact with the public even if the standard of cultural appreciation and knowledge of every consumer is not all the organization or artist could wish for. Just as churches, temples, and mosques welcome those who are sinners, so cultural organizations should also welcome those who are not culturally "pure." Everyone cannot be a true saint or gifted artist, but everyone can benefit from attempting to be one. The cultural organization must do more than open the door: they must attract, welcome, and communicate with their audience as equals. They must be willing not to just listen to their ideas but also involve them in the planning of the organization and even in the production of the cultural product.

This book is meant for those working in cultural organizations who realize that the high quality of their product does not automatically result in a full audience. However, they understand their role is more than just making sure the seats are filled. They understand that technology enables them to offer their audiences more than just culture (Shirky 2011). They can offer people a way to connect with each other over shared interests and an opportunity to build both a physical and online community of art lovers. Today, online communities are every bit as real as physical communities and meet the same needs; to feel less alone in a rapidly changing world that can be very challenging to navigate alone.

Summary

Technological and cultural changes are requiring cultural organizations to rethink how they attract an audience. The history of the development of cultural organizations shows that they evolved from the idea of the art patron. Today, the cultural organization acts as a facilitator of interaction between the audience members and the art. As a result, marketing has evolved from a passive to an active role in the organization. The use of a marketing plan can help the organization build a relationship with their customers by listening, involving them in the life of the organization, and the development of the cultural product.

References

Björkegren, Dag. 1996. *The Culture Business*. New York: Routledge.

Bourdieu, Pierre. 1993. *The Field of Cultural Production: Essays on Art and Literature*. New York: Columbia University Press.

Burnett, John J. 2007. *Nonprofit Marketing Best Practices*. Hoboken, New Jersey: John Wiley & Sons.

Day, Elizabeth. 2012. "Can you Make a Living as an Artist?" *The Guardian*, July 28.

DiMaggio, Paul. 2000. "Social Structure, Institutions, and Cultural Goods: The Case of the United States." *The Politics of Culture: Policy Perspectives for Individuals, Institutions, and Communities*. New York: The New Press.

Dowling, Siobhan. 2012 "European Arts Cutes: Dutch Dance Loses Out as Netherlands Slashes Funding." *Guardian*. UK. August 2.

Dreyer, Linda, and Maddie Grant. 2010. *Open Community: A little book of big ideas for associations navigating the social web*. Madison: Wisconsin. Omnipress.

Feld, Kate. 2012. "Kick-off: The National Football Museum Opens" July 13. http://www.creativetourist.com/featured/kick-off-the-national-football-museum-opens.

Heilbrun James, and Gray, Charles. 2001. *The Economics of Art and Culture: An American Perspective*, Cambridge: Cambridge University Press.

Hudson, Kenneth. 1987. *Museums of Influence*. Cambridge: Cambridge University Press.

Johnson, Steven. 2006. *Everything that is Bad is Good For You: How Today's Popular Culture is Actually Making us Smarter*. New York: Riverhead Books.

Keen, Andrew. 2007. *The Cult of the Amateur: How Today's Internet is Killing Our Culture*. New York: Doubleday/Currency.

Kolb, Bonita. 2001. "The Effect of Generational Change on Classical Music Concert Attendance and Orchestras' Responses in the UK and US." *Cultural Trends*, Issue 41.

McCarthy, Kevin, Brooks, Arthus, Lowell, Julia, and Zakaras, Laura. 2001. *The Performing Arts in a New Era*. Santa Monica, California: The Rand Corporation.

Museum Audience Insight. 2012. "Audience Research, Trends, Observations from Reach Advisors and Friends." July 24. http://reachadvisors.typepad.com/museum_audience_insight/2012/07/free-admission-days-and-daily-deals-.html.

National Endowment for the Arts. 2008. *Arts Participation 2008*. Washington, DC: National Endowment for the Arts.

Notter, Jamie, and Maddie Grant. 2011. *Humanize: How People-Centric Organizations Succeed in a Social World*. Indianapolis, Indiana: Que.

Pew Research Center. 2011. *Three Quarters or Smartphone Owners Use Location-Based Services*. Washington, DC: Pew Research Center's Internet & American Life Project.

Shirky, Clay. 2011. *Cognitive Surplus: How Technology Makes Consumers into Collaborators*. London: Penguin Books.

Simon, Nina. 2010. *The Participatory Museum*. Santa Cruz, California: Museum2.0.

Staniszewski, Mary Ann. 1995. *Seeing is Believing: Creating the Culture of Art*. New York: Penguin.

Sweetman, John. 1998. *The Enlightenment and the Age of Revolution 1700–1859*. London: Longman.

VanderMeulen, Ian. 2012. "Brooklyn Bridges." *Symphony*. Summer.

Wakin, Daniel. 2012. "For More Pianos, Last Note is Thud in the Dump." *New York Times*. July 29.

2 From High Art to Popular Culture

In the past cultural organizations have depended on the art patron to fill audiences and to provide funding. Over the past generation, changes in the external environment have resulted in a new type of audience member: the culture consumer. Culture consumers are fundamentally different from traditional audience members in how they view and consume culture. Culture consumers have not been socialized to view high art as inherently more valuable than the popular culture that has been the shaping force of their lives. They also differ in that rather than limit themselves to participating in only one type of cultural activity, culture consumers want to enjoy both high and popular culture. In fact, they have no objection to having them combined in the same cultural event.

Over the last ten years there has been another profound change in how people view culture. The advent of social technology allows anyone who wishes to do so to create art. This has resulted in the cultural participant, someone who views him or herself as the equal of the artist and a partner with the cultural organization. Cultural participants are still interested in consuming culture, but only as an equal. Before these profound changes can be fully appreciated, it is important to understand how the distinction between high art and popular culture came about in Western society.

Shall We Dance?

If you are in Brussels during the summer, you have no excuse not to dance. The Bal Moderne, a dance company, decided to share the joy of what they do by getting everyone dancing in the parks. They choreographed three short pieces of dance that anyone could learn. Even though the dances are simple they still have artistic merit. People are taught the dances by teachers who are non-judgmental and provide a boost for everyone's self-esteem. People, who thought they could not dance, learn, to their surprise, that they can. While at the same, they get to mix with a variety of their fellow citizens. What better way to spend a summer evening, then dancing in the park?

Brussels Life (2012)

Marketing Defined

The definition used by the American Marketing Association describes marketing as the "activity, set of institutions, and processes for creating, communicating, delivering, and exchanging offerings that have value for customers, clients, partners, and society at large" (n.d.). The practice of marketing simply takes this basic human behavior and plans its conception and implementation.

It is interesting to note that the definition calls for an exchange that satisfies more than just the organization. Marketing was never conceived as a means to manipulate individuals into behavior in which they did not wish to engage. There would be no long-term gain for any organization in doing so. Likewise, the definition does not call for the organization to satisfy the individual at any cost to society. It is an exchange where the needs of everyone are considered.

Part of the marketing process is an exchange of information on consumer desires and the organization's means to fulfill them. Individuals make their desires known and the organization makes their product known. The individual may wish to modify their desires, if there is no organization that can meet them, and the organization may wish to modify their product, if it does not meet the needs of any potential customers. It is also interesting to note that the definition describes marketing as the "creating" of ideas, goods or services. That the marketing department has a voice in deciding which product to produce, is the part of the marketing definition to which cultural organizations often object. They cite it as the reason marketing is inappropriate for a cultural organization.

High versus Popular Culture

In order to develop marketing strategies which will be successful in attracting culture consumers and the new culture participants, it is necessary to understand the historic distinction between high art and popular culture. The traditional distinction is that high art is produced from the internal vision of the artist, resulting in an artistic product with a unique and personal meaning. When producing high art, the artist has little or no concern for the desires and needs of the consumer who may ultimately purchase the art or view the performance. The art is the product of the artist's inner vision alone, with no consideration given to shaping the art for consumer purchase.

On the other hand, the distinctive feature of popular culture is that the focus is placed on the consumers. The meaning is determined by them when they consume the cultural product. Therefore, the desires and needs of the consumer are of paramount importance in the production of popular culture. If consumers should change their desires, the producer will give them a new popular culture product.

Of course, such purist positions have always been the extreme. Because of the necessity of making a living, artists who produce high art often care what the future purchasers of their art might want. And artists producing popular culture may have been formally trained in the arts and produce an art product that results from an inner vision.

Cultural Organizations and Popular Culture

The historical distinction between high art and popular culture has been of great importance to cultural organizations. In fact, the mission statements of cultural organizations may have been written with a view toward keeping their art pure from the contamination of the desires of the marketplace. One of the outcomes of the process of developing a marketing plan can be a re-examination of the boundary the organization has drawn between high art and popular culture, and how much of this distinction is still relevant. Without threatening their mission, the cultural organization can now allow culture participants to share in creating the cultural product even if they blend in features of popular culture. This is especially crucial now that there is little consumer interest in maintaining cultural boundaries.

It is interesting to note that the strict boundary between high art and popular culture is relatively recent. It was developed in Europe and the United States during the nineteenth century as a reaction to the Industrial Revolution, the resulting mass production of goods and the rise of the new middle class. It was thought that for democracy to function the masses would need to be educated into what was the correct culture to enjoy (Butsch 2008).

It is the fear of many cultural organizations that the free agents blogging and exchanging views on social media sites will result in consumer demand for work produced by only the most popular artists. In contrast, the opposite has been found to be true. Online communities that share a passion for a particular art form, whether obscure Russian cinema or political theatre, pride themselves on finding and sharing information on challenging work. As the online community members share the experience of complex work, their appetite for more challenging work grows (Dolgin 2012).

This Thing Called Art

"The term 'ART' as we now understand it began to take on its modern meaning in the eighteenth century: an original creation, produced by an individual gifted with genius. This creation is primarily an object of aesthetic beauty, separate from everyday life. Not solely political propaganda, not a religious or sacred object, neither magic nor craft, this thing called Art did not exist before the modern era."

Staniszewski (1995)

Development of the Cult of High Art

The idea of art produced by a professional artist solely for contemplation, and not use, is a recent phenomenon. The idea of an object as the individual expression of an artist with no utilitarian function became accepted only in the eighteenth century (Staniszewski, 1995). Prior to this time, art was considered an extension of a society's culture. This culture was expressed through its art, but also through its language, religion, and customs. This art, or better termed in this context as *artifacts*, included both performance and objects that were the visible production of the society's values and beliefs. The artifacts were produced not as art, even though they may now be considered art, but to meet specific human needs. These needs were pragmatic ones, such as creating pottery dishes for eating, but they also included spiritual needs, such as statues or figures for worship. The creation of both types of objects, those to meet pragmatic and spiritual needs, expressed the culture of the society, not the vision of an individual artist.

It is a modern invention to think of an individual's inner vision as necessary to produce art. In earlier historical times, only technical skills were considered necessary to produce the artifact. The artifact might have been considered beautiful or meaningful by its users, but the first purpose of the artifact was for it to be useful. Technical skill, not vision, was considered necessary to produce the art/object.

During the Renaissance, art was elevated above the level of a mechanical skill. However, the creation of art was still considered on the same level as any of the other traditional areas of knowledge. It was not until the eighteenth century that the fine arts were separated out from the other liberal arts. Then, vision and genius were added to technical skill as what was considered necessary for the production of art. While fine artists might have wished to gain technical skill so as to better create their vision, to be considered an artist the vision or genius had to exist first. Since genius was rare, the creations of such artists would have value as a scarce commodity besides their intrinsic value as art.

Those in positions of civil or royal power always were able to purchase the products of artists. With the rise of the market economy, merchants also now had the wealth to purchase art. These merchants may have purchased art because they wished to enjoy the beauty of the object and the satisfaction of sharing in the artist's unique vision. However, the value of art does not come only from the object itself, it also results from the scarcity of the art object (Budd 1995). Merchants understood the value of a scarce commodity and also bought art because it could be resold at a profit.

Once the art object could be mass produced mechanically, it lost its scarcity value and, as a result, was no longer considered high art. If the art object is mass produced, cost will be lower and it can then be purchased

How to Attract an Audience for Classical Music? Packaging!

The Lincoln Center in New York presented a series of music concerts for its White Light festival that combined classical music, world music, popular music, dance, and theatre. It had everything from Mahler to calabash flute music, the Latvian Radio Choir, and Mary Chapin Carpenter. The classical music concerts attracted an audience of people who traditionally wouldn't have attended. They attended this time because the programming was packaged as one event and they then wanted to experience it all.

Sandow (2012)

by the middle, or even lower, classes. The object will then be frowned upon by many of those who can afford to buy the original art. It is the idea of exclusivity and elitism that results from originality and therefore scarcity, which is sought after by those who can afford the object. The copy, no matter how skillfully done, is deemed vulgar. Because it is widely available popular culture cannot be used as a status symbol in the same way as high art.

Early Cultural Stratification

An example of how art became stratified is the founding in London at the end of the eighteenth century of the Concert of Ancient Music Society. Its purpose was to raise the standard of music performance and appreciation, particularly among the new professional class. The Society had a rule that only music composed over twenty years previous to performance could be part of the repertoire. The music of Purcell, Corelli, Handel, and other English and a few Italian composers was performed. This emphasis on "old" music was to protect the audience from vulgar contemporary music—Italian opera. The founders believed that the public concerts of such music pandered to the lower classes and degraded music.

The repertoire was considered "classical" because it did not include the popular music of the day. Italian opera performances were what most of the upper-middle class and nobility, along with the lower classes of society, attended for entertainment. The orchestral music at these operas was often performed by amateur musicians and entertainment of the audience, not quality of the music, was considered the most important criteria for success. On the other hand, classical music concerts were played by professional musicians and quality of the performance was considered more important than entertainment of the audience. While a member of the upper classes attended Italian opera for entertainment, it was not considered possible that classical music concerts could be appreciated by those lower on the social scale (Shera 1939).

The founders of the Society were not members of the nobility, who were seen as the natural patrons of the arts. The founders, who were mostly upper class, sought to present concerts which they considered worthy of a noble audience, while at the same time finding a middle-class audience worthy of the music. The goal was to reproduce for the public the private performance of music available to the nobility. These concerts gave members of the upper and middle classes the opportunity to become part of the social world, at least in a limited way, of the nobility. This was the first attempt to promote a public concert series to a particular class of audience (Weber 1992).

So, by the last quarter of the eighteenth century, the music world was already splitting into two opposing factions: the modern/popular group which attended Italian opera versus the classical/elite music group which attended concerts promoted by the Concert of Ancient Music Society. This split along class lines it still evident.

Shakespeare in the United States

Despite early efforts to separate high art from popular culture, the stratification of culture in the production of art for consumers was not always strictly enforced. For example, in the mid-1800s in the United States art forms such as Shakespearean plays and opera were routinely presented in front of audiences that consisted of people from all social classes and were "simultaneously popular and elite" (Levine 1988). In these productions, the art was not treated as a sacred text that had to be reverently recreated. Because society had changed since the play had originally been created, those producing the performance felt it perfectly acceptable to alter the script to increase the enjoyment of the audience. It was also considered acceptable for the audience to noisily show their approval—or disapproval—of the performance. Theatre and other art forms were considered part of the general culture that anyone was free to enjoy or not to enjoy (Butsch 2008).

It was only in the second half of the nineteenth century that the self-appointed guardians of culture decided that culture was not for entertainment but only for enlightenment. During this period the United States experienced mass immigration and the cultural behavior of the new immigrants was very unsettling to those who saw themselves as part of the established culture. As a result, there was a move by those involved in producing cultural events to make this new immigrant audience conform to accepted standards of behavior. The cultural establishment decided that theatres, concert halls and museums were no longer to be seen as places of entertainment. There were now to be institutions with a higher purpose: the improvement of society.

Popcorn at the Concert

Everyone is aware of the Metropolitan Opera's successful showing of their operas at movie theatres. However not everyone is aware that other cultural organizations are also doing the same. The Los Angeles Philharmonic Orchestra is also offering simulcasts of their concerts. The orchestra found that the audience liked the close up shots of musicians in action. This is something that previously no one except those in the front row at a concert could have seen. Now everyone gets to see the close-ups while at the same time eating popcorn; something that you can't do at the Met!

Melick (2012)

Victorian England

Meanwhile, in England, the Victorian ideal was to use culture both to improve the working class and to train the new emerging middle class. The Victorian establishment saw culture as a means to produce a sober, hard-working middle class which would accept what the upper, established classes defined as acceptable culture. This new middle class was also told the manner of behavior that was expected in the theatre, concert hall, and museum (Pointon, 1994).

There was never an intention from these custodians of culture to keep the public away. They simply wanted to make sure the public enjoyed the proper culture in the proper manner. And they got to decide what the proper culture was and decreed that the proper manner was to enjoy cultural productions quietly and individually. No longer was raucous expression of approval or disapproval to be allowed. Any behavior that suggested mass enthusiasm by the crowd was suspect, as it might be followed by uncontrolled behavior. The establishment feared that such behavior might put its status at the top of the hierarchy at risk.

Society is only now moving away from the resulting sacralization of culture that started in the eighteenth century and was with us for most of the twentieth century. In the twenty-first century people are no longer willing to accept being treated as uneducated outcasts who must be taught

Defining Art in the Nineteenth Century

"The meaning of culture itself was being defined and its parameters laid out in ways that would affect culture profoundly throughout this century. The primary debate was less over who should enter the precincts of the art museum, the symphony hall, the opera house as over what they should experience once they did enter, what the essential purpose of these temples of culture was in the first place."

Levine (1988)

what culture is best and how it should be enjoyed. The new culture consumers and participants question why they should take their valuable time to learn from others how to enjoy culture when they can decide for themselves.

The Rise of Popular Culture and the Mass Market

The effect on society of the ability to mass produce art has been studied with much concern. The ability to record and reproduce music, create copies of art work and film theatrical performances has been pronounced to have a negative impact on the public's appreciation of the real art object or performance. It was feared that exposure to these reproductions would result in individuals no longer seeking meaning in art because their senses would have become dulled by constant exposure.

Theodor Adorno

The philosopher Theodor Adorno was greatly concerned that the mass production of music and other cultural products would result in an inevitable homogenization of art (Adorno 1998). He believed that such homogenization would result in a passive consumption of art and, as a result, would no longer have any deeper meaning. Since he believed the purpose of art was to communicate new ideas, he was concerned that constant repetition of a limited number of messages would cease to communicate. As a result, art would lose any meaning. His fears regarding popular culture still echo with some cultural theorists in organizations and academia today.

The belief that high art has a deeper meaning to communicate that is beneficial to society was well established by the mid-twentieth century. In fact, after the Second World War, governments increased funding to support cultural organizations presenting high art in a belief in its beneficial effect on a population traumatized by war. However, during the same time period, there has also been an explosion in the commercial creation of and consumer demand for popular culture. Because companies that generate the products of popular culture cannot rely on government funding, they must respond to the desires of the consumer. The world-wide popularity of popular culture attests to the fact that they have been very successful in doing so.

The cultural organization, like Adorno, may believe that high art improves the lives of those who share in its expression. However, cultural organizations must accept that the dream of a universal interest in high art has never materialized and that there have always been a limited number of people who wish to experience such cultural events. Cultural organizations must face the fact that, if they are to survive, they can no longer be passive and must now compete actively with popular culture for their audience. This is because the public that desires and consumes popular

culture no longer believes that high art is always worthy and that popular culture is always vulgar.

Even if the general public does not wish to support the high art form that the cultural organization was originally formed to present, the organization will still want to both preserve and share their art with the public. For this to be possible, they need to have all types of consumers attend and come to share in the artistic experience, even if they may not believe in the art form in the same way as those who manage the organization.

Therefore, cultural organizations presenting high art have a unique and challenging task. They must produce and market high art to attract an audience of culture consumers raised on popular culture, without compromising the vision of the artist who created the art.

The Vision Belongs to Everyone

Now it may be time to go one step further. If everyone, not just the artist, can create, the cultural organization must realize that the audience will want to involve themselves in the work in other ways than just being consumers. Now the customer is no longer in awe to the artist or the cultural organization. In fact, he or she now wants to participate in the organization as equals.

Herbert Gans: Levels of Culture

Those managing cultural organizations must understand why different segments of society patronize different types of cultural events and art forms. Besides Adorno, other theorists have tried to understand why the differences exist. For example, cultural life was defined by Herbert Gans as consisting of four strata: high, middle class, lower-middle class, and working class (Gans 1977).

High Culture

In the strata of high culture, the art product is seen as a unique creation of the artist. The art which is created is the external expression of the artist's vision. While it may be difficult, it is still the responsibility of the audience to discover and understand the meaning of the vision in order to appreciate the art. It is argued that when members of the audience can reach this level of understanding, they can share in the genius of the artist. This is the reason the art forms of high culture often require a prior knowledge of art and artists before they can be enjoyed. In fact, under this theory, art that is widely popular cannot be considered high art, since it is being appreciated by a large audience that would not have this prerequisite knowledge.

Gans's Levels of Culture

Culture Class	Education Level	Art	Audience
High class	High birth/ education	Focus on artist	Responsible to interpret meaning
Middle class	Professional education	Focus on audience	Desire understandable meaning and enjoyment
Lower-middle class	No higher education	Expresses values of society	Needs easily understandable, unambiguous message
Working class	Limited education	Action oriented; stereotype characters	Demands relaxation, escapism

This argument explains why the high culture art forms of classical music, ballet, and serious theatre receive the most attention from art funders, while they actually attract the smallest audience. This is because the audience, by definition, can only consist of individuals with the high level of education necessary to decipher the meaning. They also must have an interest to do so, which is often learned only from living with a family of a high social class or pursuing advanced education.

Middle-Class Culture

Gans ranks middle-class culture next in the hierarchy of cultural life. Here, the manner in which art is created and presented switches from focusing on the vision of the artist to the desires of the audience. The audience puts equal importance both on understanding the message the artist wishes to convey and enjoying the art product.

The audience for middle-class culture consists of professional members of society. Being in a profession, they have the education which has prepared them to think critically and to enjoy the balancing of the various, and sometimes contradictory, messages that art contains. They do not disregard the importance of the artist as the creator of the work, but the artist is mostly important as the producer of the art that the individual either enjoys or does not. The artist becomes the brand name whose work will then be sought out, or avoided, in the future.

Lower-Middle-Class Culture

Lower-middle class is the third strata of cultural life as defined by Gans. For this audience, the enjoyment of the content of the art is most important. The audience still wants the art to have a message, but it is not the message of the individual artist that is of interest. The audience desires

The Birth of the Serious Music Concert in the United States

"Thus by the early decades of this century the changes that had either begun or gained velocity in the last third of the nineteenth century were in place: the masterworks of the classic composers were to be performed in their entirety by highly trained musicians on programs free from the contamination of lesser works or lesser genres, free from the interference of audience or performer, free from the distractions of the mundane; audiences were to approach the masters and their works with proper respect and proper seriousness, for aesthetic and spiritual evaluation rather than mere entertainment was the goal."

Levine (1988)

art with a message that is easily understandable, makes a clear distinction between right and wrong, and expresses the values of conventional society.

Since the members of this audience are usually without a professional education, they lack the power that results from social position and often feel constrained by the rules of society. They do not have the position or the money to avoid the unpleasantness and conflicts of life. Instead, their lives are often bound by the rules and constraints under which they must live. Ambiguity of meaning, which might be tolerated as a part of middle-class culture, would not be appreciated by a lower-middle-class audience.

Since the lower-middle-class audience desires art that has an enjoyable content and a clear message that conforms to their own beliefs, artists are now clearly in the role of producing art for the audience rather than for themselves. Therefore, the term *popular culture*, rather than *high art*, would traditionally be applied to this type of product.

Working-Class Culture

Working-class culture is the fourth strata of cultural life. Here the emphasis is again on clear, understandable, enjoyable content with no ambiguity. At this level, the audience will insist on increased entertainment value through the frequent use of action and stereotyped characters. The audience for this art often has little education and works in jobs that are difficult and repetitive. Therefore, they wish entertainment that is predictably enjoyable and offers the opportunity for relaxation and escapism. They do not wish to risk their limited leisure time and money on the unknown, nor are they interested in entertainment that challenges the status quo.

Herbert Gans's description of the levels of culture is still useful today. However, what has changed is that society is now no longer as stratified. With mass education a reality, individuals have the opportunity to move up the social hierarchy. And, because of technology, even working-class jobs now require individuals to have a level of education and sophistication unknown in the past. Both of these facts have actually increased the

Let's Get Some New People on the Wall

Pallant House, in South East, UK has a renowned collection of twentieth-century and contemporary art by well-known artists. However, the gallery decided to let unknown artists without access to the art world exhibit through a competition known as Outside In. The idea was so successful that in 2009 Pallant House decided to put the show on tour. However, the gallery found that moving the exhibition was stressful and costly, so a more collaborative approach was taken. The gallery put the submitted artwork that was accepted online. Other museums could then select work from the digital database and arrange to mount their own exhibits. Numerous museums have responded with a request to show the work.

Arts Council of England (2012)

potential audience for high art. At the same time, those born into a high social class are also working harder in a more competitive world and are more likely to attend and enjoy popular culture. As a consequence, it is important for those marketing cultural organizations to understand that they can no longer assume they know what type of culture is desired by different market segments based on income and education.

Pierre Bourdieu: Taste in Culture

It is easy to state that something is in "good taste" or "bad taste" without thinking about what these terms actually mean. Back in the 1970s, Pierre Bourdieu, a French sociologist, performed a ground-breaking analysis of taste (Bourdieu 1996). His study consisted of interviewing people regarding their preferences in art. To take just one segment of this study as an example, individuals were asked for their preference among three pieces of music: *The Well-Tempered Clavier* by Bach, *Rhapsody in Blue* by Gershwin, and *The Blue Danube* by Strauss. Bourdieu used the preferences for these and other related art works to determine class differences in taste, which he labeled legitimate taste, middle-brow taste, and popular taste.

He found there was a clear preference for each piece of music among those belonging to certain occupational groups. *The Well-Tempered Clavier* was preferred mostly by those working in education and the arts. *Rhapsody in Blue* was preferred by technicians and junior executives, while *The Blue Danube* was preferred by manual workers, clerical workers, and shopkeepers.

Legitimate Taste

Previous studies of this type had concluded that the difference in taste resulted from a difference in educational level and, therefore, that

Bourdieu's Tastes in Culture

Taste	Music	Profession	Desire
Legitimate taste	*The Well-Tempered Clavier*	High birth or professionals working in education/arts	Engage the intellect
Middle-brow taste	*Rhapsody in Blue*	Technicians and junior executives	Appeal to everyday experience
Popular taste	*The Blue Danube*	Manual workers, clerical workers, and shop keepers	Pleasure through sensory experience

education determines taste. However, Bourdieu's theory attempted to explain why people have a preference for different types of culture.

He theorized that there are two means by which people can gain access to cultural knowledge, which he called cultural capital. One means is by birth into a high social class, which results in the individual growing up surrounded by what is "correct" aesthetically. The other means is through education, where the individual learns what are legitimate works of art and the correct way to enjoy them. Although the necessary knowledge can be obtained through either birth or education, those born to a high social class consider education as the second best means. They believe that a true appreciation of art forms is innate to their life experience and cannot be learned.

Therefore, the enjoyment of legitimate high art is both a result of, and a criterion for, belonging to the upper class. To reject the art is to reject the class to which you belong. On the other hand, the more one knows about and appreciates the art, the more one's social standing is reaffirmed.

If a privileged birth or education is needed to appreciate art, it then stands to reason that art that anyone can enjoy and is easy to understand cannot be art. And, for those with legitimate taste, to enjoy such non-art means they lack the education to recognize the difference. This view of taste states that the engagement of the intellect tells us what is art. Therefore, art which appeals to the emotions and body is by its very nature suspect.

Middle-Brow Taste

Art that does not have the elements of recognizable form and melody can be difficult to appreciate if the viewer has not been trained by birth or education to understand its appeal. Therefore, the class distinction of legitimate taste is reinforced. Its very detachment from the everyday experience of life which defines legitimate taste.

In contrast, those with middle-brow taste prefer art that appeals directly to their everyday experience. Those with middle-brow taste are interested in art that can have a personal meaning, and Bourdieu found these audiences preferred *Rhapsody in Blue*.

Popular Taste

Popular taste appeals to the working-class audiences who are interested in the concrete and not in the abstract. They want pictures they can understand, dancing that looks like something they could do, and music they can hum. Because they want to receive pleasure through sensory experience, they preferred *The Blue Danube*. Unfortunately, their very desires and tastes are looked upon as vulgar by those with legitimate taste.

The Distinction

High art, which appeals to legitimate taste, is removed from the immediate sensory pleasure afforded by art which appeals to middle-brow or popular taste. High art appeals to those who are born into a high social class with a high-income lifestyle and who, as a result, already have an abundance of sensory pleasure in life. However, for those who are born into a life that demands hard work, it is not surprising that they should not only be uninterested in high art that appeals to legitimate taste and requires an aesthetic knowledge to enjoy, but also be offended by it. They are told that, after a hard day's work, they should now work hard at trying to understand art that to them, is instinctively unattractive and incomprehensible.

Unfortunately, there is a tendency for those who have the prerequisite birth or knowledge to understand high art to look down upon those who do not have it. (This tendency is still prevalent today in the use of the term

What's a Digital Engagement Coordinator?

It's someone who works at the San Francisco Ballet who is responsible for doing the Facebook posting, Twittering, and creating online buzz for the company. The SFB, the oldest ballet company in the United States, is in the forefront of the dance world in using social media. It might have something to do with San Francisco being just north of Silicon Valley. It also has to do with the fact that the ballet receives very little public funding. They must depend on their fans for funding, which makes it imperative that they build relationships. Not only the company tweets and Facebooks, so does its dancers. On the company's website is an "interact" button that gives the option of "watch," "listen," "log," and "follow." The "watch" choice allows the viewer to watch the ballet in action and also see the choreographers at work. The "listen" choice provides podcasts which inform listeners about various aspects of the ballet productions. The "blog" choice provides the traditional blogs but is also where fans can upload photos including one of a SFB fan dancing ballet with his cat! The "follow" option includes links to Facebook, YouTube, Twitter, Pininterest, and Tumblr. After all this interaction, it would be a shame not to go to the ballet and see the performance!

Mackrell (2012)

dumbing down when popular culture is discussed.) The upper classes can feel superior because those below them remain dominated by ordinary, everyday desires and interests. However, this tendency is not limited to the upper classes, as every class tries to distinguish themselves from the class below based on their taste in art. While the patron of the high arts looks down on the pleasures of the middle-brow audience, the middle-brow audience also looks down on the pleasures of the working-class audience.

Cultural Hierarchy Today

Despite Adorno's fears, people still find meaning in art. What is different is that the easy availability of all types of culture has resulted in a breakdown in the distinction between high culture and popular culture described by Gans and Bourdieu. Today, the same consumers may enjoy both without concern for labels. In fact, consumers now see themselves not just as consumers of culture but as participants. Cultural participants want to create their own meaning and see themselves as co-creators with the organization and the artist.

Creation of Meaning

The public no longer looks to the cultural organization to provide an internal meaning for the art, but to provide the raw material with which individuals can create their own meaning. Individuals in our modern society, particularly the young, are very skilled at deciding what is important to their lives. They no longer look to a single social class, religion, nationality or ethnic group to provide an infrastructure of meaning. People now feel free to create their own meaning and associate with whom they please.

In addition, the fact that consumers now can create art means that everyone can create their own meaning. There is still a place for the cultural organization in this new world. Indeed, it is the organization that can provide the nexus for cultural participants to share and engage in their own creation while at the same time, experiencing the culture that is the mission of the organization.

Those working in cultural organizations may be alarmed. They may believe their years of training and expertise about what is good art and what is bad art is no longer relevant. This is an issue of concern. If everyone is an artist, why do we need cultural gatekeepers? However, there is still a role for the cultural manager who determines what art to present (Keen 2007). The difference is how he or she approaches that role. Cultural managers can no longer dictate. They can no longer disregard the efforts of their amateur audience. Instead they must validate the efforts of their audience (after all, everyone's own baby is beautiful), while at the same explaining the culture the organization is presenting.

The People Formerly Known as the Audience

The discussion of how media no longer has the power to dominate the conversation started with news media. The traditional media system had been designed to be a one way means of communicating the news to the public. The media spoke and the audience listened. However, technology changed this formerly passive role for the world of print, radio, broadcasting, and editing as can be see below:

Former Passive Media	Current Active Media
Printing press	Blog
Radio station	Podcasting
Broadcasting	Online posting of video
Editor	Ability to design a personalized front page

The phrase "the people formerly known as the audience" resonated with many other types of organizations. Now the people who can experience the exact type of news they want, when and where they want it, are bringing these same expectations to cultural organizations.

Rosen (2006)

We The People Formerly Known as the Audience

The above phrase was first introduced in regard to media audiences. It quickly caught on to describe the people who consume culture from church services to art forms. This one statement captures the power shift that has gone on since the explosion of social media use (Rosen, 2006). Now that the people who were formerly the audience expect an equal voice in the organization, it is marketing's responsibility to become a two way communication process. Today's culture participants still desire culture, but they will no longer accept the authority of the cultural organization. Nevertheless, the cultural organization can still play a critical role in cultural life by providing a place for people to associate with others to create their own cultural life in a way which creates or reinforces community. The technology of social media, which has caused this change, can be used to build this community.

Because of today's technology, cultural organizations have moved away from a world where the level of culture and taste could be easily judged by the venue in which it was found. Novels were in real bookstores while comic books were sold in comic book stores. Serious theatre was presented in publicly funded organizations while movies were at the cinema. Not only has this physical distinction been jumbled it has been completing overturned online. Art forms have blended between popular culture and learned culture, entertainment and information, education and persuasion. Online the consumer can find in the same place culture "from the

worst to the best, from the most elitist to the most popular" (Castells 2010). The days when the cultural organization was the sole voice of authority is gone.

Summary

An understanding of the historical relationship between cultural products and the audience is helpful when developing marketing plans to attract audiences. The debate over the difference between high culture and popular culture developed in the nineteenth century during the Industrial Revolution as a way to civilize the rural people who had moved to the cities to work in factories. The philosophers, Adorno, Gans, and Bourdieu, developed models to understand why people enjoyed different types of culture. Today the emphasis on cultural hierarchy is greatly diminished. In fact, the idea of hierarchy itself is being challenged. Because of the technological ability to share and create over distance, people can produce their own art and meaning rather than be passive consumers. Cultural organizations must now have a more direct relationship with their customers who now consider themselves partners rather than patrons.

References

Adorno, Theodor. 1998 *Aesthetic Theory*. Minneapolis: University of Minnesota Press.
American Marketing Association n.d. About AMA, Definition of Marketing. June 8, 2012 http://www.marketingpower.com/aboutama/pages/definitionofmarketing.aspx
Arts Council of England. 2012. "Visual Arts and Museums: How Arts and Culture are Working Collaboratively." http://www.artscouncil.org.uk/funding/funded-projects/case-studies/visual-arts-and-museums-how-arts-and-culture-are-working-collaboratively/February 29.
Bourdieu, Pierre. 1996. *Distinction: A Social Critique of the Judgment of Taste*. London: Routledge.
Brussels Life. "This Summer Bal Moderne is Going to Make You Dance?" 2012. August 2. http://www.brusselslife.be/en/article/bal-moderne-is-going-to-make-you-dance
Budd, Malcom. 1995. *Values of Art: Pictures, Poetry and Music*. New York: Penguin.
Butsch, Richard. 2008. *The Citizen Audience: Crowds, Publics and Individuals*. New York: Routledge.
Castells, Manuel. 2010. *The Rise of the Networked Society, 2nd edition*. West Sussex, UK: Wiley-Blackwell.
Dolgin, Alexander. 2012. *Manifesto of the New Economy: Institutions and Business Models of the Digital Society*. London: Springer.
Gans, Herbert. 1977. *Popular Culture and High Culture: An Analysis and Evaluation of Taste*. New York: Basic Books.
Keen, Andrew. 2007. *The Cult of the Amateur: How Today's Internet is Killing Our Culture*. New York: Doubleday/Currency.
Levine, Lawrence. 1988. *Highbrow Lowbrow: The Emergence of Cultural Hierarchy in America*. Cambridge, Massachusetts: Harvard University Press.
Mackrell, Judith. 2012. "How Twitter Transformed Dance." *The Guardian*. July 31.

Melick, Jennifer. 2012. "Popcorn and Prokofiev." *Symphony*. Summer.

Pointon, Marcia. 1994. *Art Apart: Art Institutions and Ideology Across England and North America*. Manchester: Manchester University Press.

Rosen, Jay. 2006. "The People Formerly Known as the Audience" Pressthink. June 27. http://archive.pressthink.org/2006/06/27/ppl_frmr_p.html.

Sandow, Greg. 2012. "Programming for a New Audience — Things That Worked." July 24. http://www.artsjournal.com/sandow/2012/07/programming-for-a-new-audience-things-that-worked.html.

Shera, Frank Henry. 1939. *The Amateur in Music*. Oxford: Oxford University Press.

Staniszewski, Mary Ann. 1995. *Believing is Seeing: Creating the Culture of Art*. New York: Penguin.

Weber, William. 1992. *The Rise of Musical Classics in Eighteenth Century England: A Study in Canon Ritual and Ideology*. Oxford: Oxford University Press.

3 The New Culture Participant

Many theories on why individuals attend cultural events focus on a person's age, social class, education, and income level. Cultural organizations have particularly focused their promotional strategy on attracting different age groups. Therefore, the lack of attendance by the young has been of concern to cultural organizations for some time. What is new is that cultural organizations now must worry about declining attendance by older consumers. The decline in attendance at cultural events needs to be understood as resulting not just because people of certain age groups are not attending but rather as result of changes in consumers' attitudes and lifestyles. Consumers vary as to their emotional involvement with cultural organizations. Some people are currently culture consumers and will not progress to a deeper involvement with the culture organization, while some will want to fully engage. Cultural marketing has progressed from a model of expecting all consumers to love the art form to accepting consumers at whatever level of involvement they desire.

Because of social communication technology, there is now a new type of consumer called the culture participant. The new culture participants want to move beyond merely attending cultural events. They want to have a say in the programming and even the art product. As cultural participants are not interested in being passive consumers, marketing for cultural organizations must now provide the interactive cultural product that these culture participants demand. While still conducting traditional promotion, marketing must now be involved in a range of activities to encourage attendance. This is because marketing is no longer the only promotional voice being heard by consumers. People now can read reviews and interact with others who consume culture. Not only do people interact with the organization online they also interact with each other. In addition now besides attending traditional events, they also create their own art to share, recreate the art of the organization, or all of these. The time has come for the cultural organization to no longer think of marketing as merely filling seats and to focus on how the cultural organization can partner with the public to provide the level of participation they desire.

Declining Attendance among All Age Groups

Every five years the U.S. National Endowment for the Arts (NEA) conducts the statistically valid Survey of Public Participation in the Arts (SPPA). The survey asks correspondents about their participation in a variety of benchmark or traditional art forms including classical music, opera, ballet, plays, and art museums.

Since this data is collected every five years, it is useful in tracking not only overall changes in attendance but changes in attendance demographics such as age. Three separate issues are revealed by an analysis of trends in this data (NEA 2008). First, the average age of attendance has been increasing for all art forms. Second, and of concern for the future of cultural organizations, is the fact that attendance has been declining most among the young. Third, and of immediate concern, is the decline in attendance for audience members aged forty-five to fifty-four, which has always been considered the prime years for attendance.

A comparison of all survey participants from 1982 to 2008 shows that the average age increased by six years, which is in line with the overall aging of the American population. However, the average age of participants who stated they attend the arts versus those who do not increased even more than the age of the population as a whole. Jazz had the youngest audience in 1982. Since then the audience for jazz has aged the most among all the arts forms surveyed. Opera's audience is small but has aged right alone with the national average. The audience for classical music has aged the least, but still has the highest medium age, because it was the oldest overall in 1982.

Another method of studying this data on aging of the audience is to examine the data on the attendance by those under thirty-five as a percentage of the audience. This age group is sometimes called the "connected generation" for whom technology has always been a part of their

Median Age of Arts Attenders, 1992 and 2008

Category	1982	1992	2002	2008	% Change
All Participants	39	41	43	45	+6
Jazz	29	37	42	46	+17
Classical Music	40	44	47	49	+4
Opera	43	44	47	48	+5
Musicals	39	42	44	45	+6
Plays	39	42	44	47	+8
Ballet	37	40	44	46	+9
Art Museums	36	39	44	43	+7

Percentage of Audience Aged 18–34, Attending Arts Events

Age 18–34	% in 1992	% in 2008	Change	% Rate
Jazz	17.5	7.3	−10.2	−58%
Classical Music	11.0	6.9	−4.1	−37%
Opera	2.0	1.2	−0.8*	−40%*
Musicals	16.6	14.5	−2.1*	−13%
Plays	10.7	8.2	−2.5	−23%
Ballet	3.9	2.0	−1.4	−36%
Art Museums	22.7	22.9	+.02*	+1%*

*statistically insignificant

lives (L. Johnson 2006). For this age group the need to participate is of vital importance. They want to *do*, rather than just observe, as a means to express themselves.

An analysis of the audience by age group reveals the extent of the decline in young attenders. Jazz has seen the steepest rate of decline for young attenders of 58 percent from 1992 to 2008. Ballet also has seen a sharp decline in young attenders with a 36 percent decline in audience percentage. Attendance by the young at classical music has seen a 37 percent decline. Opera has the smallest decline with only a .8 percent drop but since the base is so small this is statistically insignificant.

It can be seen that the small percentage of young people attending the arts has become even smaller. It has often been argued that this is not a problem. Since older people attend, as these young people age, they should also become audience members. However, an examination of the change in attendance among older people shows their attendance rate is also declining. Plays have seen the sharpest decline, 43 percent in attendance among those who should be attending the most. All art forms except for art museums and musicals have a 30 percent or higher rate of decline for

Percentage of Audience Aged 45–54, Attending Arts Events

Age 18–34	% in 1992	% in 2008	Change	% Rate
Jazz	13.9	9.8	−4.1	−30%
Classical Music	15.2	10.2	−5.0	−33%
Opera	4.0	2.4	−1.6	−40%
Musicals	19.3	17.4	−1.9*	−10%
Plays	18.2	8.7	−6.5	−43%
Ballet	5.1	3.2	−1.9	−37%
Art Museums	33.9	23.3	−9.6	+29%

*statistically insignificant

the forty-five to fifty-four age group. If this decline should continue, it means attendance will go from being a concern to a crisis.

Education level has always been seen as a predictor of arts attendance. This should bode well for the arts because more adults are attending higher education than in previous generations. However an analysis of the data reveals education level is less of a predictor of arts attendance than in the past. It is true that those without higher education are attending less, thereby bringing their previously low attendance rates even lower. However, those with higher education are also attending significantly less. In fact, attendance of individuals with graduate degrees declined 9 percent from 2002 to 2008 while college graduates fell 7 percent (NEA 2008).

It is not just attendance at arts events that has seen a decline. Other civic activities have also seen declines in participation. For example, voting has seen a similar decrease as has volunteerism (Tepper 2008). All of these are activities that require people to plan ahead and show up at a designated place at a designated time. A study of people's involvement in activities such as church, professional organizations, sports, and service organizations showed a positive correlation with arts attendance. People who are involved are involved in numerous activities. The opposite is true as those who do not, are not.

From Prole to Culture Vulture

When a Parliamentary Commission held hearings on the fate of the troubled Royal Opera House, Sir Colin Southgate, the Covent Garden chairman, worried aloud that the effort to reach out to new audiences would result in opera attenders wearing "shorts and smelly trainers." On the other side of the argument, Gerry Robinson, who was at that time the new head of the Arts Council, blamed the opera administration for the dominance of "white middle-class audiences." The Independent on Sunday came down on the side of the Arts Council:

"A pantomime is underway between the defenders of privilege—who want their pleasures subsidized because, well, just because—and those who suggest that the way to widen access to refined pleasures is to make them less refined. It is a hoary old chestnut of the trainer-loathing classes that 'ordinary' people are genetically programmed not to want to enjoy the arts, or that if they do they will find their way there in the end. They all know someone who was born in a hovel, saved up their shilling for his first seat in the gods and miraculously evolved from prole [proletarian] to culture vulture. Of course, they don't expect anything like the same Sisyphean exertions from their own social peers who are introduced to high culture, quite effortlessly, as part of a fulfilled and varied life."

McElvoy (1998)

Level of Involvement

The level of emotional involvement can be used to analyze the members of media audiences (Abercrombie and Longhurst 1998). This model can also be used to understand why people who are exposed to the arts do not necessarily feel the need to become supporters of the organization. Audiences can be described as communities that vary by their degree of involvement with the media they choose to watch. The community groups that result from this analysis can be described as belonging along a continuum from consumer to petty producer. The audience continuum and their relationship to the media and each other are shown below:

Model of Media Use

Consumer:	Light and generalized media use.
Fan:	Use focused on specific stars and programs.
Cultist:	Heavy, specialized use with associated social activities.
Enthusiast:	Serious interest in entire media form with structured activities.
Petty Producer:	Amateur producer of media form.

In their model describing audiences of electronic media, Abercrombie and Longhurst (1998) describe consumers of media as having a generalized pattern of light media use with unsystematic taste. Consumers do not focus on enjoying only one type of media form or content but feel free to choose from whatever is available. The consumer's choice of a particular program to enjoy is based on factors such as convenience and cost. Although they care about the program content, it is not the only deciding factor in their choice. In addition, their involvement with the media does not extend to the point where they join in activities with others based on their mutual interest.

Fans of media have become attached to particular stars or programs and have more frequent and focused media use. When choosing a program to watch, they will base their choice on specific program content that they have enjoyed in the past. They are willing to tolerate some additional cost and inconvenience in order to enjoy their media choice. They continue to enjoy their choice of media as individuals and, like consumers, do not associate with others with similar interests.

Cultists have become highly specialized in their selection of stars and programs and have heavy media use. They will make a special effort in terms of cost and convenience to enjoy specific media programs. Cultists will also take the time to learn about their favorite star's personal life and career. They are distinguished from fans by their participation in activities associated with their choice of media, for example, reading publications about their interests. They are also distinguished from both consumers

and fans by their desire to form a community by joining with other cultists in activities focused on their joint media interests. These are the people who will travel to be a member of the studio audience to see their favorite program being filmed. They also are likely to travel to visit historical sites associated with the programs they watch.

When an individual is at the enthusiast level of involvement, there is a general appreciation of the media as an art form, without any attachment to particular stars or programs. Enthusiasts become highly knowledgeable about the media and its creators. For example, film enthusiasts will take classes on the history of cinema. They also wish to share their enjoyment with others. What distinguishes enthusiasts from cultists is the tight organizational structure of the communities they form. Their involvement with other enthusiasts in activities surrounding their media interest forms an important part of their lives and their value systems. For enthusiasts, their appreciation of the media and involvement in activities with others form an important part of their self-identity. Their social life will be planned around their interests and activities.

At the extreme of the continuum, petty producers become so involved they start to produce amateur versions of the media. Having their social life revolve around their interest is no longer sufficient. If possible, they will try to find employment that will allow them to be involved with others who share with them their media interests.

Model for Cultural Event Attendance

This model is also useful to describe different types of cultural event attenders. The extent to which an audience feels associated with the art form and each other can help us to understand their motivation for attending. The cultural organization can then produce a cultural event and create a marketing strategy which meets their needs. This need might be for a casual evening out or for an evening that is part of a deeper relationship with the cultural organization.

Are the Young Really All That Great?

It seems that cultural organizations can become obsessed with trying to lure young consumers into their organizations. Marketing managers see all the grey hair in the audience and begin to wonder what will happen when they die off. But it is important to remember that a customer is a customer no matter what their age. In fact, sixty three percent of consumers worldwide believe that we are too obsessed with age. Interestingly this view is shared by sixty percent of people aged eighteen to thirty-four.

Dobrzynski (2012)

The audience can be understood to contain culture consumers who may be visiting a museum or taking in a matinee at the theatre as something to do on a rainy day. Fans of culture would always patronize a certain cultural organization, such as the Victoria and Albert Museum, or special performances, such as plays by Shakespeare. Culture cultists can be described as those who have taken the time to learn everything about the artists in a specific art form such as ballet. Enthusiasts of culture take the next step in involvement and know everything about the art form in general and make participating in cultural activities an important part of their life by joining with others in the "Friends" organization or by going on study tours. People who reach the level of petty producers then produce or collect art themselves. Of course, cultural organizations would like all audience members to be at least fans, cultists, or enthusiasts. However, due to generational changes in how people view and use culture, the truth is that most audience members are culture consumers.

The aim of the management of cultural organizations has been to turn these consumers of culture into the enthusiasts of culture. It has long been thought by cultural organizations that the means of doing this was through education programs they provided. They believed that if only those who are currently mere consumers of culture would receive enough education, they would then understand the art form, feel a deeper appreciation and association, and become enthusiasts.

However, it has not been cultural organizations that have changed the public's emotional involvement with art but rather online social media technology. This technology makes the public able to learn about the art form, program or artist without any assistance from the cultural organization. It also lets people who share an interest in an art form find each other and form their own community. Finally technology allows anyone interested in doing so to create and share their creation with others.

Opera at the Beach

Everyone associates opera with champagne and caviar. What about with fish and chips? In Skegness in the UK the local council decided to broadcast opera on the beach. Skegness is a resort town where people come to enjoy the sun and sand. Therefore shoes and shirts were not required and the children could still have donkey rides. Did it work? Well enough that the experiment will be repeated. Rather than expecting the audience to conform to the usual attendance norms, the audience was allowed to enjoy opera while they got to enjoy the beach, the reason they came on holiday.

Wogan (2012)

The "Education" of the Culture Consumer

To use visitors to art museums as an example, through educational outreach programs it is hoped that the public will move along the continuum from culture consumer to enthusiast. The museum understands that the cultural consumer would have only a generalized interest in art and would visit the museum only occasionally as an enjoyable experience perhaps to fill a rainy afternoon, but through educational information provided by the museum, it is hoped they would learn to enjoy the art of specific artists. The museum believes that the public would then become fans and, therefore, visit the museum more frequently to see the exhibitions of artists' work. Although they would visit museums to see specific artists, fans would still have little interest in joining with others in activities focused on art appreciation.

However, after the fans had gained additional knowledge and expertise on their favorite artists, they would then become cultists. Through educational information provided by the museum, they would become involved in highly specialized areas of art, such as the pre-Raphaelite brotherhood. These new cultists would read specialized books on the subject that were purchased in the museum gift shop. They would also frequently attend educational events at the museum.

Feeling a need for closer association, cultists would then become enthusiasts who would wish to be associated more closely by becoming members or "Friends" of the museum, and would plan their social life around museum events. For them, their association with the museum would become an important part of their identity. They would go on tours marketed by the museum along with other enthusiasts. They would also feel they knew how to manage the museum as well, if not better, than the museum management. At the extreme of involvement, they would become petty producers and be amateur artists or collectors.

Stages of Audience Involvement with Art Exhibits

Type	Involvement	Enhanced with Technology
Culture Consumer	Any museum on a Sunday afternoon	Websites that provide information
Culture Fan	Attends Monet exhibits	Additional online information about the artist
Culture Cultist	Joins local museum association and attends educational events on Monet	Museum creates online community run by members who plan events on Monet
Culture Enthusiast	Studies Impressionism art movement; travels to other museums for exhibits	Online community asks members for suggestions for other activities and trips
Culture Petty Producer	Collects artwork or creates their own	Online community posts their own artistic efforts online

However, technology has profoundly changed this continuum. Now the public does not need to rely on the cultural organization to provide the educational information as it is easy to access information online. This information may be about the organization or about the specific artist. Not only will the public learn factual information, they can seek out the opinions of other members of the public about the art form. These people can then form a community that plans their own events involving the art form and cultural organization. People posting comments and opinions online quickly find a response from someone who has a similar interest (S. Johnson 2006).

In the past producing art meant that inborn talent, learned skills, and access to materials was necessary. Now anyone interested in the art form can be a petty producer. The new term for these individuals is *culture participants*. They may start producing art before they have any training in the field but, because of their interest, they then may pursue training. They are able to take this unconventional approach because of technology, which allows easy access to the tools of creativity and also the ability to share artistic creations. YouTube is an example of this phenomenon. It is used by both artists and non-artists as a means to express themselves and therefore bridges the professional and amateur divide (Burgess and Green 2011). When the artist and the audience have equal access to creative tools, it is difficult for the cultural organization to maintain the traditional hierarchy as the sole educator and provider of appropriate art focused activities and events.

They Are Already Looking Up Information; Are They Looking Up You?

Phones are being used for much more than making phone calls. How they are being used should be of interest to cultural organizations. A study discovered how cell phone owners have used their phones in the last thirty days:

41 percent	Coordinate meeting/get-together
35 percent	Solve a problem
30 percent	Decide what to visit
27 percent	Find information to settle an argument
23 percent	Look up sports scores
20 percent	Traffic or transit information
19 percent	Help in emergency

The 41 percent of cell phone owners who coordinated social plans and the 30 percent that use their phone to decide if they will visit an establishment should be of interest to cultural organizations. Ensuring that all their online information is mobile friendly should be the goal of all cultural organizations.

Rainier and Fox (2012)

Culture Consumer to Cultural Participant

Marketing has been attempting to turn culture consumers into culture enthusiasts, but the transition from consumer to enthusiast is not easy to accomplish. People have many choices on how to spend their limited leisure time and they may not be willing to spend this time learning more about culture. They simply may not be interested in attaining a higher level of appreciation of culture and may wish to remain culture consumers. It is therefore difficult to interest this group in traditional educational events that will result in them learning more and deepening their emotional involvement with the art form. Because of this, those working in cultural organizations, who are already enthusiasts or petty producers, view culture consumers as ignorant. Rather than ignorant, they can also be seen as making an informed choice. They are not willing to spend the required time and energy on learning a deeper appreciation of an art form.

Cultural organizations must accept the fact that for most people their level of interest is already set at the consumer level. Some consumers may increase their level of involvement to that of fan or higher, but most will remain at the same interest level. These consumers desire culture as an occasional activity and this preference is not easily changed. The problem is that most of the people who produce art and manage cultural organizations are at least enthusiasts. Art forms a central part of their identity and it is difficult for them to conceive that culture consumers could be exposed to their art and still wish to remain at the consumer level.

It would be more useful for the cultural organization, rather than assume that the consumption choices made by the public are faulty, to provide the level of engagement that each segment of the public desires. This will mean a major shift in emphasis for many cultural organizations. They will need to learn to accept culture consumers as they are, rather than as people in need of improvement, and provide cultural events that cater to the differing levels of involvement desired.

However, now cultural organizations, often without any effort on their part, have a new group with whom to communicate. These are the new culture participants who, because of their experiences with technology, are interested in joining with the organization to produce culture. This will take an even more radical change of world view on the part of those managing organizations. They will need to give up total control of the production and presentation of the cultural product and instead engage with the public as equals (Solis 2010). As social media can be used by culture participants to share experiences and opinions, ask for specific cultural products, change existing cultural products, and create their own cultural products, with the birth of the cultural participant, cultural hierarchy is now gone.

What Is Art and How Can We Decide What Art Is "Good?"

This has always been a tough question. But with the new technologies making the process of creating art available to many, this question is becoming even more difficult to answer. Perhaps there needs to be two separate definitions of quality: one for the artist and his or her fellow artists and one for the public who views the art. Artist Amy Bruckman explains:

"While I see the benefit of the creative process to the artist as primary, one can still speak of a secondary benefit of the product to other members of the community—and that is a rough metric for 'quality'. A work that entertains, inspires, enlightens, delights, or disgusts (provokes some significant reaction) in a broad audience can be seen as having a different 'quality' than one appreciated only by its creator. A work exists only in relationship to an audience. It's not meaningful to call something 'better' without saying better for whom, when and where, and according to whose judgment.... The word artist is broad enough to refer to both the professional and the growing number of amateur artistic communities. To blur the distinction between them is also to blur the distinction between high and popular culture, a phenomenon which has progressed throughout this century. The network is accelerating this blurring, towards a greater pluralism of creative expression."

Bruckman 1999

New Forms of Cultural Participation

The many ways people make use of the Internet to build communities are limited only by the imaginations and interests of the participants. Participation online can be broadly categorized into four methods: affiliation, expression, collaborative problem solving, and circulation (Jenkins et al. 2009).

Affiliations are not new to the art and culture world. Culture organizations have long had "Friend" groups that they used to build loyalty. These groups often received special benefits and were made to feel a part of the organization in the hope that they would not only attend but also become donors. What is different is that affiliations formed online are not sponsored or formed by the cultural organization but rather are organized by the public using social media and, as a result, they cannot be controlled by the organization. Nevertheless, cultural organizations should be involved in the online communities that are concerned with the cultural organization's art form.

Social media has resulted in a world where expressions of creativity are now available to everyone. Rather than the cultural organization alone posting artistic content, cultural participants are creating their own content and posting it online using social media sites. They create fan fiction, take existing art work and add they own ideas and upload their own creative visual work. By doing so they are stretching the definition of art.

Forms of Online Cultural Participation

Method	Social Media Use	Cultural Organization Use
Affiliations	Online communities	Online friends groups
Expressions	Uploading work	Posting on organization's website
Problem Solving	Crowdsourcing	Fund raising
Circulation	Sharing information	Podcasting, posted reviews, links to review websites

After creating their own cultural products, they then want to share this work with the world just as an established artist does. Cultural organizations can provide an opportunity for them to do so using their own social media sites.

Problem solving is another online activity. This involves people working together to meet a challenge. The challenge might be intellectual, such as writing content. It also might be practical where crowdsourcing is used so that more brainpower is brought to a problem. Cultural organizations should consider how fundraising might be changed if this framework is used. Questions regarding the best way to raise funds are usually discussed in meetings behind closed doors, but how much better if they were asked online to the people from whom the organization hopes to raise money.

Circulation involves the sharing of information through reviews and blogs. These are tools that can be used to extend the voice of the individual from those the individual may know personally to anyone online who cares to listen. Information on cultural organizations and artists is often shared using these tools. Rather than fight this trend because of a fear of negative reviews, cultural organizations should be actively involved. They may wish to respond to both positive and negative reviews. They may even wish to link review sites to their own webpage.

Cultural organizations look at the world through the eyes of the artist. They expect the audience to put aside their own concerns and consider only the message intended for them. This is almost impossible for the new cultural participant to do. If cultural participants continually blog about their life, upload videos of their cat's cute tricks and post their photos online, why are they going to forget about themselves to focus only on the artist? This does not mean the cultural organization does not communicate to the public, but it does mean that the organization now must communicate as an equal.

Cultural Equality

People are no longer willing to defer to authority. Because they want control of their own destiny, they are impatient with passive experiences.

Sometimes the Artist Could Use Some Help

Turner Contemporary, a gallery in in the UK, will be hosting an exhibit displaying the work of a Brazilian artist who weaves using straw, string, rope, and beads. The finished art work will be not just be in the gallery, but will also connect to the landscape. Viewers can walk amongst the woven objects and even enjoy the exhibit while resting on a woven hammock. What really makes the art work unique is that while the artist will be designing the work, the actual weaving will be done by local residents. The artist will start the design and weaving process but then will leave. The volunteer weavers will continue to work on their own for a period of months. At that time the artist will return and complete the work. But the collaboration doesn't end with just local weavers. In addition free workshops will be held where participants will create the beads used in the art work. Rope exchanges will also be held where residents will donate local rope for use in the exhibit and will receive colorful Brazilian rope in exchange. As a result the art work will be a true and equal collaboration of creativity!

ArtDaily.org (2012) and Destinations (UK 2012)

Therefore, they want to participate actively in recreational and leisure activities rather than just observe (Dychtwald 2003). For the cultural organization this means that passive experiences without a means for audience involvement and even creation will have difficulty attracting attendance. All cultural organizations now need to consider how to involve the public in the experience of participating in the arts, as people are no longer content to be just an audience member.

All people have an innate sense of the aesthetic; even though it may vary from person to person as to what they find aesthetically pleasing. The fact that people can find anything from a sunset to a mathematical formula to a well-ploughed field pleasing means that all people have an artistic sense that adds to the joy of being alive. Experiencing art is just one among many ways in which to enrich ones life (Dewey 1980). Taking this argument forward, the fact that now everyone has the means to discuss art, interact with art and create art should be applauded by cultural organizations because it will enrich lives even more.

These new art-creating, experience-seeking participants tend to define themselves by the experiences they have had, not by their job title or family connection. They are attracted to products that provide an experience in which they can participate (Hill 2002). Here cultural organizations have a particular advantage as they have always offered an arts experience. They must now create a means for the public to feel involved with the art and organization that goes beyond a lecture given by an expert to a passive audience.

Wouldn't You Want Your Work Hung in a Museum?

In 2006 the Art Gallery of Ontario in Canada decided to mount a different type of exhibition. Rather than feature the art work of professional artists, the AGO requested portraits from the public. The portraits all had to be 4 inches by 6 inches but could be in a variety of media. Although the request for portraits was not widely publicized by the AGO, the idea caught on with the public. "In Your Face" received 10,000 portraits from individuals, groups and entire communities from across Canada and many other countries. What was unique was the diversity of the individuals who made submissions. Not only was the exhibition a hit with the public, it changed the thinking of the AGO from a view of curatorial expertise being of the most importance to visitor experience.

McIntyre (2009)

New Participation Model

Traditional exemplars of arts participation that have been used by cultural organizations have focused on increasing attendance by using an education model. The belief is that the more the culture consumer knew about the art form, the more they would attend and support the organization financially. The culture consumer was invited to attend an event or performance. If they wanted more engagement, the cultural organization offered educational programs, such as pre-concert talks, that were designed to engage the intellect. Cultural organizations may continue to offer this type of engagement.

A newer model is based on participation with the art form, rather than just with the cultural organization (Novak-Leonard and Brown, 2011). This model views art and culture as something that is created by everyone in the community. While this has always been true, as people have always been creative, what is new is there is now the means for everyone to share their creation with the world. As a result, cultural organizations need to rethink how they design a cultural product so that it allows this interaction. Technology allows engagement with the public using online communities and co-creation that engages the consumer creatively, not just intellectually.

Management and Marketing Collaboration

When the first comprehensive books on arts management were published the focus of the field at that time was on promotion using advertising and subscription sales strategies. Most advertising was targeted to the middle class and promoted attendance at cultural events as an important part of middle-class lifestyle. The only purpose of marketing was to focus on

subscription sales strategies to encourage repeat customers and to develop the value of loyalty to the cultural organization (Rawlings-Jackson 1996).

During the early 1970s, the marketing emphasis changed to the use of audience surveying to gather demographic information on who was attending the cultural event so that marketing could attract more of the same audience. Little attention was paid to qualitative research to discover the motivation of the audience or to determine what the audience wanted. Instead, the focus was on demographic "bums-on-seats" research (Reiss 1974). By the 1980s the rapid expansion of cultural organizations in the United States resulted in too many organizations trying to attract a limited number of customers. As a result, the use of advertising simply to inform the public of the opportunities for attendance at culture events was no longer effective. The crowded arts marketplace resulted in a need for a more comprehensive marketing strategy and marketing became more central to the cultural organization.

Previously only the artistic director and the artist determined what culture the organization would produce (Bhrádaigh 1997). The cultural product was then presented to the marketing director whose role was to use advertising to find a faceless but sufficient audience for the art. Since there were no longer a sufficient number of customers, this division between the artistic and marketing functions started to break down. Both areas now discovered that they needed to understand the motivation and desires of the audience and why individuals chose to attend. In an effort to gather this information, the results of demographic studies were now not just counted but were also analyzed.

Tell Me Your Story

This may sound just like a cliché but Roadside Theatre in Kentucky in the United States really means it. Roadside specializes in productions that reflect the lives and culture of local Appalachian people. Rather than write the play themselves, the writers use story circles to develop their new theatrical productions. When a play is in production, it is shown to local residents who are then asked to tell their own stories about the play's subject matter. Some of these stories are then written into the play. Once the play is in performance, this method is again used. After the presentation of the play, the audience is asked for their personal reflections on what they have seen. This input helps the actors make their performance more realistic.

The theatre company goes one step further. They do not only share their work through theatrical productions, they document it through books, videos, audio recordings, and essays. In fact, Roadside Theatre believes so strongly in their participation model that they work with other communities to help them create and document their own local culture.

Borwick (2012) and Roadside Theatre (2012)

The new marketing model focuses on using technology to partner with the public. It requires a rethinking of how the organization defines the cultural product. For this reason it will take the support of everyone in the organization as it is not just a new way to promote. To attract cultural participants, art with which they can be involved creatively will need to be produced. To produce this product will take a new approach with artists, arts managers, and art marketers all working together.

Summary

Changes in attendance patterns are challenging cultural organizations. The challenge should not be seen as just a need to increase attendance but instead a need to redesign the cultural product to increase consumer participation. Attendance is declining for all age groups, not just the young. It is also declining among the well-educated, so the traditional predictors of attendance are not as useful a model. Involvement with cultural organizations can be thought of along a continuum of attendance alone to producing the art form. Culture consumers want to experience art events but have no further involvement. Cultural organizations have traditionally believed that these cultural consumers can be moved further along the continuum of involvement through education. Because of social media, people are now conditioned to be more actively involved in all areas of their lives, including the purchase of products. Culture participants want to not just experience the product, they want to also contribute to the organization through development of the art product. The methods of online participation range from affiliation with online groups, posting of reviews and comments, and uploading personal own art work. Rather than be threatened by the new technology cultural organizations can use it to partner with the public.

References

Abercrombie, N., and Longhurst, B. 1998. *Audiences: A Sociological Theory of Performance and Imagination*. New York: Sage.

ArtDaily.org. 2012. "Turner Contemporary Calls on Visitors to Help Create Spectacular New Art Work" ArtDaily.org. August 9. http://www.artdaily.org/index.asp?int_sec=11&int_new=57004.

Bhrádaigh, E. Ní. 1997. "Arts Marketing: A Review of Research and Issues." *From Maestro to Manager: Critical Issues in Arts & Culture Management*. Dublin: Oak Tree Press.

Borwick, Doug. 2012. "Reinventing the Wheel." *Emerging Matters*. August. http://www.artsjournal.com/engage/2012/08/reinventing-the-wheel/.

Bruckman, Amy. 1999. "Cyberspace is not Disneyland: The Role of the Artist in a Networked World." *Epistemology and the Learning Group: MIT Media Lab*. http://www.ahip.getty.edu/cyberpub.

Burgess, Jean, and Joshua Green. 2011. *YouTube: Online Video and Participatory Culture*. Cambridge: Polity Press.

Destinations UK. 2012. "Turner Contemporary Calls on Visitors to Help Create Spectacular New Art Work." August 20. http://www.destinations-uk.com/news.php?link=news&id=12327&articletitle=Turner%20Contemporary%20calls%20on%20visitors%20to%20help%20create%20spectacular%20new%20artwork.

Dewey, John. 1980. *Art as Experience*. New York: Perigee Books.

Dobrzynski, Judith J. 2012. "Chasing Audiences: Too Much Emphasis on Youth?" July 26. http://www.artsjournal.com/realcleararts/2012/07/chasing-audiences-too-much-emphasis-on-youth.html.

Dychtwald, Maddy. 2003. *Cycles: How We Will Live, Work and Buy*. New York: The Free Press.

Hill, Sam. 2002. *60 Trends in 60 Minutes*. Hoboken, New Jersey: Wiley & Sons.

Jenkins, Henry, with Ravi Purushotma, Margaret Weigel, Katie Clinton, and Alice J. Robison. 2009. *Confronting the Challenges of Participatory Culture: Media Education in the 21st Century*. Cambridge, Massachusetts: The MIT Press.

Johnson, Lisa. 2006. Mind Your X's and Y's: Satisfying the 10 Cravings of a New Generation of Consumers. New York: Free Press.

Johnson, Steven. 2006. *Everything Bad is Good for You: How Today's Popular Culture is Actually Making Us Smarter*. New York: Riverhead Books.

McElvoy, Anne. 1998. "Tiaras and Trainers can Mix at the Opera." *Independent on Sunday*, October 18.

McIntyre, Gillian. 2009. "In Your Face: The People's Portrait Project." *Exhibitionist*, Fall.

National Endowment for the Arts. 2008. *Arts Participation 2008*. Washington, DC: National Endowment for the Arts.

Novak-Leonard, Jennifer L., and Alan S. Brown. 2011. *Beyond Attendance: A Multimodal Understanding of Arts Participation*. Washington, DC: National Endowment for the Arts.

Rainie, Lee, and Susannah Fox. 2012. *Just-in-time Information through Mobile Connections*. August 2. http//pewinternet.org/Reports/2012/Just-in-time.aspx.

Rawlings-Jackson, Vannessa. 1996. *Where Now? Theatre Subscription Selling in the 90's, A Report on the American Experience*. London: Arts Council of England.

Reiss, Alvin. 1974. *The Arts Management Handbook*. New York: Law-Arts Publishers.

Roadside Theatre. 2012. August 20. http://www.roadside.org/.

Solis, Brian. 2010. *Engage! The Complete Guide for Brands and Businesses to Build, Cultivate, and Measure Success in the New Web*. Hoboken, New Jersey: John Wiley & Sons.

Tepper, Steven J., and Yang Gao. 2008. *"Engaging Art: What Counts" Engaging Art: The Next Great Transformation of America's Cultural Life*. New York: Routledge.

Wogan, Terry. 2012. "Let's Have Much More Opera on the Beach." *London Telegraph*. July 7.

4 Marketing and the Environment

Marketing is still too often thought of by cultural organizations as trying to manipulate the consumer into buying something they do not want. Because marketing developed as a business tool, cultural organizations may feel it is tainted by corporate greed. Of course, goods and services have been exchanged between individuals long before there were corporations with marketing departments. In fact, since marketing consists of making goods and services attractive and then communicating their availability to potential customers, most artists have also marketed. Artists have always needed someone to purchase their products, and marketing was used when artists tried to make what they produced attractive to those who might purchase. If artists did not wish to make the product attractive to buyers, they at least used marketing to communicate that their art was available.

It is always tempting when considering a change in marketing strategy to immediately implement new ideas. After all people working in nonprofits are creative and, as a result, there is often no shortage of ideas. However tempting it might be to just take action, first the organization must consider how factors internal to their own organizations and changes in the external environment might affect their plans. In addition changes in the customer environment must be considered. Not to do so risks writing a marketing plan with innovative ideas that fails because there are not the necessary internal resources and external support available. This process of analysis is called environmental scanning.

Approaches to Marketing

There are three basic methods of selling products: production, sales, and customer focused. The production view holds that any quality product the company chooses to produce will attract customers. The sales view is that any product can be sold if the company has the right sales strategy. The current approach is the marketing concept.

Production Approach to Marketing

The production approach to marketing looks inward to what the organization can produce. The organization determines what their employees are capable of producing and bases its production decision on these capabilities. For example, in a corporate organization the question might be asked as to what the engineers can design. In a cultural organization the question might be asked as to what type of opera the signers can sing. In a for profit company it is not likely that employees will object to producing a new product, but artists in a cultural organization may well object to producing art products in which they are uninterested. Despite its very business-sounding name, the production approach is historically the approach that has been taken by most cultural organizations. It is an approach where the capabilities and desires of those involved in the organization come first.

If the organization has sufficient funding or there happens to be a demand for the product, the cultural organization will succeed. However, if there is insufficient funding or demand for the product, the organization will fail. If there are other organizations offering the same cultural product, the demand may be insufficient for both organizations and the less favored organization, or both, will fail.

Insufficient consumer demand results in insufficient revenue, leaving the cultural organization dependent on public funding. Because there is less available funding, the production approach is a dangerous route for any organization to take. This reliance on public funding allows the organization to produce the cultural product of their choice without concern for the marketplace. In this case, the cultural organization measures success by the amount of cultural product they produce, not by meeting attendance or revenue goals. Since the organization is a culture-producing entity that wishes to produce culture, it is happy to oblige with more.

Sales Approach to Marketing

A second approach to marketing is the sales approach that emphasizes selling the product and where success is measured solely by the number of products sold and the amount of revenue received. Some cultural organizations often have the unfortunate idea that the sales approach is the only approach to marketing. In fact, it is an approach taken by only a small number of businesses. The sales approach assumes that consumers can be convinced to purchase by using aggressive sales techniques. This approach is usually not successful as most people are very savvy consumers. The approach wrongly tries to dictate to consumers rather than listen to what they desire. Many organizations that failed after pursuing a production approach, then adopt the sales approach in an effort to boost sales and save their organization.

Customer-Focused Approach to Marketing

Today, most organizations use the customer-focused marketing approach. This approach is based on first considering the needs and desires of the consumer and then creating a product. This does not mean that the organization's capabilities are ignored. No organization can meet the needs of the consumer by providing a product it does not have the capabilities or desire to produce. Of course, a mission-driven cultural organization will also have limits on how much, if any, they can change their cultural product to meet the needs of the consumer because the product must fit its mission. However, it is possible to meet the mission without becoming reliant on the production approach, where only the cultural organization's capabilities and desires are considered.

There is room in the customer-driven approach for compromise between the desires of the consumers and those of the cultural organization because each defines the product in a different way. For the cultural organization, the product is the art produced. In contrast for the consumer, the product is the total experience including the art product but also entertainment, education, and socialization. All of these can be provided by the cultural organization without changing the core art product. What must change is the way the cultural product is communicated, presented, and packaged. If the organization is unwilling to consider any modification in these features, it is back to the production approach, where either a sufficient demand must exist or the cultural organization must be subsidized.

Likewise, consumers understand that mission-focused cultural organization produces a product that provides benefits larger than just immediate consumption. Likewise, many for-profit companies, such as those marketing environmental products, serve a wider purpose than merely satisfying the consumer's needs. These types of organizations must use marketing to

Stronger Together

What to do when faced with reduced financing? Look to collaborate with other cultural organizations in the same situation. In Ohio, the Dayton Philharmonic Orchestra, Dayton Ballet, and Dayton Opera decided to merge into the Dayton Performing Arts Alliance. While part of the rationale was the cost savings of merging three administrative staff and boards, there were other more positive reasons, such as collaborative marketing. Now if a customer buys a ticket to the ballet or opera, they are offered a voucher to an orchestra performance. Likewise if they buy a subscription to the orchestra, some of their choices can be to offerings by the other two organizations. Was the merger difficult for three organizations that continue to have their own identity? Yes, but they focused on the need to fulfill their mission with limited resources available. As a result, pragmatism and cooperation won out.

Moss (2012)

communicate both their mission and product to consumers, who may even be willing to pay more, or forego some product benefits, to consume these socially beneficial products. A marketing strategy should be seen as a useful tool and not as something that is in opposition to the mission of the organization.

Changing the Organization's Focus

It is not easy for a cultural organization to switch from a production or sales approach to a customer-focus approach. The change too often only comes about when the organization has lost customers and is facing financial difficulties. This crisis is the start of the solution and may lead to a change in the entire manner in which the organization views itself and does business. However, instead of facing difficult questions about their identity and mission, cultural organizations too often continue to fall back on the argument that their existence should be subsidized by the government because it is in society's long-term interests. It must now be faced that government funding will not rescue the organization and instead each must ensure its own survival (McCleish 2010). Cultural organizations are now faced with the challenge of sustaining themselves with limited financial, personnel. and volunteer resources. They also must face the reality that consumers' needs and wants are changing in ways that mean a fundamental change in the customer relationship.

Too many cultural organizations believe that the affordability of tickets is the key to survival, and, if ticket prices could be lowered, survival would be assured. However, while price is one issue consumers consider when choosing a product, it is usually not the deciding factor. What is needed is a change of organizational focus from selling tickets to an organizational focus on the customer. This focus will require that those responsible for marketing, management, and the production of the art product work together. Everyone in the organization is responsible for its survival and developing a marketing plan is the key to bringing everyone together.

Marketing and the Cultural Organization

Cultural organizations have traditionally taken a negative view of marketing. The reasons include the belief that marketing is an inappropriate use of money and an unnecessary addition to overhead for cultural organizations that already have limited resources. There is also the negative preconception that marketing is both intrusive and manipulative and that using marketing strategy is a sell-out that makes them no better than the profit-making businesses that sell popular culture. This view may result from the fact that the people who work in cultural organizations have specifically chosen not to work in the for-profit world.

Use of Marketing

The field of arts marketing as a distinct profession is rather recent. It developed out of the old role of the arts promoter whose job was to find a public audience for the artist since the artist could no longer depend on individual patronage. It was not a partnership between artist and promoter; rather, it was the function of the promoter to serve the needs of the artist (Rentschler and Kirchberg 1998).

The growth of cultural organizations filled the need for a new type of intermediary. The new art marketers worked for the cultural organization rather than directly for the artist, but their role was similar to that of the arts promoter: to serve the needs of the artist. For the cultural organization, the criterion for success was achieving artistic goals, and financial rewards were considered to be of secondary importance.

Rather than compete for profit, the role of the arts marketer was to ensure there was an audience for the artist. The primary focus was on the production of art, with the expectation there would be an audience willing to attend. Because the reason the organization existed was first for the artistic product, second for the larger good of society, and only third for the consumer, there was, not surprisingly, not much emphasis on the function of marketing. Little attention was given to the desires of the consumer beyond considering how to arrange the art in a pleasing program or exhibit. In fact many cultural organization managers still do not understand that marketing can be used to communicate the mission (Worth 2012).

Instead the focus of marketing was on promotion using advertising and subscription sales strategies. The promotion that was conducted used advertising targeted to the middle class and promoted attendance at cultural events as an important part of middle-class lifestyle. The purpose of the subscription sales strategies was to encourage repeat customers to develop the value of loyalty to the cultural organization (Rawlings-Jackson 1996).

During the 1970s, the role of marketing widened to include research on the customer using audience surveying. Demographic information was gathered on who was attending the cultural event so that promotion could then be used to attract more of the same audience. Little qualitative research was conducted to discover the motivation of the audience or to determine what the audience wanted. Instead, the focus was on demographic "bums-on-seats" research (Reiss 1974).

As a result, cultural organizations found that their audience was a rather one-dimensional, homogeneous group of those who were well-educated, high income, and primarily of the majority ethnic culture. Since the original purpose of the arts organization was to present art that it considered to be indispensable to everyone, this was not good news. Cultural organizations had argued for public funding because art was necessary to nourish

the soul and the lives of the population as a whole. If only a limited and narrow part of the population was attending, then it was difficult for cultural organizations to argue that they should receive public funding.

Previously, only the artistic director and the artist determined what culture the organization would produce (Bhrádaigh 1997). The cultural product was then presented to the marketing director whose role was to use promotion to find a faceless but sufficient audience for the art. Since there was no longer a sufficient number of customers, this division between the artistic and marketing functions started to break down. Both groups now discovered that they needed to understand the motivation and desires of the audience and why individuals chose to attend. In an effort to gather this information the results of demographic studies were now not just counted, but were also analyzed as to audience composition.

By the 1980s the rapid expansion of cultural organizations in the United States resulted in too many organizations trying to attract a limited number of customers. As a result, the use of promotion to simply inform the public of the opportunities for attendance at culture events was no longer effective. The competitive arts marketplace resulted in a need for a more comprehensive marketing strategy.

"Is Art Good For Us?"

Such a heretical question is actually the title of a book that examines this exact issue. In it the author discusses the difference between high art and popular culture and how we came to believe that rather than change the art product we could change the consumer.

"When the arts are simply imagined to be beacons of excellence, to be created by a few for the edification of the many, they are clearly distinct from other, more popular forms. Current commentators may struggle with exactly how to determine the differences between them, based on content characteristics, but they insist on the need to prevent true art from being diluted, and to ensure that people have the training they obviously need to discern the best from the worst.... What commentators hope is that, with the right kinds of arts education, the populace will finally know enough to appreciate the wonderfulness of the arts they currently disdain, mistrust, or are bored by it. They will come to like the right kind of art, and thus be able to enjoy the benefits such arts are presumed to bestow."

Jensen (2002)

From an Audience Development to an Audience Relationship Model

The emphasis changed from filling seats to broadening the audience for the arts, and in the 1990s various marketing efforts were tried. Since the cultural organization marketers now knew that the arts were largely

attended by those with high incomes, they concluded that people without high incomes did not attend because they could not afford to buy a ticket. The focus was now on pricing. It was believed that attendance could be increased through special ticket concessions for low income people, including young people and seniors. It didn't seem to be noticed that these groups had the money to spend on other activities. After all the young, for example, are large consumers of expensive popular culture.

It did occur to some cultural organizations that a significant segment of the population did not desire their product. Nonetheless, it was believed that this segment could be educated to understand and appreciate the arts. In an effort to educate everyone to appreciate the arts, outreach programs became an increasingly important focus for cultural organizations. While these programs were good public relations, there was no evidence that they were the answer to attendance problems (Kolb 2002).

By the start of the twenty-first century, changes in the external society finally forced cultural organizations to rethink their mission, product and audience, rather than only focus on increasing attendance. With a rapidly changing society, many cultural organizations are no longer sure of their place and purpose. This period of change can be seen as an opportunity as it necessitates the need for cultural organizations to rethink the relationship between themselves and the wider society. Periods of change often make people more open to accepting the need for fundamental change (Bridges 2003).

Just when cultural organizations thought they understood marketing, the use of social media technology has forced them to rethink how they communicate with the public. However, social media is more than just a tool to communicate the organization's mission to the public (Dreyer and Grant 2010). It is also a tool that can be used to easily communicate with the public so as to build strong relationships with customers.

If You Want Something Done, Ask a Busy Person

Every community depends on citizens to volunteer their time to local causes. Cultural organizations can feel good about the fact that people who attend arts events are 25 percent more likely to donate their time by volunteering in the community. However, most cultural organizations also need volunteers. So where to find these volunteers? Research in the United States has shown that women volunteer at a rate of 30 percent, while for men it is less at 23 percent. Surprisingly, married people volunteer more than single people; at a rate of 32 percent versus 21 percent. (Maybe the single people are busy dating.) If we know that female, married arts attenders volunteer more, your next volunteer may already be in your audience.

Nichols (2007)

Components of Marketing

While originally marketing was thought of as only useful for physical products, companies soon learned that marketing could be applied not just to products but also to services. Demand for services such as tourism, transportation, and financial services were growing as the general level of income in the population rose. Those managing the service industries thought that they, too, could use marketing theory and practice to inform customers about their service products.

The cultural industries are part of the service sector, so it is not surprising that they also became interested in marketing. However, most cultural organizations lagged behind profit-making organizations in adopting marketing strategy. This may have been because reliance on public funding shielded them from worrying about obtaining revenue from customers and, therefore, cultural organizations had less interest in applying marketing theory.

The "Four Ps" and "Seven Ps" of Marketing

The standard marketing concept of analyzing the strategy for selling a product in terms of the "Four Ps" of product, price, place, and promotion was popularized in the 1981 book *Basic Marketing: A Managerial Approach* by E. J. McCarthy. This marketing concept is still used, although the "Ps" for services marketing have been expanded to include people, physical evidence, and process. Both the "Four Ps" and the "Seven Ps" stress the importance for the marketing department to consider all aspects of the product in creating their marketing strategy.

The product marketed by an organization can be a physical good, a service, an experience, or an idea. The price of the product not only includes any cash exchanged but also the time and effort that must be made to conclude a purchase. Even a "free" product can have a price if the time and effort is considerable. The place is the distribution of the product. This component of marketing considers how the customer will obtain the product. For a service, it includes the venue where the service will take place. Finally, the promotion of a product includes more than advertising, it also includes public relations, personal selling, sales incentives, direct marketing and now, social media.

Cultural Organizations and the "One P"

When cultural organizations became interested in marketing they first focused only on promotion. Since cultural organizations have a mission that already defines their product, they did not consider changing their product line to attract new customers. Because cultural organizations are subsidized, the price they charge is already below cost and probably

cannot be further reduced to attract customers. Cultural organizations are also often restricted to the place where they present their art. As a result, the one "P" of promotion has been the main marketing focus for cultural organizations.

The promotion aspect of marketing was usually handled by broadcasting a message via the mass media on the product's features, which is the traditional mass marketing approach to selling. Since at that time marketing departments had less access to information about their customers, all they could do was assume that everyone was a potential consumer. The result was a marketing message based on what the cultural organization thought any potential consumer ought to know.

The marketing of culture by cultural organizations has now moved beyond focusing only on a use of promotion. Cultural organizations are now competing not only with other cultural organizations but other forms of entertainment and leisure activity. Developing a marketing strategy that includes an analysis of the product, price, and place and not just promotion will not only help them to survive, but also to succeed. In the face of competition, cultural organizations must produce a product that provides the benefits that the consumer wants, even if part of this benefit is to be entertained. In addition, this product must be competitively priced and conveniently placed

Cultural organizations need to stop thinking of entertainment as a bad word. In today's highly competitive global workplace, consumers are working longer hours. In their leisure time, they understandably want a way to relax. Cultural organizations should remember that the word "entertain" also means to beguile, delight, enthrall, divert, charm, and absorb. A cultural organization should not be ashamed of providing a product with these qualities, while they also provide art that challenges and stimulates people to think and feel in new ways.

Situational Analysis

A marketing plan provides a strategy that focuses on the customer, product, price, place, and promotion. The first step in the process of creating a marketing plan is a situation analysis of the internal, customer, and external environments. A marketing strategy must take into account the organization's internal environment because the success of the strategy will depend on having adequate financial and personnel resources. Changes in the customer environment also need to be analyzed as the success of the strategy will depend on meeting the needs and wants of customers. Finally, the situation in the external environment must be considered. This includes an analysis of the organization's competition, and the economic, political, and legal issues along with technological and socio-cultural changes.

Situational Analysis Components

Component	Issues	Questions
Internal	Current marketing strategy	What is being done and is it successful?
	Financial resources	Is there money for product improvement and marketing?
	Human resources	Do the people have the needed skills?
	Organizational culture	Is the organization ready for new ideas?
Customer	Current customers	Who is purchasing our product?
	Potential customers	Who is not, that might be purchasing?
	Product use	How do customers fit out product into their lives?
	Motivation for purchase	Why do customers choose our product over competitors?
External	Competition	Who is our competition, both non- and for profit?
	Economic issues	Are our customers able to afford our product?
	Political and legal	How do these impact our resources?
	Technology	What do we need to add to satisfy customers?
	Socio-cultural	What trends are affecting our customers?

Internal Environment

Analyzing the internal environment involves examining the organization's current marketing objectives and strategies. The availability of resources and the organizational culture also need to be analyzed. While such an internal analysis is a necessary step in the creation of a marketing plan, such a detailed look at how the organization uses its resources will also be welcomed by funders as they expect a cultural organization to use its resources both efficiently and effectively (McCleish 2010).

The first step in analyzing the internal environment is to do review the organization's current marketing goals. It may be that the organization does not have any marketing strategy other than to sell tickets or attract people to events. In this case part of writing a marketing plan will be to analyze what the organization hopes to accomplish. This might be to attract a new audience or retain their current audience with a new promotional campaign. Or, there might be a need for a more profound change in the product, pricing, or venue.

For an organization to implement a marketing strategy both effectively and efficiently, resources are needed. The resources needed are both financial and personnel with the needed skills and time. First, the marketing

strategy must be designed to fit the budget of the organization. This can be done by funding marketing as a percent of the total yearly budget. However, if the organization is unsure of how much to budget, the amount allocated may be set as the cost of the proposed strategy. Finally, the amount allocated for marketing could be determined by what is allocated by an organization with a similar size and mission. Whichever method is chosen, it is important that some money be set aside for marketing. An organization that can't afford marketing may well be an organization that won't be around for long.

However, it is not just money for marketing that is important. Financial difficulties affect every aspect on any organization. If there are insufficient funds to keep the venue in repair or to update the technology expected by an audience, then a large marketing budget cannot make up for a product that is insufficiently funded.

The marketing strategy will also need people. The implementation of a plan depends on skilled personnel. It is a waste of time for the organization to adopt a marketing strategy that uses social media if it does not have personnel familiar with such tools. Finally, even if the organization has the financial resources and the skilled personnel, time must be set aside for implementation. Since everyone in a nonprofit is already working to capacity, this might mean that other tasks might not be allocated time in the future.

The culture of an organization is also important to analyze when developing a marketing strategy. A director or board who tend to be conservative, may make it more difficult to implement a new idea, such as a social media program. In this case, the marketing plan may use incremental steps to build support.

There Is No "Too Big to Fail" in the Arts World

From 1994 to 2008 U.S. cultural organizations went on a building binge totaling $16 billion. Why? Everyone else was doing it, trustees were overambitious, architects wanted to design the buildings, and everyone believed the economy could only continue to expand. And, after all, isn't it true that if you build it, they will come? Unfortunately, many of the organizations found that the projects pushed them toward financial insolvency.

In fact, a study of 500 U.S. arts organizations and 700 construction projects found three reasons projects can overwhelm an organization. First, the organization does not account for operating costs. Second, they do not expand fund-raising to cover these costs. Finally, they did not ask themselves if the building was needed, affordable or supportable. Because of these problems, the trend is now to reuse older, existing buildings rather than build new palaces.

Pogrebin (2012)

Customer Environment

The next task in a situational analysis is to determine the characteristics of the current customer. Although the cultural organization may wish to attract everyone to their organization, in reality most of their current customers will share characteristics, for example, age, lifestyle, or gender. While it is easy to describe the current customer, it is more difficult to determine potential customers. Yet, this is even more important. If the organization knows that there is a potential customer group they are not reaching, a strategy can be designed to do so.

To further complicate the situation, over the last two decades there has been a decline in the number of the traditional patrons of high culture willing to support the art out of a sense of social responsibility. This has strained the financial resources of many cultural organizations. However, there is good news. While many new challenges must be faced by those marketing the arts, a new potential audience is obtainable. This new audience, which can be called *cultural participants*, are willing to attend if they are invited to do so with a product with which they can interact and a promotional message that includes feedback from other consumers. These cultural participants are interested in the arts but also insist on being entertained and also being involved. They do not have a reverence for high art or an interest only in Western culture. They may attend a rock concert

What If You Threw a Party and No One Came? It Won't Happen with Social Media!

Every organization dreads putting lots of effort into an event only to have a disappointing turnout. Social media can help keep this from happening. Below are some steps that you can take before, during and after the event.

Before: Create a "first to know" list to announce the event. Letting these people know that they are the first to be invited builds a feeling of exclusivity. The organization can take a pre-event survey to find out about expectations. This way the organization can avoid disappointing the attenders. The organization can also blog and tweet about the event to build excitement.

During: Keep participants engaged at your event by asking for live tweets. Tell your guests to let their friends know the great time they are having. Take photos of the fun and post them to Flickr Live Stream. Have an area at your event where participants can record their thoughts and experience for use to promote your next event.

After: Send an email with a wrap up of the event. For example, if it was a fund raiser, state how much money was raised. If the purpose of the event was to build awareness of an issue, send out additional information. Sending an exit survey to get feedback to improve your next event will let your guests know their opinions are valued.

Padron (2012)

one night, and the opera the next. They may enjoy a Mozart concert while watching a laser light show in a planetarium and also enjoy listening to Tibetan chanting in a traditional concert hall.

Of course, customers consume the cultural organization's product. The question is how it is consumed. For example, customers may be frequent visitors or yearly visitors. They may attend with family and friends or alone. The attendance pattern might be seasonal for special events or be weekly. Finally, the motivation for attendance may be a deep interest in the art form or, at the other extreme, an excuse for a night out with friends. Knowing this information will help the organization promote more effectively.

External Environment

Changes that are external to the organization must be considered when making strategic marketing plans. This includes competition, economic conditions, political and legal issues, technological advancements, and sociocultural trends. Some of these are trends that affect nonprofits nationally or even globally. Others may be unique to the community where the organization is located.

Competition: Every product faces competition. Unfortunately, many cultural organizations think that their only competition is organizations presenting similar art forms. In reality competition includes whatever else the consumer might decide to do instead of attending. This might be to attend another art event, attend a popular cultural event such as a movie or even stay home. Understanding the competition is critical for two reasons. First, the organization can determine its competitive advantage, which is what it has that is unique. Second, it might learn of benefits other organizations provide and can adopt these as its own.

The very nature of the competition faced by cultural organizations has changed. Where formerly they considered other organizations with similar art forms as their competition, they must now broaden their view. This is because the once distinct worlds of high culture versus popular culture have now blended. As a result, cultural organizations and entertainment companies are competing for the limited time and attention of the same consumer.

Economic: Economic conditions can profoundly affect the cultural organization's marketing strategy. If the economy is doing poorly, people will have less money to spend on enjoying cultural products. Therefore, the marketing strategy must either provide less expensive ticket options or use promotion to stress that the benefits of attendance exceeds the cost. If people are concerned about the cost, the cultural organization can promote low cost tickets. If tickets are expensive, the cultural organization must explain to the public why the quality it provides is worth the price. Economic conditions also affect donations. An economic decline of

a single year does not affect philanthropic giving (Raymond 2010). However prolonged economic shocks do, and a non-profit organization must develop a strategy of alternative revenue sources to replace the lost income.

Political/Legal: Cultural organizations might think that they are immune from political and legal issues and, in the past, this might have been true. However, because of funding issues, cultural organizations must carefully follow political issues. The organization's funding may well depend on who is elected to office. Legal issues impact how the organization does business. Regulations on access for people with disabilities must be met or the organization might not be able to open to the public. If government reporting requirements are not meet, the organization might lose its nonprofit status. Keeping abreast of political and legal issues requires a marketing professional to not only read/listen to the news, but also to network with people in the government.

Technological: Technological advancements must be analyzed by the organization to determine if they mean a change or enhancement in the cultural product they produce. Most organizations understand that they need to have a website and even a social media program. However, they may not realize that the way the cultural product is presented is also affected by technology. Visitors now expect sophisticated interactive exhibits at museums. They also expect the latest staging techniques for plays and lighting at galleries. While the organization may not be able to afford all of the latest technology, it should at least make an effort to provide what it can afford to their customers.

Socio-cultural: The socio-cultural environment was a very different place in the 1970s when the field of arts marketing was popularized. The changes since then include new work patterns, globalization, an increase in marketing messages, the blurring of the boundary between popular culture and high art, and funding pressures. For example, today life is more stressful. People are working harder for longer hours as industries strive to compete in a global marketplace (Putnam 2001). People live farther from work and face long commutes. Single parents and working women face a double challenge of meeting both work and family responsibilities. As a result, there are fewer hours and less energy for leisure activities. When there is an opportunity for leisure, although people still want to experience art, they understandably also want to be entertained.

At the same time that life has become more stressful and complex; people are faced with an increasing barrage of marketing messages regarding leisure activity choices (Cappo 2005). This promotional overload results in people tuning out advertising, which has increased the difficulty of creating a successful promotion. The days when a well-designed brochure or advertisement would be sufficient have ended. Cultural organizations must be as creative in the design of promotions as they are in their art.

Demographic changes also affect a cultural organization. Changes in the age of the target population, income level, or the ethnicity can affect

What Worries Museums

The American Association of Museums (AAM) wants its members to conduct environmental scanning so they can keep abreast of changes. However, since they know museum staff members are always short of time, they publish *Trends Watch*. The 2012 edition highlights the following:

Crowdsourcing: museums can find volunteers in a new way.
 Ask the public to help identify buildings and people in old photos.
Taxes: local governments are looking at nonprofits as a source of revenue.
 53% of museums already are accessed user fees by local governments so the time to plan is now.
Community encounters: taking the exhibits to the streets or elsewhere.
 You can't expect them to come to you so you have to go to them.
Alternative funding: encouraging quick and easy methods of making micro-donations.
 Rather than cultivating a few large donors, build relationships with many who can give small amounts.
Engaging the elderly: museum attendance drops as people age.
 Older people may need programming focused on their interests.
More than real: using app technology to engage all the senses.
 Developing apps that allow visitors to "control" their experience may come to be expected.
Education: doesn't have to be the school field trip.
 Developing online lessons plans can be used by any school and also home schoolers.

AAM (2012)

who is to be a potential customer. It also might affect the organization's product. If the cultural organization is community based and the community changes, then it is appropriate for the organization to adapt its product and mission. Lifestyle trends may be harder to define but even more important. If the public embraces global issues, then the organization should reflect this change. If the public values family time, then more family friendly events should be added to the organization's programming. The only way to understand these changes is for the organization to continually analyze the external environment.

Competitive Advantage and Marketing Goal

After a thorough analysis of the internal, customer, and external environments, the cultural organization is now ready to state what sets their organization apart from their competition. There are three general categories of competitiveness. First, the organization may have what is called customer intimacy. These organizations focus on providing the best customer service and have close relationships with their customers. An example might

be the local community theatre that cannot show the latest Broadway hits but knows and shows what their customers enjoy. The second category is operational excellence. Organizations that have this advantage are able to produce products very efficiently and, therefore, are able to keep costs low. Few cultural organizations have this focus. The third type of advantage is product leadership where the organization has the newest and highest quality products. These are usually large, well-funded cultural organizations that can afford to have the biggest stars and latest technology.

The cultural organization must now state their marketing goal. This could be to attract a new market segment. It might be to change their product in some way. It could also be to adjust their pricing or venue. It will almost always involve some changes in their promotion. The steps that need to be taken to achieve the goal are the objectives. For example, if the organization feels it needs to start a social media promotional campaign, the objectives might be to develop the site, create the content, train staff and then launch.

Summary

Marketing has a unique function in the organization as it has both an outward and inward focus. It is not just promotion, but rather it targets an audience using the correct product, pricing, and distribution. Only then is promotion possible. The use of marketing has changed from being only used to promote what the company wished to produce to being used to analyze and meet consumer and social needs. This analysis is part of the strategic marketing process.

The first step before a marketing strategy can be designed includes environmental scanning of the organization's internal, customer, and external environment. As a result of societal changes and the resulting change in consumer behavior, cultural organizations must come to a new understanding of how culture is marketed and consumed as a product. A special type of product, but a product nevertheless. They must also understand how consumers make choices between cultural products based on their internal needs not external distinctions between types of organizations. Cultural organizations now need to know more than just the basics of marketing. They need to know how to develop a marketing plan using new product and promotional strategies to successfully target culture participants.

References

American Association of Museums. 2012. *Trends Watch 2012: Museums and the Pulse of the Future*. New York: American Alliance of Museums.

Bhrádaigh, E. Ní. 1997. "Arts Marketing: A Review of Research and Issues." *From Maestro to Manager: Critical Issues in Arts & Culture Management*. Dublin: Oak Tree Press.

Bridges, Williams. 2003. *Managing Transitions: Making the Most of Change*. New York: Perseus Publishing.

Cappo, Joe. 2005. *The Future of Advertising: New Media, New Clients, New Consumers*. New York: McGraw Hill.

Dreyer, Lindy, and Maddie Grant. 2010. *Open Community: A Little Book of Big Ideas for Associations Navigating the Social Web*. Madison, Wisconsin: Omnipress.

Jensen, Joli. 2002. *Is Art Good for Us? Beliefs about Culture in American Life*. Lanham, Maryland: Rowman & Littlefield.

Kolb, Bonita. 2001. "The Effect of Generational Change on Classical Music Concert Attendance and Orchestras' Responses in the UK and US." *Cultural Trends*, Issue 41.

McCarthy, E. J. 1981. *Basic Marketing: A Managerial Approach*. New York: Irwin Publishing.

McLeish, Barry. 2010. *Successful Marketing Strategies for Non-profit Organizations: Winning in the Age of the Elusive Donor*. Hoboken, New Jersey: John Wiley & Sons.

Moss, Meredith. 2012. "Philharmonic, Ballet, Opera Combine." *Dayton Daily News*. July 8.

Nichols, Bonnie. 2007. *Volunteering and Performing Arts Attendance: More Evidence from the SPAA*. Washington, DC: National Endowment for the Arts.

Padron, Katrina. 2012. "Social Media Secrets for a Sold-Out Event." *Social Media Today*. May 14.

Pogrebin, Robin. 2012. "For Arts Institutions, Thinking Big Can Be Suicidal." *New York Times*. June 27.

Putnam. Robert D. 2001. *Bowling Alone: The Collapse and Revival of American Community*. New York: Simon & Schuster.

Rawlings-Jackson, Vanessa. 1996. *Where Now? Theatre Subscription Selling in the 90's, A Report on the American Experience*. London: Arts Council of England.

Raymond, Susan Ueber. 2010. *Nonprofit Finance for Hard Times: Leadership Strategies when Economies Falter*. Hoboken, New Jersey: John Wiley & Sons.

Rentschler, Ruth, and Volker Kirchberg. 1998. *The Changing Face of Arts Audiences*. Geelong, Australia: Deakon University.

Reiss, Alvin. 1974. *The Arts Management Handbook*, New York: Law-Arts Publishers.

Worth, Michael J. 2012. *Nonprofit Management: Principles and* Practice. Thousand Oaks, California: Sage.

5 Consumer Motivation and the Purchase Process

A major problem for cultural organizations is that attendance by the middle aged, middle class that has been the mainstay of the cultural audience, has declined. The reasons are many, and include increased work hours due to poor economic conditions, increased commuting time, two career families, and extra-curricular activities of children. The result is that people are working much longer hours and experiencing more stress in their lives. The desire to experience culture may be cancelled out by the desire just to get home and collapse on the sofa. At the same time, younger potential audience members are not happy with a passive arts experience. Having come to maturity in a social media world where instant connection and feedback are the norm, they are not interested in only being an audience member. If some consumers have less time and money, while other consumers want a more participatory experience, it is obvious that any cultural product must provide multiple benefits to motivate attendance.

Product Benefits

To develop a successful strategy for attracting consumers to cultural events, it is important to understand why people chose to attend. The literature on attendance at cultural events gives a variety of possibilities that fall into broad categories:

- Interest in a particular art form or artist
- Participation in social ritual
- Desire for entertainment
- Self-improvement
- Social involvement

Those with an interest in a particular art form or artist are probably already attending cultural events. Understanding the other benefits people derive from attendance is necessary so that the cultural organization can

design the right product, select the correct price, chose the appropriate venue, and create effective promotion. When considering motivation, cultural organizations must understand that it varies depending on the art form and audience segment (Ostrower 2008). The desire to gain knowledge is the most important motivator for museums while socialization is the most important motivator when attending other art forms. The desire to experience high quality art is an important motivator for consumers who frequently attend arts and cultural events, but it is of much lower importance for those who are infrequent attenders.

Social Ritual

Besides interest in the artist or art form, another benefit consumers receive from attending a cultural event is the opportunity to participate in a form of social ritual. While the consumer may also desire the same benefits sought by those who merely chose a cultural event as an entertainment option, they also desire something more. For the traditional high art audience, attendance may be an affirmation of their social values (Small 1987). The fact that the art was created by an artist who lived long ago, and yet is still appreciated, is seen as confirmation that effort will be rewarded, even if belatedly, and that triumph over difficulty is always possible. These are core values of the middle class. The art, therefore, provides a proof of the stability of traditional middle-class values in a rapidly changing world. Of course, this emphasis on hard work and self-control may not be attractive to consumers who might be looking for relaxation, amusement, and socialization (Blake 1997).

Music

"The association of the performance of classical music with the upper levels of society developed early and remains true today. Starting in the beginning of the nineteenth century classical music was performed in elegant special-purpose halls designed to be very different from the other public places where music was performed, such as taverns and coffee-houses. The concert halls were to give the illusion that the audience members all came from a class where sumptuous surroundings were taken for granted.

The rituals on how the musicians and audience should behave in the concert hall were developed as a means to reinforce class distinctions. These rituals were very important to the upper-middle-class members of the audience as it was the means by which they sought to distance themselves from those lower in the social hierarchy and to associate themselves with those higher. Unfortunately this is sometimes still true today."

Small (1996)

Desire for Entertainment

Rather than a specific interest in a particular art form or artist, for many consumers, attending a play, concert, or visiting a museum is only one of many possible alternatives that could be chosen as a means to fill their leisure time. The benefits they seek—relaxation, entertainment, and an opportunity to socialize with friends and family—are the same benefits which would be provided by other leisure activities.

In fact, people who attend the arts are also more likely to be involved in other recreational activities. Arts participants are 30 percent more likely to attend a sporting event than people who do not attend the arts. This is because those who attend the arts also play sports. While 26 percent of all U.S. adults played sports, 44 percent of arts attenders did so (National Endowment for the Arts, NEA, 2009).

Self-Improvement

Almost all art appreciation books stress self-improvement as a motive for attendance at cultural events. However, the books on music appreciation may make it seem as this self-improvement must be achieved through hard work and pain, not enjoyment. In the music appreciation book, *Who's Afraid of Classical Music?* (Walsh 1989) learning to enjoy classical music is compared to body building: no pain, no gain. The book explains that popular music is popular because it is easy, but the author advises now that the reader is older, it is time to put aside the things of childhood. Readers are now ready to learn to enjoy "sophisticated" music, if only they are willing to work hard to do so. The desire for self-improvement varies

Letters to a Musical Boy

The theme of self-improvement continues through most old and new art appreciation books. In Letters to a Musical Boy, written back in 1940, the author explains the difficulty inherent in appreciating good music.

"And so John, we have come to the end of our discussion. If you have learned anything from what we have discussed, it will, I hope, encourage you to explore further this universal language of music, either as a listener or, if you possibly can, as a performer, even if it is only as a member of a village choir or local orchestra. You will have realized, perhaps, how great are your opportunities; but I hope that you may meet difficulties as well. For music is not an easy art either to practice or to enjoy. True enjoyment means something very much more than turning on a switch and sinking back into an armchair. To some, music may only be a pleasant pastime; but to others it is a spiritual experience. The more difficulties you overcome in the search for it, the greater your rewards."

Bruxner (1940)

by art form. Museum visitors are much more likely to have gaining new knowledge as a motivation for attendance than those who attend musicals (Ostrower 2008).

Social Involvement

While cultural organizations have always believed they provided a quality arts experience, the benefit of connection and expression are also relevant. While socialization has also always been a part of the experience of attending the arts, social media extends this experience. The use of social media means more than just keeping in touch. In the social media world, knowledge is shared and those with knowledge have social power. Social media allows people to connect with those they know, and those they don't know at many different levels. What can be called the *connected generation* is motivated by the need for experience, transparency, reinvention, connection, and expression (Johnson 2006). Culture participants want to learn but not about abstract art theory. They want to learn about the cultural organization and its artists. However, cultural participants also expect the organization and its artists to want to learn about them. Even more, they want to use the organization as a means to express themselves.

Consumer Decision Making

When making purchase decisions, consumers will consider the benefits they will receive from the product versus the cost. *Value* is the term used to describe this relationship between the satisfaction the benefits provide and the cost the consumer must pay including any ticket price, but also childcare, transportation, and other related expenses. However, even if there is no charge for attendance or other monetary cost, there is still the cost to the customer in time and effort to attend. When designing promotions, cultural organizations often do not mention value because they assume that everyone already understands that the benefits of experiencing the art outweighs any monetary or other cost to the consumer. If cultural organizations do consider value, they often only focus on communicating the availability of low-priced tickets. While it is true that price is important to most consumers, financial costs are not the only factor when assessing value. Consumers also consider the entire package of benefits they will receive from attending.

Consumer Definition of Quality

The cultural organization's mission is to produce art of the highest quality. As a result, it often believes that consumer satisfaction only depends on the quality of the art. Consumers, on the other hand, are understandably less educated on the fine points of the art form, and may have other

Making Sure that No One Needs to Wander the Galleries Alone

Everyone knows that socialization is often an important part of the arts experience. However, what if no one you know shares your passion for the arts? Before it was go alone, or stay home. Now social meeting sites can be used to find that elusive culture lover. Meetup in the United States has 45 groups devoted to visiting museums. Anyone registered on the website can post a planned outing and see who else is also interested in coming along.

Culture Seekers in the UK has the same mission—to enjoy culture with others. While Meetup has socialization opportunities of all kinds, Culture Seekers only arranges outings to cultural experiences. Museums have become aware of the power of the group and twenty-one of them offer discounts to members. They also arrange special showings and events. What better way to market than to reach out to groups that you know are already interested?

Preston (2011)

expectations that define quality. While the quality of the art is important, consumers will also make a decision to attend based on the quality of the entire experience. This will include their expectations in regard to such factors as the ambience of the venue, the convenience of the location, the additional amenities provided, and their ability to participate in the experience. The cultural organization can only provide a quality experience by meeting or exceeding expectations that result from this consumer definition of quality.

Consumer expectations are often influenced by word-of-mouth recommendations from friends and relatives that are received via social media. These expectations are more influential than recommendation from the media. Consumers will assess the quality of the experience starting from their first contact with the organization. In the past this might have been when they entered the front door. Now it is more likely that this first experience will happen online.

The Purchase Process

If the cultural organization wishes to meet the quality expectations of consumers, it must first understand how consumers make the decision to purchase. Understanding the process by which consumers make choices gives the cultural organization an advantage in both designing a marketing strategy and promoting its product effectively. In the ideal world envisioned by the cultural organization, the consumer recognizes the need to participate in a specific cultural activity, such as visiting a museum or hearing a concert, and then simply chooses from the available cultural alternatives. However, this assumes that the main motivating factor for

attendance is the cultural product, which may be true for cultural enthusiasts but not cultural consumers. In addition, each step in the purchase process must communicate about the product's benefits (Blakeman 2011). It must also communicate that the organization is focused on the quality of the total experience. Finally, it should be the start of building a relationship with the customer, not just making a sale.

Therefore, the cultural organization must understand how to attract attendance using knowledge of the purchase process. The five steps in the process are need or problem recognition, information search, evaluation of alternatives, purchase, and post-purchase evaluation.

The Purchase Process

- Need or Problem Recognition
- Information Search
- Evaluation of Alternative Products
- Product Purchase
- Post-Purchase Product Evaluation

Need or Problem Recognition

The process starts with consumers recognizing that they have a need to fill or a problem to solve. The consumer's problem may be where to attend a cultural event which will show the visual art of a particular artist. Or it may be the problem of what to do while on holiday in a foreign city or how to relax after a long workweek. Of course, the cultural organization's main mission is to present culture, but they must also recognize what additional problems they may be solving for their audience.

In reality, the problems that consumers need to solve may be as general as what to do for an evening's entertainment or as specific as the need to attend a specific cultural event with a client they wish to impress. However, before the consumer can act, they must perceive that a problem even exists. Even the most avid supporter of culture will acknowledge that it is not felt by most people as a primary need, such as food and shelter.

Information Search

Consumers next must initiate an information search to discover what potential activities are available that will meet their needs. The cultural organization must ensure that the information it is providing is in a convenient form and place. Consumers must be able to find the necessary information at the time they are making the decision. It is also important to consider who is actually making the attendance choice. In any choice there is someone who is the initiator of the process, but they may not be the person who is the ultimate attender.

Everybody's Doing It—But Is It Worth It?

Many cultural organizations are excited about using social media as part of their marketing campaigns. However it is important to remember that traditional direct mail campaigns still have a role to play in a cultural organization's marketing strategy. The idea is not to replace direct mail asking for subscription sales or donations but rather to use social media to complement these strategies. Three strategies for doing so are recommended. First, use social media to communicate with people currently not buying subscriptions or donating so that they can be added to the direct mail list. Second, target the people using your social media site based on shared characteristics and interests just as is done with direct mail. Finally, analyze how social media is helping you reach your marketing goals. If it isn't improving your image and increasing revenue, it may not be worth the effort.

Northrup (2011)

If today's consumer is feeling stressed and overworked, then it can be assumed that even when he or she has recognized a need, there will be limited time to spend on the second step in the process, searching for information. Therefore, since hectic lifestyles do not allow for long-range planning of activities, the information needs to be available at the appropriate time, which is usually shortly before the event.

Here is where social media is playing an ever increasing role. Social media has changed many consumer behaviors. One of the most significant is how consumers gather information about products (Solis 2010). They are no longer dependent on the organization but instead can get information directly from other consumers. While in the past the organization could control the information about the product, this is no longer true.

Evaluation of Alternatives

After consumers have gathered sufficient information, they must then evaluate the available alternatives. The cultural organization must understand what the most influential evaluative criteria are for their targeted audience. For some consumers, the criteria may be the quality of the art. For others it could be as prosaic as the convenience of the location or the availability of parking. So that consumers can make decisions between alternatives, they should be provided with information on the time, place, and program for the cultural event. However, they should also be given information on what other benefits will be provided. For example, consumers may want to know if food will be available, so time can be saved and socialization chances increased. For consumers with limited cultural knowledge, they need to know they will be provided with information about the performance or exhibit which will help them to enjoy the experience.

Consumers must be able to obtain enough information on the various opportunities so that they can make an informed decision on which choice to pursue. Consumers need this information because they do not have the time to risk participating in an activity that might not meet their needs. Here again is where technology has profoundly changed the manner in which people make purchase decisions. People want to share their experiences whether it is more privately on Facebook or on public review sites set up for just this purpose. The "connected consumer" uses all social media including Twitter and geolocation websites when making decisions (Solis 2012). Now, the cultural organization is only one voice in a chorus of voices informing the potential consumer about consumption choices.

Purchase

Cultural organizations often neglect to consider that, once the consumer has made the decision, he or she must actually purchase the ticket to attend the event. The organization must analyze the ease with which the purchase transaction can be completed by the potential customer. In an age when everything can be purchased online, many cultural organizations still have consumers stand in line in the rain to get tickets to their venue. Even if the organization has a website that can be used to purchase tickets, it now must consider if this website can be easily accessed and used from a smartphone. In 2012, 74 percent of smartphone users got location-based information via their phones (Zickuhr 2012). Once they have found your organization, they should be able to purchase a ticket immediately from the same site.

Post-Purchase Evaluation

After the purchase, the final step in the process is that of the consumer performing a post-purchase evaluation. At this time consumers will decide

Make Them Want to Pay More!

Today, everyone wants to get a good deal. The average consumer has been conditioned to expect "two for one" offers, bring a friend for free, 10 percent off, or late-breaking good deals. Why would anyone then want to pay full price? If you don't give them a reason to do so, paying full price just makes people feel like losers for not getting a good deal. But, if paying full price has perks, consumers may see the value. These perks might include early access to a venue, free refreshments, better parking, and a discount at the gift shop. Other venues from amusement parks to ball parks are already using these ideas. Why not cultural organizations?

Carr (2012)

if their quality expectations have been met, or even exceeded, or whether they have been disappointed with the experience. The cultural organization must remember that it is not enough just to get the audience in the door, but they also must make sure that the audience's experience is what they expected and provides the desired benefits. Only if the consumer is satisfied that the event provided an acceptable solution to the initial problem will they choose to repeat the experience. There is an old business expression that a happy customer tells one other person, but an unhappy customer tells ten. Now, an unhappy customer can tell the world by posting a negative review online.

Consumer Motivation

When going through the decision-making process, consumers are influenced by internal (personal) or external (social) motivating forces. Internal forces include the customer's values, the resulting beliefs and their own unique personality. The external social forces that influence the consumer include education, family, social class, ethnicity, and reference groups.

Internal Factors Influencing Consumer Choice

The values, beliefs, and personalities of consumers shape all consumption decisions, but particularly of cultural products. Values can be defined as enduring beliefs on what conduct is acceptable or unacceptable. Individuals may not always act in accordance with their values, but acting in contradiction to them will often result in a state of internal unease that they will seek to avoid. Personal values, some of which the individual may be unaware, arise from the influences of family and society. Beliefs about appropriate conduct are formed from these underlying values. These include whether or not to attend the arts.

Values: Cultural values are strongly held, enduring beliefs about how life should be lived. These values will affect when, where, and with whom people attend the arts. For example, an increasing emphasis on family values may result in more families wishing to attend a museum or the ballet or a concert together. If cultural marketers want to take advantage of this, they must include in their promotional material information on children's activities and events.

Beliefs: The decision to attend a cultural event may arise from the belief that a good person patronizes the arts or that the arts are enjoyable. However, it also may arise from a belief that cultural events are a place to gain or maintain social standing. People attending a cultural event may all say they believe that attending the arts is important, and yet each person may mean something different.

Negative beliefs about attending cultural events also exist. These beliefs, which might include that the arts are elitist, boring, or expensive, must

Art Attenders Make Good Citizens

It's not known if values, beliefs, or personality are the reason, but what is known is that people who attend the arts are civic minded. Over 50 percent attend community meetings at least once a year. This was 35 percent higher than the rate for meeting attendance by non-arts attendees. They also volunteer at a rate 35 percent higher. And, as if they weren't busy enough, they also have time to get out and vote at a 22 percent higher rate.

National Endowment for the Arts (2009)

be changed by providing a positive message or a direct experience that contradicts the negative belief. However, it is true that it is difficult for cultural organizations to attract consumers who have pre-existing negative beliefs about the arts and culture.

Personality: Of course, the influences of motivation and personal values and beliefs also combine with the individual's unique inborn personality. Personality traits that can affect the purchase decision include curiosity and tolerance that can make people more open to new experiences. The interaction of all these factors results in the individual's lifestyle choices that involve the consumption of leisure, social, and cultural activities.

External Factors Influencing Consumer Choice

Influences from the external environment also affect purchase motivation. It is especially true that the higher the social class of the individual, the more likely they are to be interested in the traditional high arts. However, both in the United States and Europe, social class has less influence on attendance than in the past (Huysmans, van den Broek, and de Haan 2005). These factors, which include education, ethnic culture, reference group, family, and social class, help shape consumer consumption decisions. Without taking these factors into consideration, a promotion campaign to attract attendance cannot be effective.

Education: Cultural organizations often consider education the most important external factor influencing the attendance decision. The common belief is that if individuals are educated about culture as children, they will feel a need to experience culture as adults. However, as stated earlier, values and beliefs formed by family, along with inborn personality traits, play an equally important role in determining attendance. If these factors are negative influences, they may cancel out the positive influences of education. Even if other influences are not negative, it may not be true that exposing young people to culture at school leads to a life-time of cultural participation. Students are also exposed to math, geography, and literature at school, but only a small minority continues to enjoy these subjects as adults.

While there has been a strong correlation between years of education and arts attendance, even those with education are attending less frequently (NEA 2008). The percentage of college educated adults attending has declined from 1982 to 2008. Classical music, opera, and plays have seen declines in college-educated attendance in the 30 percent range. The decline in college educated attendance, 43 percent, has been steepest for ballet.

Cultural organizations are correct in believing that consumers cannot desire what they do not know. In this way educational programs in the schools do allow students to experience culture. The hope is that the cultural experience will be enjoyable and the student will wish to repeat it in the future (Myers 1996). However, even if the student tries the cultural product and enjoys the experience, if learning is to be retained, the experience must be repeated. One-off trips to the symphony or the art museum for groups of school children probably have little lasting effect because the children do not have the ability to repeat the experience on their own. They may attend again with their family, but in that case the family probably has already been attending cultural events.

Family: It can be debated as to whether the family or education has the largest influence on an individual's behavior. However, the family certainly does play a large role in shaping the types of activities in which the family members engage. This is especially true in the area of cultural consumption. Although being raised in a culture-loving family does not automatically transform the child into a culture-consuming adult, the opposite is rarely true. The child who has grown up without the experience of being raised in a culture-loving family will rarely grow into a culture-consuming adult.

Cultural organizations might better reach out to families through organizations other than schools. It is the parents who will make the attendance decision and if they believe that the cultural experience is desirable, this will lead to increased attendance by everyone in the family.

When cultural organizations design a promotional message for families, it is important to remember to target the message to both the parent who makes the consumption decision and those who will ultimately attend. When families attend a cultural event as a group, it may be the children who have heard of the event and wish to attend, but it is the parents who have made the decision. For example, the promotional message for a dinosaur exhibit would contain information about participative activities that are attractive to children, but also information about its educational value, which motivates the parents to bring the children.

Social Class: A hierarchy of social classes exists in all societies. A social class can be defined as a group of people who associate both formally and informally and share the same value system and activities. The division on which the hierarchy is based may be wealth, birth, or power, but in modern capitalistic societies, the distinction is usually based on wealth.

Sociologists usually divide the class structure of these societies into high class, upper-middle class, middle class, working class, working poor, and underclass. This hierarchy mirrors the older distinction of social class based on birth found in more traditional societies. Social class is important as it relates to the types of cultural activities in which the members are likely to engage.

There is a historical tie between high social status and consumption of culture. Those who have been born into high social class have the time and money to pursue artistic and cultural interests. In fact they need leisure activities, as work does not consume all their available time. On the other hand, members of the middle class often have achieved their status through hard work that has allowed them to move up from lower classes. They now wish to associate even further up the ladder of social hierarchy and may see the consumption of culture as a means of doing so. They know that the upper-middle class participates in cultural activity. By closely associating themselves with cultural organizations through providing funding and support, they are emulating the behavior of, and associating themselves with, the higher classes.

On the other hand, the working classes often do not have the time and energy to consume culture because the necessities of everyday existence take precedence. Because money is often a problem, and they have less education, their world-view is often local. As a result of this financial dependence and inward view, they do not have the same interest in attending the traditional high arts. When they do engage in cultural activities, it will be a low cost, local event which they will attend with their family or other social group.

To YouTube or Not to YouTube?

If you knew that YouTube attracts 800 million unique viewers per month, would you consider it? How about if you knew three billion hours of video are viewed each month? Or, that 10 percent of the usage is now on mobile phones? When you do decide to start posting video online, here are some issues to consider:

Your video doesn't have to have a cute kitten or be funny. The style should fit your audience and what they expect from your brand.

"How to" videos are extremely popular with "how to" being among the most popular search words. A video that shares your organization's or artist's expertise is more likely to be viewed than one that is only promotional.

You can target your local audience with your ad campaigns. While YouTube may be global, the ad campaigns can be localized.

Use the analytics to find out which videos people are watching. You can also learn from what sources people found your videos. Finally, if you have your own YouTube channel you can analyze who subscribes.

Thomases (2012)

Another manner of analyzing social class is to examine social engagement. People who are engaged in their communities by voting, volunteering, and attending community meetings are also more likely to attend the arts (NEA 2009). For example, people who attend cultural activities are three times more likely to attend community events and are 35 percent more likely to volunteer. On the other hand, there is a new class of socially disengaged Americans that are less likely to be involved in their communities. This group is characterized by low skills, low education levels, and low income. In the past many cultural organizations would do outreach to these communities as part of their mission. However, what is new is that the new lower-class communities are less likely to be engaged in any civic or organized social activity (Murray 2012). This will make it extremely difficult to engage them in cultural activities.

Ethnicity: Another external factor that affects the attendance decision is the individual's ethnicity. Ethnic culture, the way in which members of a group approach the choices that life presents, is transmitted through life experience from one generation to the next. The decision to participate in cultural activity is not just an individual preference, it is also part of an ethnic cultural pattern.

The use of art and culture is an important component of ethnic identity. Western society's conception of culture is not universal. In the West, art is often treated as separate and sacred and is used to elevate the individual above the concerns of daily existence. Art that is used in everyday life, and enjoyed by the uneducated, is designated differently as crafts or folk art. Many ethnic cultures have an opposite view of how art fits into society. Art in other cultures is imbedded into the social fabric of everyday life. Art forms, such as music, dance, and visual display in these cultures would not be seen on an elevated level but would be viewed as part of everyday existence.

The cultural organization is often managed by individuals from the majority culture who assume their form of culture is universal and will be appreciated by everyone. This is rarely the case as art forms usually develop from the experiences of the cultural group. For this reason, art

Sports and Art? Maybe They are not That Different

One doesn't usually think of arts attenders at the ballpark but that is actually the case. Over half of adults who attend the arts also attend sporting events. This is in contrast to only 20 percent of all adults attending sporting events. You might think that arts attenders just want to watch sports, but not true! While overall 26 percent of Americans played sports, 44 percent of performing arts attenders and museum visitors played sports. So don't be surprised if you see someone at the theatre in a ball cap.

NEA (2009)

does not easily translate across cultural boundaries and may not be appreciated by someone who has not experienced the same cultural forces. Cultural organizations must remember that all ethnic groups have their own art forms which they enjoy and consider valid.

Reference Groups: Consumer behavior is also affected by reference groups with whom the individual chooses to associate. These groups are unrelated individuals who choose to socialize together. They include groups as diverse as amateur sports teams, civic organization, and gangs. Individuals will adopt the behavior of members of their group either because they already belong, or because they wish to belong. Today, these reference groups also form online using social media.

The influence of reference groups is especially strong for young people because they feel a need to establish a sense of identity separate from their family. They form this identity through associating with others who share the same interests. If they desire to be accepted by a particular group, they will need to behave in the same manner as current members. Likewise, they will avoid activities that are associated with a group with which they do not wish to be associated. Attendance at a certain type of leisure activity, such as the dance club scene, may be seen as positive by the young because participation in the activity defines the values of those who participate or attend. Since high culture events are attended by an older, conservative group of individuals, they may be avoided by those not wishing to be seen as belonging to this group.

This type of behavior is also true of adults. If they view participating in cultural events as something that is done by a group to which they wish to belong, they will also participate. If a well-educated, socially connected group attends opera, and they wish to be considered as such, then they will be motivated to also attend opera.

Previously, cultural organizations had little means of influencing the behavior of groups. They were limited to targeting the groups with promotional messages. For online groups this is no longer true. The cultural organization can join online groups that share an interest in a particular art form, geographic location, or activity. The purpose of joining would be to build a relationship with the group by sharing information. These new relationships can be used not just to influence how people think about culture but also to convince them to take the next step and attend or donate (Kanter and Fine 2010).

Maslow's Hierarchy

Maslow's hierarchy (1987) is a theory which describes how a person's life circumstances motivate them to fill basic human needs. In this theory, the strongest motivator is to satisfy the immediate physiological or human needs for food, clothing, and shelter to keep body and soul together. After these needs are met, the individual can then focus on safety needs

or ensuring that these needs will be met in the future. Once the basic needs of life have been secured for today and the future, individuals can then meet their social needs by associating with others either in person or online. This can also be met online. This basic need can explain the rapidity with which social media has caught on.

Once their social needs are met by associating with others, they then feel the contrary need to separate themselves from the group to gain esteem, either as an individual, or as a member of a unique group. And after all these needs are met, individuals can then develop the unique nature of their inner selves through self-actualization.

Maslow's Hierarchy
 Self-actualization—self-development, self-realization
 Esteem—recognition, status
 Social—belonging, love
 Safety—security, protection
 Physiological—hunger, thirst

Maslow stated that these needs are satisfied in an ascending order. Lower-order needs can be satisfied externally through factors such as food and drink, regular employment, and family associations, while higher order needs are satisfied internally through feelings of self-worth. Individuals will be motivated to meet a need, but once the need is met, they will start to feel the next level need and seek to meet it. What is interesting is how the theory can be used to examine how cultural organizations view the public's need for culture.

The typical audience for culture usually consists of educated individuals with high incomes who are from the upper-middle class or above. It can be assumed that these individuals have already met the lower-order physiological, safety, and social needs and the need for culture is felt only because these other lower-order needs have already been met.

Most cultural organizations believe high culture improves and develops the human psyche (Woodmansee 1994). However, except perhaps for a few rare individuals, people who are struggling with the basics of existence do not feel the need to use culture for a self-actualizing experience because other, lower-order needs take precedence. Those few individuals who will ignore their basic needs in the pursuit of art often are artists themselves, or members of what was once termed *the bohemian class* and is now called *the counter-culture*. These individuals put the need to appreciate culture first, with other needs such as security, a regular job, and adequate income falling lower in the scale. These individuals will then look down on members of the middle classes, whose appreciation is suspect since they have not sacrificed meeting any of their basic needs in order to enjoy culture (Lloyd, 2010).

This does not mean that individuals who are unable to take the time to participate in cultural activities because they are busy satisfying lower-level

needs are unable to appreciate culture. It does mean that culture must be presented to them in a manner and setting which also helps to satisfy their other needs at the same time. This group may have no objection to self-esteem and self-actualization, but they may want a cultural event they attend to also meet socialization, and even physiological, needs.

Unfortunately, some people working in cultural organizations feel that supplying cultural events that meet lower-level human needs somehow debases culture (Woodmansee 1994). They have a traditional belief that culture should only be enjoyed for the higher motivations and culture that meets any other needs is suspect. This belief may exist because the original audience for culture consisted of the upper classes and nobility. Their place in society was defined by having sufficient money to free them from focusing on lower-level needs and that allowed them to pursue cultural activities.

However, if individuals can meet more than one need at the same time, there is no reason that self-esteem cannot grow and self-actualization occur even when other lower-level needs are being met. Cultural organizations can use this theory of human behavior to understand how to make the presentation of culture attractive to a wider span of the population.

Summary

The reasons for attendance at cultural events usually include an interest in a specific artist or art form. However, the reasons may also include a desire for self-improvement and a need for socialization. The purchase process is more complicated than just a "to buy" or "not to buy" decision. It starts with the recognition of a need, an information search, and an evaluation of alternatives. After the purchase, consumers will evaluate if the product has meet their needs. The decision to purchase a cultural product is affected by internal factors such as values, beliefs, and personality. In addition, it is affected by external factors such as education, family, social class, ethnicity, and reference groups. Maslow's hierarchy of needs describes that people will meet their needs in a certain order. First, they will meet the physical needs and only after, the social needs.

References

Blake, Andrew. 1997. *The Land Without Music: Music, Culture and Society in Twentieth Century Britain*. Manchester: Manchester University Press.

Blakeman, Robyn. 2011. *Strategic Uses of Alternative Media: Just the Essentials*. Armonk, New York: M.E. Sharpe.

Bruxner, Mervyn. 1940. *Letters to a Musical Boy*. Oxford: Oxford University Press.

Carr, Eugene. 2012. "The Case for 'Premium Full Price' Tickets." *CRM & Ticketing Newsletter 2*. July 16. http://patrontechnolgy/newsletter-the-case-for-pfp/.

Johnson, Lisa. 2006. *Mind Your X's and Y's: Satisfying the Ten Cravings of a New Generation of Consumers*. New York: Free Press.

Huysmans, Frank, Andries van den Broek, and Jos de Haan. 2005. *Culture-lovers and Culture Leavers: Trends in the arts and cultural heritage in the Netherlands.* The Hague: Social and Cultural Planning Office.

Kanter, Beth, and Allison Fine. 2010. *The Networked Nonprofit: Connecting with Social Media to Drive Change.* San Francisco: Jossey-Bass.

Lloyd, Richard. 2010. *Neo-Bohemia: Art and Commerce in the Postindustrial City.* New York: Routledge.

Maslow, Ahraham. 1987. *Motivation and Personality.* New York: Harper & Row.

Murray, Charles. 2012. *Coming Apart: The State of White America 1960–2010.* New York: Crown Forum.

Myers, David E. 1996. *Beyond Tradition: Partnerships Among Orchestras, Schools, and Communities.* Washington, DC: Georgia State University and National Endowment for the Arts.

National Endowment for the Arts. 2008. *Arts Participation 2008: Highlights From a National Survey.* Washington, DC: National Endowment for the Arts.

National Endowment for the Arts. 2009. *Art-Goers in Their Communities: Patterns of Civic and Social Engagement.* Washington, DC: National Endowment for the Arts.

Northrup, Amelia. 2011. "Three Ways to Put Social Media in its Place." ArtsBlog. October 4. http://blog.artsusa.org/2011/10/04/three-ways-to-put-social-media-in-its-place/.

Ostrower, Francie. 2008. "Multiple Motives, Multiple Experiences: The Diversity of Cultural Participation." *Engaging Art: The Next Great Transformation of America's Cultural Life.* New York: Routledge.

Preston, Jennifer. 2011. "Rendezvous with Art and Ardent." *New York Times.* October 21.

Small, Christopher. 1987. *Lost in Music: Culture Style and the Musical Event.* New York: Routledge.

Small, Christopher. 1996. *Music, Society, Education.* Middletown, Connecticut: Wesleyan University Press.

Solis, Brian. 2010. *Engaged! The Complete Guide for Brands and Businesses to Build, Cultivate and Measure.* Hoboken, New Jersey: John Wiley & Sons.

Solis, Brian. 2012. *The End of Business as Usual: Rewire the Way You Work to Succeed in the Consumer Revolution.* Hoboken, New Jersey: John Wiley & Sons.

Thomases, Hollis. 2012. "Using YouTube? 4 Tricks for Video Marketing." *INC.* June 26.

Walsh, M. 1989. *Who's Afraid of Classical Music?* New York: Simon & Schuster.

Woodmansee, Martha. 1994. *The Author, Art, and the Market: Rereading the History of Aesthetics.* New York: Columbia University Press.

Zickuhr, Kathryn. 2012. *Location Based Services.* Washington, DC: Pew Research Center's Internet & American Life Project.

6 Consumer Segmentation

Few cultural organizations have an audience that consists of the broad spectrum of society that is the goal of their mission statements. The current audience for culture is skewed toward those from the upper social class with high incomes, who are older and well educated. Because the typical arts audience represents only a portion of society, the cultural organization needs to understand how to use segmentation to both increase and broaden its audience. Cultural organizations formerly thought of increasing the audience through audience development. This strategy relied on finding more of the same type of audience member. Instead, marketing needs to segment the audience based on demographic, geographic, benefit, and usage rate characteristics. Each unique segment will have similar characteristics and will share a similar motivation for attendance. The cultural organization can decide to concentrate on attracting a single segment with a marketing message. Or a larger organization may choose to attract more than one segment with unique messages for each. Whichever choice is made, the organization must develop a marketing message that will communicate the benefits sought by each segment. In addition, many cultural organizations choose to target tourists as a market segment.

Developing a Segmentation Strategy

Developing a market segmentation strategy is easier for large organizations with the resources to differentiate their product by packaging cultural events for multiple segments. For example, a museum may offer family activities, hotel packages that include tickets for visitors to the area, and "singles" nights all for the same exhibit. This approach is more difficult for smaller cultural organizations that may need to use all their resources to produce one type of event or product. The target marketing strategy usually favored by such organizations is to aim at a small segment which is already predisposed to their product.

However, even small cultural organization can better serve their current audience by breaking it into segments based on the benefits it desires. For example, the organization may have an audience for ballet that is

All Customers Are Equal: But Some Are More Equal than Others

Arena Stage at the Mead Center for American Theatre, Washington, DC, granted certain benefits to subscribers, such as a no-fee ticket exchange. If you are not a subscriber, you must pay a fee, which sounds very reasonable. But what if you are a large donor but not a subscriber? The fee will still be charged. When this happened to one of their largest donors, Arena Stage realized it had a problem. The donor information from their development office was not being shared with the information from the box office that collects customer ticket information. Arena Stage realized it needed to look at their customers based on the overall value they delivered to the organization, not just the amount of tickets they purchased. Now when a person's name is entered into the database, the front desk person can see if this is a customer that is especially valuable to the organization.

Bauman (2011)

consistent in demographics, but the product could still be differentiated by benefit. Attendance among this group could be increased by targeting ballet attendees who wish to learn more about dance. The attendee who only wishes to be entertained can be targeted separately. In this way, segmentation can be used to build frequency of attendance.

Audience Development

Increasing attendance is the central responsibility of the marketing department. It is responsible for increasing the size or depth of the audience, but this would also be true of the marketing department of any commercial business, since having additional customers results in additional revenue. However, audience development in a cultural organization also means increasing the range, or breadth, of the audience. This involves targeting new segments of the population who are currently not attending. Commercial businesses will also wish to increase the breadth of their market segments, but only as a means to increase the size of the customer base so as to increase revenue for the company. In contrast, because reaching a broad range of people with their art is the central mission of cultural organizations, they view increasing the breadth of the audience as a goal in itself. Indeed they will spend considerable resources to reach and attract non-attending groups even when these customers bring in limited additional revenue. The goal of the cultural organization is to expose as many people as possible from a broad spectrum of society to their art product. This focus on mission before money is a fundamental difference between them and a profit company. As a first step in the process of segmentation of their current and potential audience, cultural organizations must decide whether to develop market depth, breadth or both.

Market Depth: To develop market depth, the cultural organization first must determine their current audience segment and then develop a marketing strategy which attracts more members of this same group. This has been the traditional response of cultural organizations. It is an easy strategy because the cultural organization is already familiar with their current audience and what motivates them to attend. However, following this approach will result in limited growth in attendance as members of this segment are already aware of the organization and have made their decision on whether or not to attend.

Market Breadth: If the cultural organization wishes to expand the audience for their product by developing market breadth, members of new market segments must be attracted. Because consumers have other means of using leisure time besides consuming culture, organizations will need to attract consumer segments who are currently consuming other forms of entertainment. The consumers in these new market segments may desire different benefits than the cultural organization's current audience. Therefore, the cultural organization needs to use benefit segmentation to differentiate its cultural product so that the product can be marketed to the new segment of the population while retaining the current audience. To do so, cultural organizations must be willing to adjust the benefits provided by their cultural product.

New Ways to Segment an Audience

The Arts Council of England conducted research to understand how people engage with the arts. The Council concluded that people can be segmented into groups based on whether they are highly engaged, have some engagement, or no engagement. These groups can then be segmented further. The highly engaged was broken down into what was called the "urban arts elite" and the "traditional culture vultures," two groups that were already attending. The no engagement group was broken down into "time-poor dreamers," "a quiet pint with the match," "older and homebound," and "limited means, nothing fancy," all of which would be very difficult to motivate to attend. However, the segments with some engagement could be motivated to attend more with the right strategy:

Fun, fashion and friends: Choose the right communication channels.

Mature explorers: Provide programs that help them learn more about what is happening in the world.

Dinner and a show: Reach them online, where they book events.

Family and community focused: Communicate that your event is fun for all.

Bedroom DJs: Create unique activities that they can discuss the next day.

Mid-life hobbyists: Motivate them to develop their creativity through attendance.

Retired arts and crafts: Offer transportation to help them get to the event.

Arts Council of England (2011)

Market Involvement: Another way of examining the development of the audience is not to think about numbers of people but rather people's level of involvement. If consumers are more involved with the organization, they will attend more often. While there are people whose only involvement with the organization is to attend, others contribute more (Kanter and Fine 2010). They may share the information about the organization with others. They may also contribute financially. They even may do more and actively encourage others to attend and contribute funds.

Targeting Strategies

There are four strategies for determining how many segments should be targeted by a cultural organization. These include undifferentiated, concentrated, multi-segment, and micro-segment. The choice of strategy is determined by the size of the organization and its available resources. Cultural organizations often use an undifferentiated targeting strategy where the entire public is treated as one large consumer market segment. In doing so, they have assumed that everyone has the same need for culture and also seeks the same experience.

Concentrated

However, a more successful option is concentrated targeting. With this strategy, the organization carefully analyses the benefits the product offers to its potential customers. The cultural organization then selects a segment of the market to target that includes those individuals who will be most interested in the product's benefits. Since most cultural organizations have limited marketing funds, concentrated targeting helps them to use their funds more effectively by promoting to a specific segment.

By concentrating on a specific market segment, the cultural organization can better ensure that it can provide a product that meets the needs of the group that is targeted. It is especially true that small cultural organizations cannot be all things to all people. If small organizations focus on the needs of a specific market segment, such as families or an ethnic group, they are able to provide the services and benefits best suited to that segment. This strategy allows smaller organizations to more effectively compete with larger organizations. The promotional message of the small cultural organization may not be heard if broadcast generally, but will be heard if targeted carefully.

Multi-Segment Targeting

Large cultural organizations may adopt a multi-segment strategy and target more than a single market segment. This can be done by repackaging the same cultural product for different market segments. A change in

presentation style, ambience, or services may be all that is necessary. For example, a concert may be targeted to families as a matinee with additional entertainment in the lobby and refreshments that appeal to young appetites. The same concert may be targeted to young singles in the evening with a different ambience including exotic drinks and upscale snacks. The same cultural product can be offered in a different manner, at a different time or even location, in order to attract a unique market segment.

Rather than change the product, another approach when targeting to multiple segments is to keep all aspects of the product the same, but to vary the message that is sent to the consumer. Even cultural organizations who do not wish to change their product can use this approach. Because cultural products provide a variety of benefits, the organization can communicate different marketing messages that promote the benefits most sought after by each target market segment.

Cultural organizations should be aware that if they market to multiple segments they must continually reassess the marketplace to ensure that their choice is still correct. With today's fast pace of social change, many market segments change quickly and as a result so do their needs and desires.

Micro-Segmenting

Technology now has provided organizations with an opportunity to micro-segment to the few people that may share an interest in a more obscure art form or artist (Verdino 2010). While people with very specialized interests have always existed, before technology there was no economical means to reach them. With technology, even if they are geographically distant, the cultural organization can form a community around the art form. If they are geographically distant, they may not be able to attend events frequently. However by interacting with them using technology, such as social media, the cultural organization can ensure that they will become fans and will learn more about the art and artist.

Methods of Segmentation

Every cultural organization needs to examine their existing audience and also the audience they wish to attract. Most cultural organizations are familiar with using demographic data to segment their audience on the basis of age, gender, income, and ethnicity. While this is an important first step, the cultural organization makes a mistake when it assumes that consumers in these segments, even though they have similar demographic characteristics, will always desire similar benefits. There are other methods that can be used to segment markets and a cultural organization is not restricted to only segmenting their audience by a single method. The other methods most commonly used are geographic, psychographic, benefit, and usage.

Demographic Segmentation

For small cultural organizations, demographic segmentation is usually a good first step in the segmentation process. The demographic factors used can include gender, age, education level, occupation, family status, income, and ethnicity. Marketing departments in for profit companies use income segmentation to determine how consumption decisions are affected by the amount of available income, so they can market to the appropriate income segment. Because the cultural audience is already dominated by high income individuals, cultural organizations face a particular challenge when attempting to reach other income-level market segments. Many consumers outside of the high income segment will have already decided that the price for attending is too great, even though this may not be the case. If the preconception exists that the performance or event will be too expensive, it is necessary for the cultural organization to strongly communicate to lower income market segments that there are opportunities to attend events at reasonable prices.

If the only marketing message on the availability of affordable ticket prices is a small statement at the bottom of a brochure which was designed to attract the high income market segment, it will probably not be read by those who most need to receive the message. To reach those who may believe that the cost to attend is too high, the low cost must be communicated directly to this segment with separate promotion.

Probably the greatest challenge faced by cultural organizations is the need to segment by ethnicity to attract a more diverse audience. Of course, cultural organizations will insist that everyone is welcome, which is true. It is also true that for most cultural organizations, particularly those that present high culture, the audience consists of members of the majority ethnic group. To attract other ethnic segments successfully, the cultural organization must determine how their product can be made more attractive to a specific ethnic population segment by providing the type of experience the group desires.

Rather than just decry the lack of participation, by exploring the needs and desires of the different ethnic communities, cultural organizations can take active steps to ensure that all segments of the community who are interested feel welcome to participate (Radbourne and Fraser 1996). This may mean presenting the cultural product in a different manner or at a different location or time since ethnic culture not only affects the choice of leisure consumption, it also affects the pattern of socialization. For example, in Western culture, many cultural events are considered "adults-only" which will negatively affect the attendance rate for a cultural group where family interaction is highly valued. Members of these groups will prefer events that are planned for the family to attend together.

Another issue for particular ethnic groups is that cultural organizations may be seen as presenting the art of the majority, and perhaps oppressive,

What Do Families Want To Do on Vacation?

Cultural organizations know that families on vacation are looking for activities to fill their time and many of the organizations have responded by targeting tourists. But what special needs does this segment have? The PGVA, a planning and design group for cultural and entertainment destinations, decided to research the question of what families want from a vacation experience. Getting everyone in the family together is the foremost goal with 66 percent stating this is the reason they go on vacation. Therefore, they want a destination or event which will be of interest to both adults and children. People are working hard, and so it is not surprising that the second most important criterion when choosing a destination or event is that it be fun.

If everyone, both young and old, is going to have fun at the same place, a variety of activities are necessary. Variety ranks third on the list of qualities desired. Fourth on the list is an experience that is unique. There is no reason to travel if you are going to engage in the same activities that you would do at home.

Any business targeting tourists can provide these four qualities to a family. However, the fifth most desired quality is to learn something new and that is where a cultural organization has a distinct advantage. A cultural organization needs to provide a variety of family orientated activities that are fun, unique, and also educational. A challenge? Yes. But one for which a cultural organization is uniquely qualified.

PGVA (2012)

ethnic group. Ethnic minority groups may not be interested in applauding art that seems to negate them as individuals. The cultural organization must ensure that their cultural product is also created, and presented by, individuals other than members of the majority culture.

Geographic Segmentation

Geographic segmentation is also an easy way to segment. The cultural organization should determine how far most consumers are willing to travel to attend the venue; this knowledge will determine where and what media to use for promotion. Small cultural organizations may depend on local audiences because they might find it impossible to attract consumers to come from a distance, when there are other, closer cultural organizations that provide the consumer with the same benefits. However, if the cultural product offered is unique and attractive to a specific demographic segment of the market, then carefully targeted communication can bring these customers from other geographic areas.

On the other hand, if the cultural organization is large and well known, geographic barriers may not exist. In fact, the cultural product may be the reason why individuals are travelling to the area. "Superstar"

organizations such as the British Museum and the Metropolitan Opera in New York have local visitors but also attract many international tourists for which they are a "must-see" during their visit (Murphy 1997).

Psychographic Segmentation

While demographic and geographic segmentation are good first steps in analyzing the audience for culture, psychographic segmentation, which focuses on factors such as attitudes, values, and lifestyles, is a more powerful segmentation tool for cultural organizations. When analyzing the current and potential audience, psychographic characteristics may not be as easily discernible as demographic or geographic factors, but they are the factors that actually motivate the consumer to attend a cultural event (Walker-Kuhne 2005). While a consumer's perceptions and beliefs may have been formed by his or her surrounding culture, attendance is also affected by an individual's inborn personality. Participation in most cultural events does require at least some predisposition toward introspection and a desire to be exposed to new ideas.

Psychographic segmentation attempts to understand and group consumers based lifestyle characteristics. For example, a cultural organization may find that their audience divides into lifestyle segments consisting of the young and trendy and the older and conservative.

Most cultural organizations do not have psychographic information on their audiences because it is difficult to obtain and analyze. It is true that these market segments are not immediately apparent, and focus groups and interviews will need to be conducted to discover the psychographic factors that motivate the various groups to attend. However, once this information is obtained, and it is correlated with demographic and geographic factors, it can be used to design a very effective strategy to target the resulting market segments.

Benefit Segmentation

The benefits sought by segment members will vary due to many different factors. The benefits could be as dissimilar as an opportunity to socialize with friends, family time together, or a comforting, familiar cultural experience. For many, a benefit sought is an interactive rather than passive visiting experience (French and Runyard 2011). For this reason benefit segmentation is an easy method for many cultural organizations to segment their current and potential audience.

Usage Rate

The cultural organization also needs to determine how frequently each segment group consumes its product. The young and trendy may be

occasional attendees for some art forms, such as symphonic concerts, and yet may be heavy consumers of modern dance. The usage pattern of the old and conservative may be just the opposite. Young family groups may be heavy users of museums that allow their children to participate in activities, but not serious drama. Once the cultural organization is aware of the attendance frequency, a decision can be made about the amount of resources that should devoted to marketing to each target market segment.

Segmentation Process

Cultural organizations may have been using target marketing for their current audience without even realizing they were doing so. However, in the current competitive environment, cultural organizations who wish to increase attendance must now target new consumer segments. To do so, they must design marketing strategies for each specific market segment they wish to target. Even in profit companies the days of mass marketing are gone. Now, rather than have a single strategy and try to attract everyone, the organization must develop a targeted marketing strategy focused on a particular group.

The first step in the segmentation process is for the cultural organization to determine what segments are in their current audience. Based on this information, it can determine what new or potential segments should be targeted as audience members. The cultural organization then must develop a promotional message that communicates effectively to each targeted segment.

Market segmentation is particularly useful for small cultural organizations. It may seem a betrayal of the organization's mission because it means going after a smaller targeted market segment rather than trying to

Children Love Theatre They Can Control Just Like a Video Game

Children really can control the production of *Escape from Peligro Island* just like their favorite video game by using handheld controllers. The production features characters such as aliens, vampires, and superheroes, all of which are popular with children. The play can have one of 24 different endings because the audience will determine what happens during the production. During the play, the production stops and a question will appear on a video screen at the back of the stage. The audience will then determine the action such as "save the time machine" or "fight the giant squid." The percentages for each response are shown on the screen and the actors then proceed with what the audience chose. Children who play video games will immediately understand the process and enjoy the performance even more because they can make the action happen.

Sydney Opera House (2012)

attract everyone. Unfortunately, cultural organizations must face the fact that it may be an unrealistic expectation that everyone will be interested in their product. As a result, they cannot consider everyone a potential audience member. Besides, small organizations do not have the resources for a large marketing effort, and market segmentation allows them to save time and effort, and perhaps even ensure survival, by concentrating their marketing resources.

Defining the Target Segment

Because there are numerous ways to segment markets, a cultural organization may feel confused when faced with the process of segmenting their current or potential audience. However, the process of analyzing and segmenting will assist the organization in thinking through whom it serves, how it serves them, and whom it wishes to serve in the future.

In traditional marketing theory the process of segmentation is started by first examining either consumers or the product. The company may first decide to analyze the existing consumer marketplace and then develop a product that meets a segment's needs. Or it may start with the existing product and find a market segment that desires the product's benefits.

Cultural organizations could begin by choosing a consumer segment to target and then designing a product to provide the desired benefits to this segment. However, cultural organizations have usually not taken this approach, as they have felt that they should not change their cultural product to meet the desires of the public. Cultural organizations have usually employed the segmentation process to find a consumer segment to which their existing cultural product will appeal.

However, it is possible for a cultural organization first to target a consumer segment and then to design their cultural product in a manner that will appeal to this segment, without compromising its mission. For example, it may present a specialized form of its current art that would still fall in the scope of its mission but also appeal to a new target market segment.

Whichever initial focus cultural organizations take, either product or consumer, they must ensure that the target market segment is distinct enough to qualify as a market segment. For example, a cultural organization may decide to focus on providing the benefits sought by younger consumers, but this segment is too broad to be workable. The segmentation process would be more effective if the cultural organization divided young consumers into sub-groups such as well-educated, upper-middle-class singles and less-educated, lower-middle-class parents. Also, young consumers may be from the dominant ethnic group or from a minority group. The only common characteristic the young share is age and that is not enough to effectively target them as a segment. The benefits they seek will be too diverse for the organization to be able to meet all the needs of all young people.

Creating the Marketing Message

Cultural organizations tend to be insular, perhaps because people working in cultural organizations share a similar vision that is not constrained by the everyday reality in which most people live. Because of this insularity, there is a danger that the organization will become so focused on the importance of the cultural product that it will forget that the product is not a priority for most people. Because the cultural organization believes that everyone should be interested in the product, it can come to believe that everyone is interested in the product. The result is that the organization tries to communicate everything to everyone, rather than communicate a specific message to a specific group.

The cultural organization might broadcast the same marketing message to everyone as if there is only one undifferentiated segment. Or, it might consider each individual entirely unique, which makes it extremely difficult to design a marketing message. Both methods are ineffective, as while all individuals do differ, some also share similar characteristics. By focusing on these similar characteristics, the organization can create a message that will improve the chance of attracting the consumer segment to the product.

The cultural organization can communicate much more effectively if each communication about its product is channeled to a specific market segment. The members of the group may, or may not, share similar demographic characteristics. What is similar is that those belonging to the group all feel a shared need for the specific benefits the cultural product offers. Once an organization has determined the targeted market segment, it can design a marketing message that communicates directly to this segment.

However, after segmenting the audience using one or more of these factors, the cultural organization often makes the mistake of only using this information to modify its marketing message. It may change the type, layout, and copy of a brochure or the media in which it advertises so that it will be more attractive to a new market segment. While this is a valid approach, market segmentation is most useful on a more basic level, i.e., finding the correct match between the cultural product and the audience.

When everyone is constantly bombarded with communication, information, and advertising, it only makes sense for the cultural organization to focus its message on the specific consumer target market that will be most attracted to the product. Once the benefits desired from the product by the target segment have been determined, the organization can then establish a communication style and message attractive to that segment. However, the message must accurately reflect the product. The cultural organization may attract young people to an event using a message that it is an opportunity to socialize with other young people. However, if the young people who then attend do not find the benefit they desire, they

How Do You Make Kids Happy?

All children are unique but they can be segmented by age group. Below are suggestions on how to engage kids of different ages.

Sense and Sensibility (Ages 1–4): For the smallest children, touching various textures keeps them involved. As children become more verbal, story time is of interest.

The DIY Years (Ages 4–7): Children of these years are learning that the real world is just as much fun as fantasy. They can now enjoy thinking about people from other places and times. Interactivity is very important to engage their interest.

Identity Quest (Ages 8–11): Kids of this age group love to ask questions so that they can learn facts that they will later explain to their parents. At this age, boys still want interactive experiences, but they are of less interest to girls.

The Thrill Years (Ages 12–17): Young people now crave challenge, risk, and intensity. They also want authenticity. Historic sites with thrilling tales satisfy both the desire for reality and thrills.

PGVA (2012)

will learn to mistrust the messages from the organization and will not return.

Cultural marketing has been traditionally described as the process of finding an audience for the art. A better description of cultural marketing would be the process of determining what segment of the population will be interested in the product and then determining how to motivate them to attend by providing appropriately packaged arts events communicated with a focused marketing message.

To do this successfully the responsibilities of cultural marketing should be expanded to include the process of segmenting the current and potential audience, using research to determine the needs and desires of each segment, and designing a promotional strategy to motivate the segment members to attend. This research can be as simple as collecting data at the ticket office (Wallace 2010). In addition, the cooperation of the rest of the organization, including the artistic department, is needed if the product is going to be designed to add the segment's desired benefits. The entire organization must contribute to designing an arts event that is packaged with the benefits the consumer segment desires.

Tourists as a Market Segment

Growth in travel opportunities and communication technology has contributed to an increased awareness of global culture. Consumers are now familiar with the art and music of many other countries besides their own. It is natural that they would want to visit cultural organizations to

experience these art forms when they travel. Heritage sites and museums, along with theatres and other performing arts venues, are a significant reason why tourists visit major urban areas (Hughes 1997).

As government funding provided to cultural organizations for operational expenses has decreased, cultural organizations have become increasingly interested in attracting cultural tourists to its venues. Targeting cultural tourists is a means for cultural organizations to earn additional revenue, while still being true to their mission. In addition, the wider community increasingly sees cultural organizations that serve tourists as a source of revenue and employment (Broadway 1997). Government agencies have become aware of the positive effect cultural tourism has on economic growth and are starting to collaborate with cultural and tourism groups to promote it. In fact, besides promotion of the art itself, one of the main rationales for having music festivals or major exhibitions is to attract tourists to visit an area.

Because of the generation of employment and income, businesses used by tourists, cultural tourism may also be supported by the businesses in the community in which the organization is located. Cultural tourism can help the entire community through regeneration of an economically depressed area and, as a result, increase the status of the community. If cultural organizations work together in attracting cultural tourists, they will be seen as others as an integral part of the community.

Rationale for Targeting Tourists

Besides offering an opportunity to increase their audience, a cultural organization should market to tourists for the same reasons they would wish to market to anyone—to expose others to its art form. In addition, the cultural organization provides tourists with a cultural opportunity unavailable to them at home. Tourists feel less of the "class" division that cultural events sometimes manifest. They are more likely to attend a museum or concert as just another event on their itinerary along with a visit to a pub and a movie (Kennedy 2009).

Ideally, the tourist is travelling to gain an understanding of foreign countries and cultures, but, in reality, most tourists are travelling for enjoyment. Therefore, cultural tourists want an experience that is both exciting and memorable so that they can share the experience with friends and family when they return home. Even so, cultural tourists are also interested in education programs that will help them understand what they are experiencing, as long as they are enjoyable. Because tourists often have a crowded itinerary, they will have limited time to spend at each place they visit. The cultural organization faces the additional challenge of providing a worthwhile experience for the tourist in a very short time period.

Tourists often visit cultural organizations out of a feeling of obligation. They know that there are certain sites that must be seen on their trip, so they visit the historic sites, museums, and performances that are listed in their guidebook, discovered online, or that friends or relatives visited on their holidays. For example, when in London, they must visit the British Museum and when in New York, they must visit the Metropolitan Museum of Art. Cultural tourists feel a need to visit these cultural organizations because it is part of the expected holiday experience. If the cultural organization can successfully expose these tourists to new cultural experiences, they will also bring home a new appreciation of culture.

Issues in Targeting Tourists

While the idea of having access to an additional target market segment interested in their art form may be attractive to cultural organizations, the organization must consider carefully whether to promote to tourists (Boniface 1995). If the cultural organization feels that the potential tourist market segment desires benefits that conflict too dramatically with its mission, it might not wish to market to tourists. For example, if the cultural organization's primary goal is to educate visitors on a rather obscure and difficult art form, while the tourist's primary goal is enjoying the sun and surf, it may be too difficult to create an experience which is satisfactory to the tourist while also meeting the mission of the organization.

Another reason for not promoting to the tourist market is if the cultural experience is too specific to the country in which it is located. In this case, it may not be understandable or attractive to tourists because it is too

Tourists Will Pay!

The question of whether museums should charge is influenced by their location. Museums in cities tend to charge while those in small towns tend not to. Nearly half of the museums in the United States are free. However, many of these may still add a charge for a special exhibition. These free museums made less than 1 percent of their operating budget from ticket revenue. On the other hand, the museums that do charge an entrance fee earned 9.5 percent of their total budget from ticket sales. So, why doesn't everyone charge? It may be that the museums that do charge admission do so because they can. In larger cities there is more demand for museum visits, especially from tourists. In fact, the Museum of Modern Art (MoMA) in New York City earned almost 20 percent of its $100 million budget through ticket sales. On the other hand, the Los Angeles County Museum of Art, located where tourists come for the beach and Hollywood, only received 5 percent of its budget through ticket sales.

Stoilas and Burns (2011)

culturally distinctive. A third negative consideration is that in meeting the needs of tourists, the organization may not be able to meet its responsibilities to the established local market segments it already serves.

Segmenting the Cultural Tourist Market

Of course, "cultural tourists" is too broad a category to easily target. The cultural tourist market needs to be further segmented into the demographic and psychographic groups that are most likely to be attracted to cultural activities.

Demographic segments of the tourist market that are attracted to culture include older visitors. These older tourists are naturally inclined toward culture because of their socialization experiences and probably also patronize cultural organizations when at home. Another group interested in cultural organizations is young tourists. They may consider attending a cultural event while travelling in another country as an adventure, while they may not attend the same event at home where it would be considered less exciting. For this reason, cultural tourism is an excellent means of exposing young people to cultural experiences in which they might not otherwise participate.

The tourist market can also be further segmented by the benefits sought by the tourists (Boniface 1995). Some cultural tourists seek escapism. They want an experience that is different from what they experience in daily life. Other tourists want their visit to a cultural organization to provide them with a feeling of status. They want a unique experience unobtainable elsewhere of which they can boast when they have returned home.

There are also smaller target markets of specialty cultural tourists. Some specialty cultural tourists travel with the purpose of meeting religious or spiritual needs. They want to connect with their values by visiting sites which may be as varied as Westminster Abbey and Stonehenge. For tourists with no spiritual inclinations visiting temples or churches may provide them with an opportunity to encounter the values of faith that are important to many people (Stausberg 2011). Other specialty cultural tourists travel with the specific purpose of doing research or receiving education. For these tourists, who are often students, professionals, or hobbyists, knowledge is the most important benefit derived from cultural tourism.

Tourists and the Marketing Message

Some of the benefits communicated to the tourist segment in the marketing message will be the same as the benefits communicated to other segments. However, cultural tourists do have some additional needs for which the cultural organization must provide. Because they are unfamiliar with

the country's culture, and not just the cultural product, they need to be provided with even more information about the history and meaning of the art form. Cultural tourists will not bring the same assumptions and knowledge as the local residents and need additional information so that they can understand and enjoy what they experience.

Because they are visitors, cultural organizations should ensure that tourists are especially made to feel welcome at the venue. The tourist segment gives cultural organizations an excellent means to attract people to a new experience with which that they may feel uncomfortable at home. Tourists might not visit a cultural organization at home because they feel they don't belong, but while travelling, they may be ready to take the risk.

Tourists who are travelling a long distance to visit the cultural organization have a need for the experience to be as they expected it to be. The cultural organization must provide a certain amount of dependability in the cultural product presented to tourists. The experience needs be consistent over time so that tourists will have a similar experience to that of their friends, who may have visited last year. This does not mean that the product must be absolutely the same, but that it needs to be of the type expected.

Because the cultural tourist is unfamiliar with the local area, it is also very important that all marketing and media messages contain sufficient information on location, including information on how to travel to the site using public transportation. If the organization is located in an out-of-the-way area, cultural tourists also need to be provided with information that addresses any safety concerns they may have. And, because they are tourists and want to have fun, they need information on opportunities for nearby shopping and eating.

Summary

Cultural organizations can use segmentation to increase the size of their audience. Or, it can be used to find new segments to attract. Cultural organizations can segment their audience into groups differentiated by demographic differences, such as age, marital status, income, or ethnic background. They can also use geographic segmentation based on where the current or potential audience member lives. Demographic and geographic segmentation are easily understood. Psychographic traits, such as attitudes, values, and lifestyles, are also a useful method of segmenting an audience. An additional means of segmentation is by benefits; the audience is grouped by the benefits desired from the product. Usage rate divides the audience based on frequency of attendance. It is important for the cultural organization to understand demographic, geographic, psychographic, benefit, and usage segmentation along with the unique needs of the cultural tourist segment.

References

Arts Council of England. 2011. *Arts Audiences Insights 2011.* March 16. http://www.artscouncil.org.uk/publication_archive/arts-audiences-insight-2011/.

Bauman, Chad M. 2011. "Who are Your Best Customers (and why many don't know)?" *Arts Marketing.* December 15.

Boniface, Patricia. 1995. *Managing Quality Cultural Tourism.* London: Routledge.

Broadway, Michael J. 1997. "Urban Tourism Development in the Modern Canadian City: A Review." *Quality Management in Urban Tourism.* Hoboken, New Jersey: John Wiley & Sons.

French, Ylva, and Sue Runyard. 2011. *Marketing and Public Relations for Museums, Galleries and Cultural Attractions.* London: Rutledge.

Hughes, H. L. 1997. "Urban Tourism and the Performing Arts." *Quality Management in Urban Tourism.* Hoboken, New Jersey: John Wiley & Sons.

Kanter, Beth, and Allison H. Fine. 2010. *The Networked Nonprofit: Connecting with Social Media to Drive Change.* San Francisco: Jossey-Bass.

Kennedy, Dennis. 2009. *The Spectator and the Spectacle: Audiences in Modernity and Postmodernity.* Cambridge: Cambridge University Press.

Murphy, Peter E. 1997. *Quality Management in Urban Tourism.* Hoboken, New Jersey: John Wiley & Sons.

PGVA. 2012. "The Art of the Family Vacation: What They Want, How They Plan, Why They Go." *Destinology.* July.

Radbourne, Jennifer, and Fraser, Margaret 1996. *Arts Management: A Practical Guide.* Sydney: Allen and Unwin.

Stausberg, Michael. 2011. *Religion and Tourism: Crossroads, Destinations and Encounters.* London: Routledge.

Stoilas, Helen, and Charlotte Burns. 2011. "To Charge or not to Charge." *Museums.* September

Sydney Opera House. 2012. "Escape from Peligro Island." March 8. http://www.sydneyoperahouse.com/About/12EventMediaRelease_EscapeFromPeligroIsland.aspx.

Verdino, Greg. 2010. *Micromarketing: Get Big Results by Thinking and Acting Small.* New York: McGraw Hill.

Walker-Kuhne, Donna. 2005. *Invitation to the Party: Building Bridges to the Arts, Culture and Community.* New York: Theatre Communications Group.

Wallace, Margot A. 2010. *Consumer Research for Museum Marketers: Audience Insights Money Can't Buy.* Lanham, Maryland: AltaMira Press.

7 Researching the Consumer

The marketing concept states that the cultural organization must listen to the wants and needs of the consumer. The only means to discover these wants and needs is through conducting research. Most cultural organizations already conduct research to find who and how many are attending by counting attendance. Unfortunately, they are less likely to conduct research on why their audience attends and what benefits they are seeking. This may be because managers of cultural organizations often assume that the audience is motivated by the same reasons they attend. This is highly unlikely since individuals who work in cultural organizations have an enthusiasm for the art form that goes far beyond what most other people feel. Because of this enthusiasm, the cultural organization may object to conducting marketing research because it believes it already knows what its audience wants and sees research as a waste of time and money.

In reality it is vital for the cultural organization to know what motivates its audience to attend. Research does not need to be expensive, but it does take effort. First, the organization needs to understand the types and methods of research. It needs to learn the research process and the use of the different research tools. With this knowledge, research can be used successfully by even small cultural organizations on limited budgets.

Types of Research

Besides basic demographic audience research that tells the organization who is attending, there are other types of research the organization should consider conducting. Competitor research is rarely conducted but can provide valuable information on how an organization can improve. Cultural organizations should analyze their audience's perception of competitors and also visit the competitors themselves. Such research helps the organization to determine if it should attempt to add any of the services, programs, or amenities provided by organizations producing competing products.

Motivation research examines the consumers' reasons for attendance and is critical to increasing the depth and broadening the breadth of the

Types and Purpose of Research

Types	Purpose	Research Question
Audience	Composition of current audience	Who is in our audience?
Competitor	Audience perception of competition	Where else do they attend?
Motivation	Reasons for attendance	Why do they attend?
Satisfaction	Extent event meets expectations	What are we doing wrong?
Product	Improvement of product	Does our product provide the desired benefits?
Promotion	Effectiveness of different messages and media	Where and how do they hear about us?
Pricing	Choosing pricing levels	What are they willing to pay?
Policy	Attitudes toward the arts	Who out there supports us?

audience. Satisfaction research is conducted after the art product has been consumed to examine how the experience compares with customer expectations. Information gathered from both motivation and satisfaction research will help the cultural organization to learn if, and how, it can better meet the expectations of customers. The organization also needs to focus internally by routinely examining its product to determine if it can be improved.

Another type of research that is vital is promotion research. This research seeks to determine if the message the cultural organization is communicating is reaching its target audience and whether the message is effectively motivating attendance by communicating the desired benefits. Pricing research is conducted to determine if the audience perceives the price as appropriate and competitive

Because cultural organizations are dependent on government funders for support, they are vulnerable to changes in government policies in the level of support for the arts. However, since many cultural organizations

What Is Research Good For?

Here are some ideas:
- To learn more about the organization, its competition, environment, and audience.
- To learn why recent successes and failures happened.
- To reduce risk and waste when decisions have to be made.
- To better position the organization by learning about changes in demand and preference.

Chen-Courtin (1998)

are also now dependent on corporate support, they need to be aware of changes in corporate giving patterns as well. For these reasons, cultural organizations need to conduct policy research to keep abreast of attitudes toward supporting culture.

Conducting Marketing Research

Too often the research done by cultural organizations is conducted without proper planning. A well-designed research process consists of six steps.

The Research Process

1. Designing the research question
 What do we want to know?
2. Deciding on the source of information
 Who has the information we need?
3. Choosing the research method
 Which type and method will we use?
4. Creating the research design
 Where, when, and how will the research be done?
5. Conducting the research
 How long will it take?
6. Analyzing and reporting the findings
 What does it mean?

Only after the first step, designing the research question, should the organization proceed with its research. Because cultural organizations are in a hurry for answers, the temptation is to start the research before determining what they really want to know. As a result, they may ask too many questions and try to obtain too much information from too many sources. To be effective, a research study must be both well designed and narrowly focused. If the research question is designed too broadly, too much information will be obtained. The mass of resulting data will be difficult to analyze and, therefore, of little use to the organization. Even worse, if the wrong question is asked, the research effort will be wasted.

Likewise, the cultural organization needs to put considerable thought into studying the sources from where the information can be obtained. The different sources for data are categorized as secondary or desk—data that already exists—and primary data that the organization will collect itself.

Secondary Research

Secondary data is information from research that has already been conducted. Secondary research should be conducted first to find any already

What To Do During Intermission? Research!

Why not conduct observational research every time you have an arts event? Take ten minutes to observe your audience so that you can answer these questions:

- What do you see? Singles—Families—Couples—Groups?
- Are they reading your program?
- Are they noticing the art work on the walls?
- Are they discussing the art or other subjects?
- Are they able to get to the bar?
- Is there a line at the toilet?

If you can, talk with the audience and conduct informal interviews. Make a point of asking different types of people:

- How did you hear about this event?
- Why did you decide to come today?
- How do you like this show compared with others?
- Where else do you attend?

Watch and ask at a number of events and on different days/nights and see if the answers vary.

Keep this up and you soon will have your own internal database about your audience!

ArtsMarketing (2004)

existing sources of information. Sources of secondary data include internal data that the organization already possesses, perhaps in a customer database. Even just analyzing existing ticket sales data can be helpful in discovering events or days and times that attract a larger audience than others.

Other sources of information include previously conducted and published surveys that can be obtained through the government, arts council offices, or public libraries. Most of this information is now available online. If there are sufficient funds available, information can be purchased from commercial research firms whose business is to gather data.

It may be that the question that needs to be answered has already been asked. This is particularly true for policy issues. Data on attendance demographics for art forms is also readily available. Even if the information is not specific to the cultural organization, it can be used as a comparison.

Primary Research

Primary research involves generation and collection of quantitative or qualitative data from individuals, usually through surveys, in focus groups, or using other methods. However, there are others methods of collecting primary data besides directly asking consumers. Simply observing

the audience to see if, and how, they are enjoying the product and any difficulties they may be having while at the venue can provide considerable data that will help the organization to improve both its product and service. Indeed, if the organization wishes to change the product or service in an effort to improve the benefits, it may wish to experiment first by trying the change on a small scale and observing the effect it has on customers.

The next step is to choose a research method. Understanding how the cultural organization plans to use the information will help them to design the study appropriately. If the organization wishes to impress a government office with the size and diversity of its audience, then a simple demographic survey would be appropriate. If, on the other hand, the organization wishes to discover why attendance is falling, they will need in-depth information that cannot be obtained through a simple survey, but will require focus groups or interviews.

After choosing the research method, the cultural organization must plan the research design. This will include the details of when the research will be conducted, where, and by whom. The more detailed the planning, the more smoothly the research will proceed. The planning should include details from how many copies of the survey form are needed to whom will be responsible for ensuring that the focus group participants arrive.

Finally the cultural organization is ready to conduct the research. Once done, the final tasks are to analyze the data and report the results. Analyzing requires going over the collected responses to see common themes, patterns, and connections.

The Research Question

It may seem easy at first but deciding exactly what the organization needs to know can be difficult and time consuming (Richards and Morse 2013).

Where You Live Does Determine What You Do

Since 88 percent of all performing arts organizations are located in urban areas, it is not surprising to find that urbanites are more likely to attend these venues. People who live in a major urban area are even more likely to attend because the ten largest metropolitan areas are home to 30 percent of the nonprofit arts organizations. Does this mean that people living in small towns and rural areas do not have access to the arts?

No, it means that they experience music, theatre, and dance at different types of venues. Rural residents are more likely to enjoy these art forms at churches or schools. Rural residents are even more likely to engage in creative activities. For example, they are more likely to sing in a choir and engage in the fiber arts such as quilting or crocheting.

National Endowment for the Arts (2010)

However, unless this question is designed correctly, the rest of the research might be a wasted effort. When designing the research question the following issues should be kept in mind:

- What do we need to know that we don't know now? Or, what needs to be asked?
- What methods are appropriate for the study? Or, how should it be asked?
- Where and how can the information be obtained? Or, can it be asked?

The first question most cultural organizations want answered is "who are our current audience members." They may also want to know why they come and where else they attend. The answers to these questions tell the organization what benefits motivate their current audience. They also tell them what competitors are attracting their audience so they can assess the benefits their competitors provide.

While these questions are certainly valid and provide important information, they do not tell the cultural organization how to attract new groups of consumers who are not attending. Therefore, the organization also needs to research the question of what would bring in new consumers who do not attend their organization and also, if possible, customers of its competitors. Because these consumers are not currently members of the audience, they must first be found before they can be researched. This, of course, is much more difficult to accomplish then researching the current audience, but it can be done. Professional assistance from a marketing researcher may be needed, but small-scale studies can also be conducted, even by organizations not sufficiently funded to hire professional researchers. To do so the cultural organization needs to determine where these

Who Should Get the Grant? Why Not Ask the Public

A program called Connect10 asked cultural and historic venues for ideas for programs. The venues needed to come up with original programing that fit one of ten artists and also the organization's mission. The rationale for the program was to allow venues that could not afford world class artists to have access to this level of talent and for local audiences to experience creative work that was usually beyond the reach of the venue. Of the two hundred ideas submitted, twenty-eight venues were selected. These were put to a vote by the public.

Twenty-one thousand votes were submitted. The winning ideas included a fluorescent installation of 55,000 tons of green luminous jelly, a taxidermy demonstration, and an illustrated lecture by a photographer, thereby demonstrating the wide range of interests of the British public.

Arts Council UK (2012)

non-attenders associate and go to this location to conduct the research. Such locations might include clubs/associations, community groups, or universities.

Classifications of Research

Once the research question has been decided upon, the organization must choose a method. To do so it first must decide what type of research to conduct based on the research question. The cultural organization may choose either descriptive or exploratory research. This decision will help to determine the correct method.

Descriptive Studies

The cultural organization will perform a descriptive study when they need to obtain specific data on their audience. A descriptive study is used when facts are needed, and the method used to conduct descriptive studies is almost always surveys. These surveys are called quantitative studies because they collect statistical data. Quantitative research consists almost entirely of surveys where respondents answer predetermined questions with answers such as "Yes" or "No" or "Frequently" or "Never." Quantitative studies can give answers such as 37 percent of the audience is over the age of fifty-five or 42 percent or the audience attends a specific venue on average twice a year. The advantage of a quantitative study is that if the number of people surveyed, the sample, is large enough compared to the total group, or population under study, the answer can even be said to be proved.

The difficulty cultural organizations have in conducting surveys is that they can be expensive and time-consuming to undertake. If the organization wants to "prove" something, such as the percentage of older audience members, they must survey a sufficiently large number of individuals to ensure that the sample is statistically valid, which can be costly in both financial and staff resources.

Despite this difficulty, many cultural organizations have relied heavily on surveys as their only means of market research. This is unfortunate because the type of information that surveys can provide is limited. There is also a growing problem in obtaining responses to the traditional survey. Because everyone is so pressed for time, it is now difficult to get people to respond to a survey in person, over the phone, by mail, or even by email. If surveys are left on seats or at the entry or exit point of the venue, few audience members will bother to fill them out. Surveys conducted over the Internet are limited to obtaining responses from only those people who are online, which can bias the response.

For all surveys, the people who are most likely to respond are those individuals who are most motivated to give their opinion because they are

How Much Participation Can They Stand?

Everyone talks about participation and that it is what consumers want. But what do we mean by participation? Using the example of a mystery murder, theatre production can give other cultural organizations a model to think about for their own events. Participation at the dinner theatre productions can be at five levels. Attenders can:

1. Simply mingle while talking with each other or the actors.
2. Question the actors.
3. Participate in dances or sing.
4. Have a bit part in the play.
5. Be a cast member.

The organization wanted to know the level of participation with which their customers were comfortable. Only 18 percent wanted to limit their interaction to only mingling while 52 percent wanted to question the actors. A further 20 percent wanted to get up on stage. The lesson is that the cultural organization should design events that allow for varying degrees of involvement.

Murphy (2012)

already emotionally involved with the organization. What is particularly needed is the opinions of those who are not regular attenders, and these individuals are the least likely to complete a survey form.

Exploratory Studies

The cultural organization should conduct an exploratory study when the research question deals with feelings, values, or motivation. Such exploratory research can be useful when there isn't a specific problem to investigate and the organization is simply trying to determine if there are any trends or changes in consumer behavior of which they should be aware.

This type of research is qualitative. It differs from quantitative in that it is designed to let the people being studied provide their own answers. The questions, rather than asking for facts, focus on needs, desires, preferences, and values. Because so many different answers may result, statistics cannot be generated. However, qualitative studies, if designed with sufficient thought as to what information is wanted and how it is to be obtained, can provide invaluable information to the cultural organization. A qualitative study may be very involved, time consuming and difficult, or it can be conducted on a small scale. Either way, the information received will be rich in details and insights that will help the organization adapt their product to meet the desires of the audience.

As noted, it is even more difficult to obtain information from those who do not attend regularly or at all. Qualitative research is helpful in these cases. It does not treat the audience as an undifferentiated mass from

Research Purpose and Use

Study	Example of Use	Methods
Descriptive: Use when details and numbers are needed	Research on audience composition or attendance frequency	Survey Intercept survey
Exploratory: Use when seeking insights on motivation/behavior	Research on reasons for attendance or attitude toward the organization	Focus group Projective Techniques Observation

which a statistically valid sample is needed, but targets the specific groups from which the cultural organization needs to obtain information.

When conducting qualitative research, the emphasis is not on the size of the sample, but on the quality of the question design and the analysis of the resulting information. For example, if asked why they attend, even if each individual has a unique answer, common themes will almost always appear. By analyzing the information, the responses can be grouped so that the themes can be discovered and understood. An advantage of qualitative research is that it can also be approached in low-cost ways that are available to smaller cultural organizations.

Research Methods

Once the research question has been decided upon and the research type is chosen, the next step is to choose a research method. Methods include the survey used in quantitative descriptive research. There are more research methods available for conducting exploratory research. These are usually qualitative methods and include focus groups, projective techniques, and observation.

Traditional Survey

Designing a traditional survey is a three-step process. The cultural organization must first decide upon what it wants to know. Then, it must decide what types of questions they want to ask and, finally, how the information will be analyzed. Because it is difficult to motivate people to complete survey forms, it is important that the survey be short enough to encourage completion. Therefore, if possible, when deciding what to ask, the questions should be kept to a single topic. Of course, most surveys also ask for demographic information such as age, educational level, occupation, and/ or income. However, the main questions should only pertain to one topic such as what type of programming is preferred or frequency of attendance. It is very tempting for the organization to include a laundry list of questions, but unless the survey participant is very motivated to respond, the survey will probably not be completed.

Sample of Traditional Survey Question

1. Are any of the statements below reasons why you attended the Museum's First Saturday event? (Please check as many as apply)
 ___ I feel at ease with the other people here.
 ___ I came to hear the gospel choir.
 ___ I came to eat and drink.
 ___ I might meet new friends here.
 ___ I want to learn more about art.
 ___ My friends or family wanted me to come.
 ___ I feel that the total cost including food/travel is reasonable.
 ___ I came for the dancing.

Another means of increasing the likelihood of the survey being completed is by offering incentives. The incentive might be the opportunity to enter a contest, a small gift or perhaps a seating "upgrade" to a more expensive seat. In addition, a visually interesting, well-designed survey will receive more responses than a visually cluttered survey.

Once the questions are written, the next step is to design the answers. Survey questions should be designed so that the most of the possible answers are included in the responses. This is easy with questions that can be answered with responses such as Yes/No or Frequently/Never. If asking questions on attitudes, it becomes more difficult. A question such as "what was your motivation for attendance" could be followed by suggested answers, but this results in the respondent being limited to these choices. This is why surveys are not the best choice for exploratory qualitative research on motivation.

After the questions and answers have been designed, they need to be tested on a few sample participants to make sure they are interpreting the questions correctly. When designing a survey it is important that the questions be worded in the everyday language that people use. The only way this can be accomplished is by testing the survey to determine whether the answers are understood correctly. If a particular group is targeted that might not speak the language of the survey as their native tongue, testing the survey is even more important. The survey may also be offered in more than one language.

The final step is to decide how the data will be tabulated. For a large research study it may be necessary to have extra assistance to enter the responses into a computer database. For a small survey with few participants, a low-tech counting of responses will suffice. The responses for online surveys are tabulated automatically.

Online Survey

There are a number of reasons for the increasingly popularity of putting survey forms online using software tools. One is the difficulty in motivating individuals to participate in traditional survey research. An online form can be completed at the time and place that is convenient for the participant, unlike a phone or personal survey. In addition the completed form is automatically returned, unlike a mail survey. Online administration can be done via email, Internet/intranet, or mobile phone. The criteria for deciding on an online format include features about the population sampled and the organization conducting the survey (Ritter 2012). If the geographic reach of the population being surveyed is widely dispersed, online works best. However, if the population does not have access to technology, other methods must be used. It is also necessary for the organization to have personnel who understand the software.

In addition, there are design advantages in using an electronic form. With an electronic form there is less concern to keep the questionnaire to as few pages as possible. The participant only sees one or two questions at a time and, therefore, will not be intimated by the length. The form can be laid out so that it is easy to read with a larger font size and more white space.

Tabulating responses when conducting online surveys is not needed because the results from an electronic form are calculated automatically without data entry. In addition, the routing of questions can be handled automatically. The next question that needs to be answered will appear on the screen based on the answer to the previous question. On an electronic survey form, when a participant responds to a question on how they travel to the venue with the answer "by car," for example, the next question automatically asked will be about the difficulty of parking. If the response to the question is not "by car," the next survey question will not ask about parking.

Another advantage in laying out an electronic survey form is the ability to use drop down boxes for answers to questions. In written surveys, the researcher faces the temptation of limiting the number of responses provided to any one question so that the survey form does not become too lengthy. Using drop down boxes, where participants use their cursors to pull up a menu of answers and then make their choice, solves this problem.

Survey questions often ask participants to rank choices of products or desired benefits. In a paper survey, the choices are ranked in the same order. There may be a bias toward the early responses as research subjects may find a likely answer and stop before they read the complete list. With an online survey this order can be randomly generated so as to eliminate this bias.

If They Can See You Online, Will They Still Attend?

Everyone knows that you don't have to be physically present to enjoy the arts. Media technology has opened up the opportunity to visit museums, see dance performances, and hear concerts from the convenience of your TV, computer, tablet, or mobile phone. Does this mean that people will no longer be interested in attending? No, in fact, it may be the opposite. People are more likely to attend if they also experience the arts online. How many are experiencing the arts electronically? Over half of Americans did so over a one year period, with 37 percent of these engaging with benchmark art activities. What did they do?

- Viewed programs about art
- Used the Internet to view visual art
- Listened to recorded music
- Watched dance performances

What should be of interest to arts organizations is that electronic engagement does not replace attendance. In fact, people who participated through media attended twice as many events are people who did not participate through media so don't worry. Engaging via media encourages attendance.

National Endowment for the Arts (2009)

Intercept Survey

Traditional surveys are usually composed of questions that can be answered by only a limited amount of responses. This is done so that the answers can be counted and expressed as percentages and statistics. Surveys can also be designed that ask open-ended questions that allow respondents to provide an answer in their own words. These surveys are more time consuming for the participant to complete. Therefore, if this type of survey is put into the mail or left on a seat it usually will get a low response rate. However, a survey with open-ended questions can be used if it is conducted by asking each individual participant to participate and filling out the survey form while they respond. Because this will limit the amount of completed surveys, it should only be used when targeting a specific issue on which more information is needed. Another advantage of intercept surveys is that information can be obtained from a specific group who might usually not respond.

An intercept survey might be conducted during intermission when audience members, perhaps selected on the basis of some demographic trait such as age or ethnic group, are asked to participate. After explaining the purpose of the study and its importance, the survey taker gives the survey to the participant on a clip board. This allows the participant to take the survey right where they are and also allows survey taker to keep

Sample of Intercept Survey with Open-ended Questions

We hoped you enjoyed today's visit to the craft fair. Would you mind answering three simple questions?

What did you enjoy most about today's event? _____

What did you enjoy least? _____

What should we do differently at next year's event? _____

track of their progress. Or, the survey taker may fill in the responses for the participant.

This type of survey will not allow the organization to "prove" anything. However the advantage of this type of surveying is that it can target a specific group and receive answers that will not be guided by any predetermined answers.

Focus Group

A focus group is the process of bringing together a group of individuals who are then encouraged to share their opinions and concerns. The advantage of a focus group over a survey is that the focus group can obtain more in-depth information by exploring an individual's first response with additional follow-up questions. Often when first asked a question, people will respond with what they believe to be the correct, or appropriate, answer. Also, most people want to be polite by answering in the affirmative and with positive praise whenever possible. By putting people together in a focus group, they can be encouraged to respond to each other's comments and go beyond their first response.

Focus groups can also be used by small cultural organizations. Even if they cannot afford a focus group planned and conducted by a professional researcher, a small cultural organization will still find value in asking a few of its customers to participate in an informal focus group. The person moderating the focus group does not need to be a professional market researcher, but does need basic skills in listening and human relations. Often graduate students can be used for this purpose. The role of the moderator is to be noncommittal and objective and to listen and record what the participants say. What is critical is that the moderator should help to guide the conversation by keeping the comments of the participants on the subject while not guiding the opinions expressed.

Small cultural organizations can use focus groups to gather information on subjects such as proposed future programming of cultural events. During the group session, programming ideas can be described and the participants' responses recorded. This information can then be used as one factor in the programming decision-making process. Other purposes for

You Call This Fun?

Little research has been done on what benefits young people derive from the experience of attending a classical music concert so an inexpensive study was designed to learn the preferences of young people. Groups of students who had never attended a classical concert were taken to a concert and then a focus group was held to explore their opinions and reactions.

Each group of five to seven students attended a different type of concert including a traditional concert with music by Wagner, Dvorák, and Sibelius, a "pops" classical concert and a concert featuring new compositions by Michael Nyman

Focus groups held prior to attending the concert concentrated on determining the students' preconceptions of classical music, classical music patrons and the experience of attending a concert. After the concert, the students were asked what they liked best and least about the concert and how they felt the concert experience could be improved. The focus groups were planned to be as informal as possible. Besides open-ended questions and discussion, projective techniques were used to obtain information, including asking the students to write advertisements for a classical music concert and asking them to complete cartoons featuring typical classical music patrons.

The results? They liked the music but recommended:

- More comfortable seats
- Better food choices
- Free programs
- More visual stimulation in the hall
- Friendly looking musicians

Perhaps the musicians didn't know that their looks of concentration were being interpreted as unfriendly. Maybe next time a smile and a wave?

Kolb (1999)

focus groups might include exploring issues such as food choice and quality, customer service, and additional amenities to be offered to customers.

Focus groups can also be used to learn how to attract non-attenders. If the organization has a new market segment it wishes to target, it can conduct a focus group to determine what benefits they desire. This may be done by finding participants from an organization to which this segment already belongs, such as a university, social club, or civic organization.

Projective Techniques

Projective techniques can be used to encourage communication in interviews, focus groups or used on their own. These are techniques that elicit information in other ways then requiring verbal answers. The idea is borrowed from psychology but is gaining increased use in marketing. Some simple techniques include word association, sentence completion, and

cartoon tests. These are creative tools that people in cultural organizations should enjoy using.

Word association is simply asking for the participant's first response to a name, photo, or event. The idea is to get emotional responses, rather than intellectual. Word association can be used in focus groups or on surveys using an open-ended question.

Another technique is sentence or story completion. This technique allows the participants to frame an experience in their own words. One task might be to ask the participants to write an ad for the organization that would appeal to them and their friends. Or they might be asked to construct what they consider to be an ideal performance program. If these ideas are too creative for the audience, they can be given sentences to complete such as:

- The Starving Artist Galleries is …
- The people who visit the gallery are …
- The Starving Artist Galleries should …

Cartoons can also be used. The cartoon set usually consists of two characters with balloons over their heads similar to comic books. One character might be saying, "Hi Alan, I was thinking of visiting the Starving Artists Gallery. Want to go?" The survey participant than puts their own answer into the empty student bubble.

Observation

Another inexpensive research method that can be used by small cultural organizations is observation. If the cultural organization wants to know if its customer service desk is being used, it can watch to see who approaches and who does not. Or, a museum can observe the actions of specific groups of patrons, such as families or single visitors, to help the organization to determine which areas of the venue they most use, the length of the visit, and what exhibits attract the most attention. This method will often give more accurate information than surveying, as most people do not keep track of how they use their visit (Wallace 2010).

Additional Research Methods

Method	Description of Use
Traditional Survey	Collect quantitative data
Intercept Survey	Collect answers to short open ended questions
Focus Group	Group dynamics to draw out subjects
Projective Techniques	Creative techniques to get emotional responses
Observation	Watching people's behavior and actions

What Do You Look Like to a Stranger?

Here is the experience of a first time visit to the Kirov Ballet at Covent Garden by someone who usually attends rock concerts:

"The Opera House itself, meanwhile, is a sumptuous edifice. And it should be, given the quite unbelievable generosity of thousands of ordinary Lottery players who wouldn't normally go to the opera or the ballet—the Great Untutu-ed (I include myself). It all makes a very pleasant change, however, from the squalid basements ankle-deep in drink and worse where rock is played.

There are millions of ladies toilets too. This is because there are millions of ladies. Perhaps the Saturday matinee audience weights the male-female ratio, unduly, but going to the ballet seems akin to going to the changing rooms of a department store: the men trail stoically in the wake of great gangs of chirruping women. All my previous experience of audiences suggests that vast swaths of humans shout and smell like spilled beer. Here, there's a faint miasma of rose petal. Can they smell my fear?

I'm on my own, but happily, there are free copies of the *Financial Times* available in the foyer to hide in. Free things are always good—the kind of people the Opera House wants to attract nowadays really like free things. But free FT's are evidence of this august institution's dilemma; trying to convince ordinary folk the Opera isn't all that posh, while convincing the posh that it is."

Empire (2003)

Competitor Research

Cultural organizations often overlook research on competitors and competing products, which is often referred to as benchmarking. While a focus on improving their own product is important, cultural organizations should also keep track of what other organizations are offering to consumers. The organizations benchmarked should include both other cultural organizations and entertainment businesses. This research is crucial, as it is difficult to compete without knowing what competitors are offering to consumers.

The cultural organization should use competitor research to discover how other organizations are meeting the needs of their consumers. The study should include an analysis of the competitors' product characteristics, strategy, and organizational strengths and weaknesses.

The competitor research should be conducted on organizations providing the appropriate competing products. For example, theatres offering contemporary plays should be benchmarked against other theatres offering contemporary plays. In addition, the benchmarking may also be done with a related, but not similar, type of product such as benchmarking contemporary plays with all other plays produced at nonprofit theatres.

The competing product may also be of a related but different medium such as benchmarking a theatre with a cinema. The benchmarking can

also be done on organizations offering entirely different products that provide similar benefits, such as benchmarking restaurants, sporting events, or other leisure activities. The cultural organization should not make the mistake of focusing too narrowly by researching only similar cultural products.

Researching Competitor Product Benefits

When performing competitive research, the cultural organization should carefully research what features, and resulting benefits, the competitor's product offers to consumers. The purpose of the competitor research is to determine what attracts the competing organization's audience. Of course, the audience is attracted by the cultural product, but it is also attracted by other benefits such as the quality of service, ambience, ease of ticket purchase, or low cost. Once the cultural organization knows what features attract the consumer to its competitor, it can decide if these features can be added to their own product. This research can be done by interviewing managers of the competing organization, by attending the venue as consumers, or by interviewing the competing organization's audience.

The cultural organization should also analyze the strengths and weaknesses of its competitors. If the cultural organization is a theatre that targets families with children, it should examine the strengths and weaknesses not only of other theatres, but also of other competing leisure providers, such as a local amusement park, in meeting the needs of families. If the cultural organization feels that one of the benefits that families seek is

First the Good News, Oh, Wait … It's All Bad News

The National Endowment for the Arts in the United States has been tracking attendance at arts events since 1982. From 1982 attendance at cultural events has declined in all areas. Attendance at jazz concerts declined 1.8 percent, while attendance at classical music declined 3.7 percent. Opera has suffered the least decline of only .9 percent, but this was starting with a very small base attendance of only 3 percent. Attendance at musical plays has declined 1.9 percent, while non-musical play attendance has dropped 1.6 percent. Ballet is down 1.3 percent. Other types of arts activities have also suffered declines. Attendance at arts and craft fairs has shrunk 14.5 percent while visits to parks and historic sites have declined 12.1 percent. But wait! There is good news. Americans visited museums at a rate of 22.1 percent in 1982 and in 2008 the rate was 22.7 for a .6 percent gain!

Who attended less? The young, the old, and the middle aged. Who else? The well-educated and the less well educated. Those with higher incomes and those with lower incomes also attended less. Denying realty doesn't change the fact that just about everybody is attending less.

National Endowment for the Arts (2009)

educational opportunity, then the lack of educational opportunities at the amusement park can be exploited. The theatre should then market to families that it provides a cultural experience that is both fun and educational.

If cultural organizations discover through competitor research that they have a strength that profit competitors do not have, such as educational content, they should not assume that this advantage will continue to exist. It is important that the cultural organization analyze any future trends that may change the competitor's strategy. As mentioned above, profit organizations are very good at looking for market opportunities. If they discover that consumers want benefits that are provided by cultural organizations, they will also attempt to provide them.

Summary

When most people think of research they immediately think of writing a survey. However, the first issue when considering conducting research is what question needs to be answered. The issues that the organization may need to learn more about include the customers, product, pricing, and promotion. The organization may find helpful secondary data from previously conducted research. Although more often, the organization will need to conduct primary research. The organization then needs to decide if it is going to do descriptive or exploratory research. Descriptive research uses a survey while exploratory may use focus groups, projective techniques or observation. It is also critical for the cultural organization to routinely research their competitors.

References

Arts Council UK. 2012. *Connect10: Connecting Artists and Cultural Venues*. June 19. www.artscouncil.org.uk/funding/funded-projects/case-studies/connect10-connecting-artists-and-cultural-venues/.

ArtsMarketing.org. 2004. "Practical Lessons in Marketing." January 2006. www.artsmarketing.org/marketingresources/tutorials.

Chen-Courtin, Dorothy. 1998. "Look Before You Leap: Some Marketing Research Basics." *ArtsReach*. June/July.

Empire, K. 2003. "Observer Writers Trade Places to Bring a First-timers Perspective to the Arts." *The Observer*. August 24.

Kolb, Bonita. 1999. "You Call This Fun? Response of First Time Attenders to a Classical Music Concert." *Music and Entertainment Industry Education Association Journal*, Volume 1, Number 1.

Murphy, Annelise. 2012 "The 5 Levels of Audience Participation." July 30. www.poisonivymysteries.com/murder-mysteries/294-the-5-levels-of-audience-participation.html

National Endowment for the Arts. 2009. *2008 Survey of Public Participation in the Arts*. Washington, DC: National Endowment for the Arts. November.

National Endowment for the Arts. 2010. *Come as You Are: Informal Arts Participation in Urban and Rural Communities*. Washington, DC: National Endowment for the Arts. March.

Richards, Lyn, and Janice M. Morse. 2013. *Readme First for a User's Guide to Qualitative Methods, 3rd edition*. Thousand Oaks, California: SAGE.

Ritter, Sue. 2012. *Conducting Online Surveys,* Thousand Oaks, California: SAGE.

Wallace, Margot A. 2010. *Consumer Research for Museum Marketers: Audience Insights Money Can't Buy*. Lanham, Maryland: AltaMira Press.

8 The Product and the Venue

Marketing theory was originally focused on selling tangible goods, which are physical products that are handcrafted or manufactured (e.g., a can of soda, a jacket, or a bed). With the growth of the service industry in the 1980s, those in charge of marketing realized that services may differ in some aspects from tangible products, but they still need to be marketed. Therefore, marketing theory was expanded to address the unique challenges presented by the need to market service products. With the expansion of the service industry, it is now understood that ideas, such as political parties, and experiences, such as a visit to another country, are also products that must be marketed. In marketing theory, the word product can now be used to describe any combination of a tangible good, a service, an idea, and an experience.

Cultural products can be thought of as just such a combination. Cultural organizations provide a service when they present a play, concert, or exhibit. However, consumers attending also purchase tangible products from the organization, such as refreshments, programs, and gift items. In addition, the cultural organization also markets the idea of supporting the arts when selling memberships. The complete package of benefits provided by attendance is the experience.

Because culture is such a unique and complicated product, it is important to understand how consumers perceive and categorize products, including the unique features of services. Such concepts as product knowledge, categories, branding, packaging, and distribution also must be understood. This knowledge is necessary before an effective promotional campaign can be designed.

Unique Characteristics of Services

As stated earlier, the word *product* is used interchangeably for tangible goods, services, ideas, and experiences. Services are distinguished from tangible goods by several characteristics of which the most important to cultural organizations are intangibility, inseparability, and perishability. These characteristics add to the difficulty of marketing cultural products.

A Crowd is Always More Fun!

Crowdsourcing is defined as taking a large job, which might be too difficult or time consuming for one person, dividing it up into smaller actions, and then getting many people to each be involved by doing a portion of the larger job. Because many people are needed to complete the job, the people who are involved are solicited online. What does this concept have to do with art? Art has usually been defined as a solitary activity performed by an artist. However, this concept is now being redefined as the creation of art products are being crowdsourced. The public's traditional role with art was to simply be spectators. Cultural organizations then involved the audience more by having lectures and programs. Now the crowdsourcing concept is being applied to the creative process. Some examples where this idea is being used are:

- The Brooklyn Museum allows anyone who sets up an account to tag, like, or comment on any image on the website.
- An exhibition, Clicked, asked the audience to submit photographs that were included in the final project.
- A crowdsourced film. *A Life in a Day*, used clips from 80,000 uploads submitted from around the world.

New ideas will continue to be generated that may change the way the term "artist" is defined.

Rothler (2012)

Intangibility

The performance of music, dance or theatre, or an exhibit of art or artifacts has tangible features that can be seen and heard. However, cultural products more closely resemble services because they are purchased by the consumer for the intangible benefits seeing the performance or exhibit provides. The art form is not purchased but rather experienced for its benefits.

These intangible benefits are difficult for the cultural organization to communicate and, therefore, market to consumers. This is particularly true of marketing to consumers who do not have sufficient experience with the benefits provided by cultural events. As a result, cultural organizations must carefully choose the words and images used in their marketing material so as to inform consumers of the benefits. Unfortunately, if not chosen properly, the words and images can reinforce the culture consumer's negative stereotypes of elitism and product inaccessibility.

Inseparability

Because the consumer purchases the right to experience the performance or exhibit, not the performance or exhibit itself, the tangible features of the cultural product can only be examined after purchase and are therefore

said to be inseparable from purchase. Even if consumers have experienced the performance or exhibit elsewhere, each experience will be unique. This makes marketing the cultural product similar to marketing a service and also similarly difficult. Cultural organizations must market cultural experiences of which many, or even most, consumers are totally unfamiliar until the actual purchase and consumption.

Perishability

Because, by their nature, services cannot be stored, one of the challenges is to connect supply and demand. The cultural performance or exhibit is available for only a limited time and, if there is no audience, the opportunity to sell is lost. Product perishability presents great challenges to cultural organizations that are already operating with limited financial resources. If there are empty seats at a performance, they cannot be put on sale the next day. As a result, the opportunity to make the revenue has been lost forever. Determining the price that will maximize both attendance, by having affordable prices, and revenue, by having high prices, is critical. With a decline in government funding, pricing of the cultural product becomes ever more critical.

Product Knowledge

Before consumers can make a decision to consume a product, they need to first be aware of its availability. Their product awareness or knowledge level can vary from the superficial, knowing the product exists, to comprehensive familiarity with all the types and levels of the product.

Levels of Product Knowledge

Consumers have different levels of knowledge about the cultural product including product type, form, brand, and features that they will use to make their attendance decision. They may be only familiar with the

Church + Circus?

Circa, based in Australia, has come up with the one of the most unusual venues for their performances. Circa will mount an hour-long air-borne rope ballet in the naves of British cathedrals. Sacrilegious? The performance will be accompanied by choral music and is designed to be respectful of the cathedral space while not being religious. The company thinks that the performance, *How Like An Angel*, will focus the audience's attention on the great spaces above them that are sometimes overlooked by those in prayer.

Sawer (2012)

product type, and know that something called classical music or ballet or theatre exists. Or, if they have more knowledge, consumers may also be aware that classical music comes in various product forms such as live concerts, recorded concerts, broadcasts, and online; or, for theatre that Shakespearean, contemporary drama, and musical theatre exist. Consumers do not restrict themselves to consuming culture in only one form. Cultural organizations presenting live events should not believe that engaging in the arts via electronic media is stealing audience away from that live venue. In fact, engaging in culture via media actually encourages attendance at live events (Byrnes 2011).

The next level of product knowledge is consumers' recognition of brand names. For example, if consumers wish to attend a live classical performance, they may make their decision to attend based on the brand name of the venue, such as Carnegie Hall or the Royal Festival Hall, offering the product. They will make their attendance decision based on the belief that the brand name of the venue guarantees a quality experience. If they are very knowledgeable about the art form, they may base their decision on specific features of the program or exhibit, such as a particular artist.

The levels of product knowledge on which the attendance decision is based can be described using classical music as an example. At the most superficial level, a person first must be aware that classical music exists. At the next level they must know that, if they wish to enjoy classical music, they have the choice of different product forms. They can listen to classical music on the radio, buy and listen to a CD, listen online, or attend a live performance. If they decide to attend a live performance, they must have additional knowledge of brand names of orchestras or venues. Individuals who are very knowledgeable about classical music would be much more concerned with the details of the concert. They would base their decision on specific features of the concert, such as musical style, composer or soloist.

Too often, those involved in marketing believe that all they need to do is announce the availability of the product in their promotion. This would provide sufficient motivation for consumers with appropriate knowledge of the art form. However, for those who only know that classical music exists, an announcement of a baroque recital at Wigmore Hall would have no meaning.

Levels of Depth of Product Knowledge for Classical Music

Product Type	Product Form	Brand (live)	Features (live)
Classical Music	Live	BBC Orchestra	Baroque Composer
	Broadcast	Philharmonic	Contemporary Conductor
	CD	South Bank	Chamber Soloist
	Online digital	Wigmore Hall	Choral Program

Value Chain Decision Making

People make consumption decisions based on a value chain that starts with the product's features. The chain then moves to the benefit's these features provide. Consumers will then consider the emotional component of what the purchase of the product will mean to them. The cultural organization must provide the appropriate type of information needed by consumers to help them make their attendance decision. The following three levels of product knowledge can be thought of as a chain.

Value Chain
 1. *Features* What is it?
 2. *Benefits* What does it do for me?
 3. *Values* What does it mean to me?

The first type of information concerns the features of the product. Using live performances of classical music as an example, this information would include such physical characteristics as performer, time and date of concert, music programming, physical attributes of the venue, and additional services provided. Cultural organizations are already skilled at providing this information.

The second type of information concerns the bundle of benefits that will be provided to consumers when they purchase the product. They include such benefits as self-improvement by attaining additional knowledge about classical music. They also might include an excuse for a social occasion that provides relaxation and entertainment. Cultural organizations are less skilled at providing consumers with this type of information because they themselves are sometimes unsure of how consumers benefit.

The third type of information needed by consumers concerns what values are associated with use of the product. Consumers may be motivated to attend a live classical concert because it satisfies a personal value such as contributing to the betterment of society or performing an expected ritual of one's social class. It is known that people who attend the arts are also more likely to be involved in their communities in other ways, so attendance might be a way to be involved with and support a community organization (National Endowment for the Arts 2009).

In a successful promotional message, the cultural organization provides all three types of information. Consumers who are already enthusiasts

Types of Product Information Used when Attending a Classical Music Concert

Features of Product	Benefits Provided by Product	Values Associated with Product
Program	Opportunity to socialize	Support of arts
Performer	Increased knowledge	Social standing
Venue amenities	Relaxation/entertainment	Community involvement

and knowledgeable may make the attendance decision based only on values, as they are already familiar with the features and benefits of culture. However, to influence the decision of culture consumers, the cultural organization must first educate them as to the features of the cultural product. Consumers then must be convinced that they will benefit from attendance. Only then, can consumers learn if a cultural event reflects their personal values.

The worldwide economic downturn has resulted in a change of values that can be useful for cultural organizations to understand. Many people are no longer able to rely on the purchase of status goods as a way to express a personal value based on achievement. They are now more likely to seek activities that allow them to be involved with others in the community (Gerzema and D'Antonio 2011). Social media allows these individuals to find each other and to share information on how to be more involved with local cultural groups.

Product Risk

Unfortunately, some values which culture enthusiasts find attractive, such as exhibiting membership in a social status group or demonstrating their cultural knowledge, may actually prove a barrier to culture consumers. Rather than being considered benefits, these values pose risks to consumers with little knowledge of the art form. These risks must be minimized if culture consumers are to be attracted. The negative risks of attending a cultural event might include:

- Feeling like an outsider or social failure;
- Enduring a boring evening;
- Having no opportunity for social contact;
- Feeling ignorant.

Technology can be used to overcome these risks. If potential audience members are able to view samples of the arts online, they will know if it is a product they wish to consume. They can also learn more about the art form online. Finally, if they can read reviews of audience members on social media sites, they are even more reassured. Influential bloggers can also share the message of the benefits that the art form provides. These social messages are much more persuasive then the messages communicated by the organization (Li and Bernoff 2009).

Technology and the Cultural Product

The cultural product, whether the organization sees it as a product to enlighten, entertain, or both, is the mission of the organization. It is the organization that produces the product, which is then presented to the

Forget Group Therapy, Just Go to the Opera

Between 1990 and 1995 the Canadian Opera Company, based in Toronto, lost half of its subscribers. The company realized that drastic action was needed to attract a new and younger audience. It succeeded by launching the "18 to 29: Opera for a New Age" membership promotion. For a small fee, a member received one free opera ticket, a discount at a popular music store, an opera CD, a souvenir program, and the opera newsletter. Canadian Opera Company attributes the success of the promotion to two factors: offering good seats at reduced prices and having a cultural product which is attractive to today's media-savvy young consumer. To promote the scheme, the ad campaigns focused on universities, bookstores, cafes and pubs. The original marketing message made no apology for opera's focus on sex and violence. The following is an example from a brochure:

"Your mother and her lover have just killed your father with an axe. Your exiled brother is probably dead. People are plotting to imprison you in a dark tower. In the midst of all this, your sister just wants to settle down and have a normal family. The time for group therapy has passed. Experience the rage and fury of Electra."

Oh, by the way, the program is still going strong. In the 2012/13 season you can pay $22 and sit in a designated area. However, for $35 you will be moved to the best available seat!

Fanciullo and Banks (1998) and Canadian Opera Company (2012)

public. However, the public no longer views products in this static fashion. Instead, because of social media, they may see themselves as co-producers of the product (Shirky 2010). While social media first was used as a means for people to connect with one another, it now also allows the public to be part of the creative process. Many consumers want to be creative and then share their own cultural creation with others. The culture product that the organization presents now must be understood as not standing alone, but as a part of this process of connection, creation, and collaboration.

Categories of Products

Products can be divided into convenience, comparison, and specialty items based on how the product is purchased and used by the consumer. The different categories of products require different promotional strategies.

Convenience Products

Convenience products are routinely purchased by consumers with very little thought or research going into the purchase decision. Convenience products are usually low cost for the consumer and low profit for the producer. Because of the low profit, producers can only make money by

selling in volume. Therefore, convenience products are designed to appeal to a broad range of consumers and are distributed widely to reach a large market segment. The promotional message for convenience products focuses on cost and convenience. Typical convenience products are soft drinks, fast food, and toothpaste all of which are relatively inexpensive, widely distributed, and quickly consumed.

Comparison Products

Comparison products have a higher price, are available in fewer locations, and the benefits last longer than convenience products. Consequently, consumers will spend some time comparison shopping and researching the product before the purchase is made. The features offered by comparison products are usually fairly consistent across brands. When this is true, consumers will make the purchase decision based on price and, only second, on features. For example, a refrigerator is a standard, basic appliance and therefore price variance between products will be an important factor in the purchase decision. However, the lowest priced refrigerator must also be convenient in terms of purchase location and product delivery. If consumers have to spend additional time and energy on making the purchase and getting the product home, these factors will negate the lower price.

If the comparison product offers a choice of features, consumers will approach the purchase decision differently. For example, when choosing an automobile, even though all autos perform the same function, the decision of which to purchase will often be based on features such as design, size, and power, and only then on price. To obtain the desired features, consumers may even spend more money than they anticipated. Therefore, the promotional message for comparison products focuses on features and their benefits.

Specialty Products

Specialty products have distinctive features or a unique brand identity. Consumers will not accept substitutes when they decide to purchase a specialty product, e.g., a piece of jewelry from Tiffany's. Other expensive pieces of jewelry may be just as lovely, but consumers purchase at Tiffany's because they consider other store brands unacceptable. The promotional message for specialty products focuses on image, not features.

Comparison of Different Cultural Products

Culture may also be described as a convenience, comparison, or specialty product depending on the type of art form, whether it is high or popular culture and the market segment targeted. The category of product will

also depend on how the art form is presented. Understanding how a consumer categorizes the cultural product can help with the designing of an effective promotional message.

Culture as a Convenience Product

If culture is sold as a convenience product, with wide distribution and low cost, it will almost always contain at least some elements of popular culture. To sell the product at low cost and still gain sufficient revenue requires a cultural product that will appeal to a broad range of consumers. Companies selling "convenience" culture are willing to make the necessary compromises in designing the product so that it appeals to the wider public. Sometimes these cultural convenience products may be of a lesser quality, but consumers will still purchase them because of the low cost.

Organizations working with high culture are often unwilling or unable to make the compromises in quality necessary to appeal to a broad public. Because of their focus on producing art of the highest quality, they are also unable to lower the cost of their product. Their mission requires them to have the best (and most expensive) artists and performers. Because they are not able to change their product to attract culture consumers, they cannot earn anywhere near sufficient revenue to cover costs and must rely on outside financial support. The lack of wide public appeal and sufficient revenue results in the cultural organization, even though it has a high quality product, being unable to distribute their product more widely. For these reasons, high culture can rarely be sold as a convenience product. Promotion for convenience products will focus on low price and convenience.

Culture as a Comparison Product

If consumers lack knowledge about art and culture, they will consider the cultural event a comparison product. They will believe that any cultural event is substitutable with any other form of cultural event because to such consumers all the events have similar features and provide similar benefits. Therefore, when deciding between specific performances or exhibits, consumers will attend the most convenient alternative and familiar event.

However, people who are knowledgeable about culture will decide that they are willing to pay more for a specific feature, such as a particular performer or a visit to a specific exhibit. They will also be willing to travel and arrange their schedule so they can attend the performance or exhibit even if the location and time are inconvenient. Promotion for these types of products will focus on features.

Culture as a Specialty Product

Some people view culture as a specialty product and have specific brand preferences. They will not accept substitutes and will incur additional expense and inconvenience to purchase the product. When such people wish to see Monet paintings, for example, they will not wish to view the work of another artist as the only acceptable product is a Monet exhibit. They may also view the cultural event as a specialty product because of the brand name. If they desire to attend an opera at the Royal Opera House, the same opera, performed elsewhere, will not be acceptable. Promotion for specialty products, of course, does not focus on low price. It also does not focus on features as the people who purchase specialty are already educated as to what the product has to offer. Instead, promotion focuses on the values associated with the product.

Branding

Branding is becoming an issue of increasing interest to cultural organizations. Branding is defined as the visible identity of the product that represents the benefits consumption provides. This identity consists of the organization's name, logo, slogan, or combination of all three. The brand is not the product but is designed to evoke the product's benefits. Use of the brand then serves as a shortcut in communication between the organization and the public.

As it is difficult to market art because its benefits are intangible, branding can be particularly useful to cultural organizations as a means to distinguish their product from others in the mind of the consumer. The brand of the cultural product is the benefits that make the organization distinctive. It is the sum total of what makes a cultural organization different from its competitors.

Of course, brand identity lets a consumer know that an opera company produces opera and that an art gallery exhibits art. However, brand identification goes beyond identifying the tangible elements of the product and allows organizations to distinguish their cultural product from other cultural products by denoting its intangible features. Such features could be the excitement of live theatre, the grandeur of classical music, or the edginess of contemporary visual art.

Cultural organizations can also use branding to align their product more closely with other types of similar products that may be attractive to consumers. Such benefits as the social aspects of the evening and how they will be entertained can be communicated with the brand. This allows them to inform the consumer as to the type of experience they are going to have. If the consumer enjoys the experience, they will then identify their enjoyment with the brand name and consume the product on a repeat basis.

Let's Play All Day!

The National Theatre of Scotland is a theatre company without a permanent venue. So, it decided to celebrate its fifth anniversary by broadcasting 24 hours of live theatre made up of five-minute performances that were staged everywhere and anywhere. How did it come up with enough plays and actors to fill the 24 hours? It didn't. The National Theatre asked the people of Scotland to do the job. Not all 235 pieces were critically successful, but how can you judge the success of plays held in laundromats and swimming pools and with actors including two elderly women on mobility scooters and parents with babies? The performances were then left online for continuing enjoyment. The event was so successful that a specialized five-minute theatre project for youth was held.

Caird (2011)

A cultural organization needs to be aware that it will be branded even without the organization's active involvement. The branding of the cultural organization's product is created in the public's mind through word-of-mouth, stories in the media, and online consumer reviews. When these reinforce negative stereotypes, the branding works to the detriment of the organization.

Another way to understand branding is to consider how the organization reaches the potential consumers by engaging with their heart, head, and hands (Daw and Cone 2011). Most cultural organizations understand that they want to reach the public's emotions. As part of their brand they promote their transcendent music, uplifting theatrical performance, and their sublime art. What they also should consider as part of their brand is how they can engage the intellect of the public. This can be done by promoting how the organization is differentiated from their competitors. The organization must explain that they provide something that no one else can. Finally, part of the brand needs to be a means for the public to engage with the organization.

It could be said that the organization no longer controls the brand and that today brands are co-created (Solis 2012). Consumers understand that the organization is going to define its brand by saying the product is wonderful. However, the cultural organization is now a single voice in the online conversation about the product. The public may create a brand image for the organization that is more accurate in communicating the benefits than those inside the organization can create.

The Cultural Package

The cultural product is more than merely the performance and/or object which is produced by the artist. The cultural product is the complete

package of the performance/object along with everything else the experience has to offer. This includes additional features such as lobby entertainment or educational lectures. It also includes the physical surroundings, social atmosphere, and the customer service. The cultural product is in actuality always an "event," even if it is only a visual arts display and not a three-day Celtic music festival.

All products consist of more than just the good or service that is provided. The cultural product has a primary core product, the performance or exhibit, which the organization provides to the consumer. This core product should be seen as only the central element, which then must be packaged.

Packaging the Cultural Product as an Event

Packaging is usually thought of as the paper or container in which a tangible product is purchased. The package is designed to protect the product but also to assist in creating the product's brand identity. Different packaging can be used to have the same product appeal to different consumers.

Cultural products are intangible services but they can also be thought of as being packaged. Rather than surrounding the cultural product with foil or foam, the product is packaged with additional services and events. The core product of the play, concert, or exhibit without "packaging" may be just as difficult to sell as a book without a cover. Of course, serious readers understand that you can't tell a book by its cover, but cultural consumers use the cover to decide if they will even bother to pick up the book.

For this reason, it is especially difficult to attract consumers to the cultural product without exciting packaging. The packaging they desire might be lobby entertainment, unique food and beverages, or distinctive décor. A successful package also includes intangibles such as the ambience and staff attitudes, which should be designed to attract culture consumers. All of this packaging together creates a buzz of excitement as soon as the cultural consumer enters the door. The organization's online presence is also part of its brand image (Blakeman 2011). Having a website that mimics the look and wording of other pieces of media reinforces the image the organization wishes to project.

The same cultural product can be packaged differently for different target segments. The packaging that will attract cultural enthusiasts will include additional features which will meet their needs to socialize with others who are knowledgeable about the art form. This packaging might include pre-concert lectures, extensive program notes, and opportunities to meet the artists.

Other packaging could be an opportunity to become more involved with the art form and cultural organization by becoming a sponsor or volunteer for the organization. This type of packaging not only provides assistance and support for the cultural organization, it also helps to develop

the relationship with the organization and helps the cultural organization fulfill its mission by becoming more closely involved with the members of the community.

Distribution of Culture

The distribution system for cultural products has been a non-issue for most cultural organizations. The cultural event has usually been held in a traditional venue such as a performance hall, museum, or gallery. When cultural organizations have considered the problem of the distribution of culture, their response has been to send the event on tour to other traditional venues in the belief that it is only geographic distance which keeps consumers from attending. However, it may be the traditional venue itself that keeps consumers away.

A new approach to cultural distribution is to understand that it is as much psychic distance as physical distance that keeps consumers from attending. If the audience is not willing to come to the venue, there is no reason why the cultural product cannot be brought to the audience. The distribution of culture to new types of venues to increase attendance is being tried by adventurous cultural organizations. The approaches they use vary as to the type of organization and art form, but include taking the art form into non-traditional venues such as shopping malls, churches, and dance clubs. Consumers are much more likely to attend a concert, play, or exhibit for the first time when it is in a venue with which they are already familiar.

Distributing culture via electronic media is also an option for organizations. The generation that has become teenagers since the start of the new century has been named the "always on" generation as they have always been connected (Swerdlow 2008). However, their attention span is short. The culture that the organization provides via electronic media, whether on computers, smartphones, or tablets, needs to be easily and quickly assessable.

The Non-Traditional Venue

If the mission of a cultural organization is to expose as many people as possible to their art, it only makes sense to take the art where the people are. While it is common for arts organizations to take their work to schools, there are many other venues that are possible. Chamber groups could perform during lunch break in public venues such as the lobbies of corporate headquarters. This could even be part of their rehearsal process. Museums and galleries could exhibit in restaurants, businesses, or stores. Of course, the audience can be instructed either verbally or through written information on how to experience more of the art through attendance at the traditional venue. The cultural organization might be surprised

Ballet at the Bar

Ballet is usually performed in a dignified venue with a proscenium arch. But the Blankenship Ballet holds unconventional ballet performances in abandoned buildings. In fact they perform in a bar; their own bar located in a rundown historic hotel the company bought in Los Angeles. The company's founders are from Cuba and were comfortable with the idea of performing in unconventional sites. Their shows mix ballet with a cabaret mixture of opera and dance. The founder believes you don't need a traditional venue to perform great art. While rundown buildings present maintenance challenges, the spaces provide the audience and the dancers with an opportunity to interact that would be impossible in a traditional venue.

Josephs (2012)

at how interested businesses are in incorporating art into their physical environment.

The Role of the Venue

The venue is more than just a place to show art or hold a performance. It can play a critical role in building a sense of community. To do so, the cultural organization must understand the crucial need to ensure that all visitors feel welcome. The venue can also be used to exhibit the creativity of all members of the public. The cultural organization can widen this sense of community from their venue to their online presence. Or, it may be that the organization's primary contact with the public may be online and the venue is a way to enhance the sense of online community. In other words, people will come to the venue not to just experience the art, but to experience each other.

Community Building

Cultural organizations should think of their venue as more than just places to view art. They can also serve the purpose of building community. Everyone needs what is called a "Third Place," a place besides work and home where people can associate with others. It allows for informal public life where different types of people can connect as equals. Historically, these places have been the local coffee shop, bookstore, or barber. But today more people commute long distances to and from work and when they do get home they tend to retreat behind their own front door.

Society needs a place that is a friendly "leveler" where people from different social positions can come together because of a shared interest. People are social and one of the main reasons for arts attendance is a social experience. Unfortunately, cultural organizations sometimes wrongly

A Play, A Town, One Weekend

Port Talbot in Wales became the location for a staging of "The Passion". In fact the town was the stage as the three days of acting took place in many locations throughout the municipality. The play was staged over Easter weekend using over 1,000 local volunteers. The production was adapted to the community by adding local myths and stories, including such elements as angels on bicycles and snipers on rooftops. The event was staged by the National Theatre Wales and Wildworks. The event was grand but the local stories are what held everyone's attention and made the event an experience for the entire town, not just traditional theatre goers.

Gardner (2011)

perceive this as frivolous. Nevertheless, it is a basic human need and helping people to maintain social connections is an important contribution to the community (Oldenburg 1999).

Welcoming Visitors

To build a feeling of community, the venue, whether traditional or non-traditional, must be welcoming. The cultural organization should treat each visitor as if he or she were a guest in the organization's home. This includes maintaining the small, but important, touches. The organization should ensure that if refreshments are served, there are tables available on which to put down the glasses. Comfortable seating should be provided. Small touches such as a few fresh flowers on the ticket counter communicate that the organization cares about making the community feel welcome. Just as when one invites friends home, it is importantly to be friendly and welcoming to put guests at ease. It's better to meet guests with a smile and friendly greeting rather than just a hand out for a ticket.

Building Community through Technology

Rather than merely bemoan the changes in cultural consumption habits caused by technology, cultural organizations can use it to involve the individual and the community in the artistic process. Cultural organizations, which have always been believers in community outreach, can use technology to help build an online community where the public is an equal partner. The new information technologies, including social media, also provide cultural organizations with new possibilities for reaching segments of the public, such as the disabled and ethnic minorities, which have been difficult to attract to the venue itself.

Technology has taken the relationship between the organization and the consumer one step closer toward equality. The public now has the

option of actually creating art themselves and sharing their work with other community members. Of course, not everyone is doing so. However, the young, who are the future audience for cultural organizations, feel that this ability puts them on an equal footing with artists. They may not create art of the same quality, but still consider themselves to be creative. This should make these young culture consumers more, not less, receptive to cultural products.

Within the community the level of engagement will vary (Kanter and Fine 2010). There may be people who simply read the organization's blogs and look at its Facebook page. Others will become more involved and donate financially because they believe in the organization's mission. Some will become involved in sharing the mission with others. Finally, some will start to create and share art with the organization and other members of the community.

The term *cultural participation* is derived from how the Internet is used (Jenkins 2009). First used only as source of information, the Internet soon changed into an interactive tool that allowed two-way communication and creativity. Culture participation has developed because technology has lowered the barriers to artistic expression. In addition, technology has made the sharing of artistic creations easy. Through sharing these participants create a bond with each and a belief in the importance of the work they are creating. Finally, there is a means for those most experienced with the art form to pass on expertize. It is this last point where cultural organizations can play a role in the online communities they create. They can help explain that while all creations are valid, not all creations are equal.

Beyond Bricks and Mortar

Most cultural organizations have been venue based. The purpose of marketing was to motivate the audience to attend the venue. However, using news media as an example, there is another way to think about the delivery of culture using the model of media and audience fragmentation (Napoli 2011). Because of technology, a newspaper, which formerly was only read in a paper format, can now be read on a computer monitor, on an electronic book reader, a tablet computer, or smartphone. Likewise, culture can be viewed and enjoyed in many different formats besides the live experience. As a result of these numerous consumption choices, audiences are fragmenting into many more, but smaller segments. Cultural organizations, rather than think of attendance as people coming in the door, may need to start thinking about attendance as the number of people exposed to their art form; whether they come to the organization or are exposed online.

You are More Than Your Collections

The Walker Art Center in Minneapolis, Minnesota is major contemporary art gallery that decided to use its website in a new way. Websites have traditionally been used by cultural organizations as marketing platforms to inform the public of the organization so as to entice them into the venue. The Walker decided to use its website as means of pushing out information rather than just pulling in an audience. On their website there is a list of top recent articles on the contemporary art scene with some articles just focused on what is happening in Minnesota. There is a section of active blogs and a video channel that shows past events at the Walker. In addition there is the traditional section on collections, but with more. The collections are searchable, and, once the art work of interest has been located, people can comment online on the image. They can also email the image. Or, they can share the image via several social media platforms. Lastly they may just wish to print the image for themselves. A visitor can derive significant benefits from the Walker by only visiting its website. A visit to the Walker, situated as it is in the center of North America may not be possible, but now everyone can experience the Walker online.

Madrigal 2011

Summary

A product can be a tangible good, a service, an idea, or an experience. Culture can be thought of as a combination of all of these elements. A service differs from a tangible product because it is intangible, the production of the product is inseparable from its consumption and it cannot be stored. Consumers can have different levels of knowledge about a product from a vague awareness that the type of product exists to an understanding of all its features and benefits. The value chain describes this process as moving from features to benefits to values. All products can be classified as convenience, comparison, or specialty with culture fitting into the last two. Branding is a means of quickly communicating the product's value to the consumer. Distribution can take place in a traditional venue, online, or out in the public.

References

Blakeman, Robyn. 2011. *Strategic Uses of Alternative Media: Just the Essentials.* Armonk, New York: M.E.Sharpe.

Byrnes, Jennifer P. 2011. *Public Participation in the Arts and the Role of Technology.* New York: Nova Science.

Canadian Opera Company. 2012. "18 to 29: Opera for a New Age." June 30. http://www.coc.ca/PerformancesAndTickets/Under30/OperaUnder30.aspx.

Caird, Jo. 2011. "National Theatre of Scotland's Five Minute Theatre – the verdict." *Guardian*. June 23. http://www.guardian.co.uk/stage/theatreblog/2011/jun/23/national-theatre-of-scotland-five-minute.

Daw, Jocelyne, S., and Carol Cone. 2011. *Breakthrough Nonprofit Branding: Seven Principles to Power Extraordinary Results*. Hoboken, New Jersey: John Wiley & Sons.

Fanciullo, D., and Banks, A. 1998. "Surge of Popularity Creates a New Age for Opera." *Arts Reach*, September.

Gardner, Lyn. 2011. "The Passion – review." *Guardian*, April 24.

Gerzema, John, and Michael D'Antonio. 2011. *Spend Shift: How the Post-Crisis Values Revolution is Changing the Way We Buy, Sell, and Live*. San Francisco: Jossey-Bass.

Jenkins, Henry. 2009. *Confronting the Challenges of Participatory Culture: Media Education for the 21st Century*. Cambridge, Massachusetts: The MIT Press.

Josephs, Susan. 2012. "Blankenship Ballet's Unconventional Platform for Dance." *Los Angeles Times*. July 28.

Kanter, Beth, and Allison H. Fine. 2010. *The Networked Nonprofit: Connecting with Social Media to Drive Change*. San Francisco: Jossey-Bass.

Li, Charlene, and Josh Bernoff. 2009. *Marketing in the Groundswell*. Boston, Massachusetts: Harvard Business Press.

Madrigal, Alexis. 2011. "Museum as Node: What to Love About the Walker Art Center's New Website." *The Atlantic*. December 5.

Napoli, Philip. 2011. *Audience Evolution: New Technologies and the Transformation of Media Audiences*. New York: Columbia University Press.

National Endowment for the Arts. 2009. *Art-Goers in their Communities: Patterns of Civic Engagement*. Washington, DC: National Endowment for the Arts.

Oldenburg, Ray. 1999. *The Great Good Place: Cafes, Coffee Shops, Bookstores, Bars, Hair Salons and Other Great Hangouts at the Heart of a Community*. Emeryville, California: Marlowe & Company.

Rothler, David. 2012. *The People Formerly Known as the Audience: Participating and Crowdsourcing in Arts and Culture*. January. http://www.scribd.com/doc/97334222/Crowdsourcing-Culture.

Sawer, Patrick. 2012. "Art Meets the Holy as Cathedrals Host Circus Act." *UK Telegraph*. June 17.

Shirky, Clay. 2010. *Cognitive Surplus: How Technology Makes Consumers into Collaborators*. New York: Penguin Books.

Solis, Brian. 2012. *The End of Business as Usual: Rewire the Way you Work to Succeed in the Consumer Revolution*. Hoboken, New Jersey: John Wiley & Sons.

Swerdlow, Joel. 2008. "Audiences for the Arts in the Age of Electronics." *Engaging Art: The Next Great Transformation of America's Cultural Life*. New York: Routledge.

9 Pricing and Funding as Revenue Sources

Cultural organizations have too often thought of marketing as only involving a product and its promotion. However, to develop a sound marketing strategy, the pricing of the product must be considered. Cultural organizations are not able to price their product so as no other revenue is needed to cover their expenses. If they could, they would then be a for profit business. Since non-profit cultural organizations cannot exist on direct revenue alone, they also receive funding from additional sources. Fundraising from the public and government grants are critical sources of revenue. However, pricing theory is still important to understand because the more revenue that can be obtained directly from customers, the less time and effort will need to be put into other forms of raising revenue. The days when cultural organizations could ignore the basics of pricing theory are gone. Pricing strategy, such as differential pricing, can even be used to motivate attendance at cultural events. Therefore, an understanding of the cost, competition, and prestige approach to pricing is necessary.

Public Funding of Cultural Organizations

Money has always been a critical issue for cultural organizations, which have two main sources of revenue. The first is directly from the consumers and includes revenue from ticket sales, fees, food and beverage served, and related merchandise sold. However, only half of the income of a typical nonprofit arts organization is from earned sources such as ticket and gift shop sales (Raymond 2010). Since this revenue stream is insufficient to cover all the costs of the organization, funding from the government, corporations, and wealthy patrons is needed. However, due to the economic decline starting in 2008, external funding has been increasingly difficult to obtain. The increased need to search for revenue has affected the management of cultural organizations. The financial providers who are not direct recipients of services have a vested interest in the type of cultural product produced. As a result, the search for funding also affects the marketing strategy for the organization.

Historically, the main financial support for artists and the arts was provided by either the royal courts or the church. The relationship between the courts or church and the artist during the sixteenth and seventeenth centuries was not based on altruism but on the use of art for political or religious purposes. Art was used as a way to display power and wealth (Hogwood 1977).

As cities and then government bodies took over providing funding for cultural organizations, the rationale was similar. Art was used as a means of competition between rival cities. A high level of quality was sought not as an end in itself or to better serve the audience, but with the aim of beating the competition. This is still true, particularly in describing the funding of cultural organizations located in the international capitals of the world. The government support of these organizations often has had more to do with attracting tourists and large corporate headquarters to the city than with promoting the art form itself.

Rationale for Public Funding

The traditional argument for government funding for art is based on the argument that it helps make the world a better place is becoming increasingly difficult to make to taxpayers. As a result the argument has shifted its emphasis from a general improvement of society to more specific benefits (McCarthy et al. 2004). It is argued that the government should use taxpayer funds to support culture because cultural organizations supplement the educational opportunities of the schools. Another rationale is that cultural organizations provide economic and employment benefits to the community and can also be used as a focal point for urban regeneration. Support of public funding also continues to be defended because cultural organizations provide a community with increased status. However, there remains the very traditional belief that the arts should be supported

Wanted by Traveling Museum: A Home

The Guitar Museum has been traveling the United States looking for a home. The plan at first was to have a permanent venue but with the difficulty in finding funding the organization decided to take the exhibits on the road for five years looking for a city that would support the establishment of the museum. The exhibit, which has been hosted by existing museums, has been very successful with visitors. It is a "hands-on" museum because guitars are meant to be played. This interactivity has made the exhibit very popular. However, even with the success on the road, the president of the American Alliance of Museums warns that it might not be the time to find sufficient funding for a startup museum.

Begos (2012)

with public funds because culture is a civilizing influence, an argument which the supporters of building football stadiums cannot match.

Government Pressure on Cultural Organizations

There has always been tension in cultural organizations between those creating art and those responsible for presenting art (Bhrádaigh 1997). In fact, this creative tension is sometimes necessary for art to happen. Those working in cultural organizations have always argued about the meaning and definition of art and how it should be presented. For example, a cultural organization may be torn internally over how it should present a performance. Heated discussions might be held over the vision of the artistic director, there might be feuds in the orchestra over the repertoire that should be played, and the new playwright might be proclaimed a visionary by some and a failure by others. These tensions remained within the artistic and cultural family. Once a consensus was reached over what art to present, the public was expected to accept the decision. They might disagree and not attend but this was not considered a serious problem. This disconnection between the public and the product was possible because the cultural organization was not reliant on the customer for revenue.

Instead, the cultural organization relied on the government for funding. There was a well-established policy in most countries that while the government should fund the arts, it should not be involved in decisions concerning the creation or presentation of art. Cultural organizations expected that they should receive the money with no questions asked and no advice given. This traditional "arm's-length" policy of funding is no longer as true. Now when a cultural organization accepts government funding, they are also faced with increased political pressure to be responsive to the public. This pressure comes from the government's belief that if the taxpayers are providing the funding, cultural organizations have certain obligations; including ensuring that the art presented is of interest to the public. While cultural organizations would argue that the arts are of

It Sounds Good ... But Do They Believe It?

According to author Joli Jensen, the response to taxpayers' complaints about funding the arts, has been to find a number of rationales:

"So how can arts supporters respond to hostility from people who resent being told that stuff they don't understand, don't like, and often find offensive is still good for them and for America, and should be funded by tax dollars? They found ways, however vaguely, to redefine the arts as a creative continuum and creative heritage."

Jenson (2002)

interest to everyone, it is also true that attendance at the high art forms has always been skewed toward higher-income and better-educated individuals. Now organizations must prove that they not only welcome everyone but that they are taking active steps to encourage attendance.

Implications of Nonprofit Status

Besides the continuing concern with funding, the fact that cultural organizations are non-profit has a negative impact on their managerial effectiveness. One of the negative impacts is that the absence of a profit motive makes it difficult for the cultural organization to measure success. The classic goal of making a profit lets businesses know quickly if they are successful. Even if the business states that its goal is to have satisfied customers, the attainment of this goal is measured by the level of revenue. After all, if customers were not satisfied they would not buy the product.

Implications for Measuring Goals

Because earning a profit is not a goal for a cultural organization, it can have difficulty in articulating its goals and whether they have been met. One common goal of a cultural organization is to expose the public to the art form in the belief that such exposure enriches the community. This is a praiseworthy goal, but it is difficult to measure.

If the community does not support the art form, and therefore is not enriched, the cultural organization may view the public, not the organization, as responsible for the failure of the mission. In fact, for some cultural organizations, the absence of customers is accepted as a sign of success because it is seen as a consequence of maintaining high artistic standards. Indeed, the cultural organization may believe that the majority of the public is too ignorant to appreciate their art form. This can be the unfortunate result when the source of revenue is separated from the customer, as there is less need for cultural organizations to incorporate the public's desires in its goals.

External Pressures

The reliance on other sources than revenue for funding also leaves the cultural organization susceptible to political pressure and other external influences. The organization may be subject to pressure from a board of trustees, who are also major donors, to adhere to a manner of presenting art that has limited appeal to today's audience. Or the opposite pressure, to popularize the art to increase attendance in a way that the organization feels is inappropriate, may come from the government. If the cultural organization relies on fundraising, it can become hostage to the competing

claims of special interest groups, which may keep the organization from making changes it knows should be made.

Financial Implications

Nonprofit status also has practical financial implications. Since there is no excess revenue, the organization has limited means to motivate staff financially. This can result in employees who are unresponsive to customer needs, as additional attendance will not benefit them. Having small personnel budgets, cultural organizations often must rely of volunteers that while less expensive for the payroll, may cost considerably more in time and effort than managing paid employees. And the organization's inability to pay executive salaries commensurate with business makes it more difficult to compete for top talent.

A last constraint which results from non-profit status is that it is difficult for cultural organizations to build up a cash reserve to pay for the ever-increasing cost of technology. If London's for profit West End or New York's Broadway productions are using expensive special effects, the audience may expect the same from the local theatre, which cannot possibly afford to provide them. Even museums are facing this challenge as visitors are no longer willing to view objects passively, but instead want to be involved by using the latest technology.

Pricing

Cultural organizations rarely compete on price. In fact, they may not even use the word price but refer to fee, donation, gift, or contribution. Some cultural organizations may feel that they should not charge for their product because it should be widely available to everyone. However, there are three good reasons for charging. First, the organization needs revenue, especially in hard economic times. Second, price affects the behavior of people. A product they must pay for may be consumed with more care and thought than a product that is free. Third, charging a price results in financial records that track the use of the product (Burnett 2007).

Relationship Between Price and Revenue

Cultural organizations sometimes misunderstand the relationship between price and revenue; if they think of it at all. Price is what is charged for the product. If price is multiplied by the number of units sold, total revenue is calculated. This simple calculation can give rise to misunderstanding. It may seem that if the price is raised total revenue will be increased. Of course, this is not necessarily true as the rise in price may be offset by fewer units sold as some people may refuse to pay the higher price. It

Being Free Isn't Always Good

Who doesn't like something that's free? No one! So, if culture is "free," everyone will like it! This is the rationale for not charging for tickets. When people are offered something for free most will opt to receive the product. However, the fact that the product is free does not make people value the product and can even have the opposite effect. When the UK decided that all museums would be free attendance rose sharply. Nevertheless, this did not mean that the public was rushing to visit museums. Two-thirds of the new attenders were previous visitors who were attending more often. When free tickets were offered to young people in the UK to attend theatre performances, only 8 percent of the users were first-time visitors. There are two problems that result when the product is free. First, it sends a message that culture does not have enough value to charge and, second, once someone receives something for free, they will expect more "free" product in the future.

Baker and Roth (2012)

may then seem that a reduction in price would raise revenue as then more people would attend. However, the cultural organization needs to be careful, because revenue is being lost on every ticket sold at the lower price. The additional tickets sold may not make up for the loss of revenue from selling every ticket at a lower price. The calculation of a change in ticket price must be carefully considered.

Non-Price Competition

Rather than promote on price, most cultural organizations use non-price competition and stress the quality of the product. This is also a common practice for profit organizations that sell specialty products that have few substitutes. Because the consumer cannot find other similar products with which to compare the price, they usually accept the stated price as correct. However, that does not mean they are willing to pay the price. Cultural organizations usually respond to a refusal to purchase by lowering the price believing that the consumer is unable to afford to attend. However, the refusal to purchase is often because the product is unacceptable based on the perceived value, not because of a lack of funds. In fact, lowering of the price may not inspire a purchase but have the opposite effect, as it sends the psychological message that the product is not worth the price.

Pricing Methods

Even though cultural organizations are not able to raise all their needed revenue directly from customers, they still must understand the three

basic approaches to pricing, which are cost, competition, and prestige. They also must understand the role price plays in the attendance decision.

Cost Pricing

When thinking about pricing, one of the first issues that marketing must consider is the actual cost of producing the product. For a profit business, the price charged for a product must at least cover the cost of production. If not, the company will sooner or later become bankrupt and have to close its doors. Therefore, the company must be able to price the product to cover costs and also provide a profit. This profit can be reinvested in the company, set aside to cover any future costs, or be paid to the employees, owners, or stockholders.

Cultural organizations, being nonprofits, are unable to even cover the costs of producing their product through revenue from purchases alone. Even if they were able to, because of their nonprofit status any extra revenue above cost would need to be reinvested in the organization. This does not mean that the practice of pricing to cover the costs of the product is irrelevant for cultural organizations. After all, the more money that is made from purchase revenue, the less time and money the organization will need to spend on fundraising.

The cost of a product is calculated by determining the fixed and variable costs. The fixed costs of any organization, profit or nonprofit, are the costs that would be incurred even if no product is produced at all. For example, a theatre organization must still pay rent or mortgage for its premises even if they do not mount a production. Fixed costs will also include the cost of any payments for equipment, whether purchased or rented, that is necessary to produce its product. For example, any office equipment, such as computers and copying machines, along with specialized production equipment, such as special lighting for theatres or galleries, are fixed costs. Having to cover high fixed costs is the reason why small cultural organizations should think carefully before maintaining expensive offices, permanent galleries or theatres. Another fixed cost that must be covered is administrative staff. The staff is needed to run the organization even when no play or exhibit is taking place. Therefore the smaller the administrative staff, the less dependent the organization will be on generating revenue.

Once the organization has determined its fixed costs, the next step is to calculate the variable costs. Variable costs are directly related to the production of the cultural product. The more cultural product produced, the higher the total variable costs will be. For a theatre company, variable costs might be payment for the right to produce a play, with each play requiring an additional payment. The cost of the actors is variable; as the more productions that are mounted, the more costs that are incurred. Variable costs for a gallery would include the cost of mounting a specific

show. Variable costs will differ for every organization and for each type of production within each organization.

If a cultural organization could work out the amount of all fixed and variable costs, it could use the breakeven formula, which calculates the amount of tickets that must be sold at a certain price to cover all costs. The calculation is as follows:

Breakeven Point
Fixed Costs divided by (Price per Unit – Variable Costs per Unit)

First, the variable cost of producing the event per person attending is subtracted from the ticket price. The remaining amount of the ticket price must then be applied to cover the fixed costs. Only once the fixed costs are covered, does the organization make a profit. If the organization decides that they would be unable to sell this amount of tickets, they have two choices. Either raise the price of the ticket of lower the costs of producing the event.

However, it is very difficult for even profit businesses to determine the cost of a service. This is because it is difficult to determine the variable cost of the product. It would be much easier to use this formula if an organization is producing a tangible product, e.g., a table, where the variable costs would be the price of the wood and the labor to make it.

Competition Pricing

Unfortunately, the difficulty in calculating the actual costs of producing the arts product has led some cultural organizations to believe the only alternative method for deciding a price is to just randomly choose a

Free Means More Than Full Seats

In Minnesota there is a trend to designate some seats as free. At Mixed Blood Theatre there are a limited number of tickets for purchase, but most seats are available for free two hours before the performance. Called Radical Hospitality it had radical results. Did the theatre lose revenue? Yes, but they gained in other ways. They were able to increase contributed income to help make up for the loss of ticket revenue. They increased their audience size by 18 percent and also its age, ethnicity and income diversity. Forty-seven percent of audience attracted by Radical Hospitality was under the age of 30, 30 percent were people of color and 33 percent earned less than $25,000 per year. In addition, 36 percent were new to theater. Will they do more than attend? The number of new donors is three times what it was previous to the new pricing policy.

Jackson (2012)

number. However, there are other pricing methods that can be used. One of the simplest is to use the organization's competition as a guide. This approach to pricing assumes that the consumer has money to attend and will make the decision on what activity to pursue based on other considerations than price. Price will only be a consideration if it is dramatically different from the competing products under consideration.

Cultural organizations must understand what consumers consider an acceptable price. Because smartphone apps allow comparison price checking, consumers are able to very quickly assess how the organization's price compares to that of the competition. While geographically based apps provide information, including price, on nearby competitors, these same apps can be used to communicate the fact that the cultural organization has competitively priced products. Using these apps to communicate pricing information is becoming common in for profit retail businesses and can be similarly used by nonprofits (Solis 2012). Mobile geolocation services can also be used to generate price discounts on upcoming events. Doing so can attract a new segment that the organization has previously been unable to reach and build brand loyalty among existing consumers.

To use this pricing concept, the cultural organization should check the price of other similar cultural organizations in the area. It should also check the price of other competing leisure activities. This might mean that the cultural organization should price its product in line with the cost of a cinema ticket, or the price of an evening at the pub. A different cultural organization might consider its competition to be a more expensive evening out, such as a dinner and dancing, and price accordingly. However, even when using this approach, the organization still must also consider its costs. The further the price it charges is from the theoretical price that would allow the organization to cover all costs (the breakeven point) the more reliant the organization will be on fundraising.

Prestige Pricing

There is a third method of pricing. Often cultural organizations have not focused on price when promoting their products but rather on the benefits and quality that will be received. The most thought they may have given to pricing is to ensure that their price compares well with the price charged by their competition. However, for some art events, even the price charged by the competition is not relevant. These organizations produce specialty cultural products for which there is no easily obtained substitute. In this case the cultural organization can price high and still attract attendance. Examples of such events are blockbuster shows of Impressionist art or operas with star performers. Fundraising galas and opening nights are other examples.

Consumers are willing to pay high prices for these events because they know that they will be given the opportunity to consume a product that

is rarely available. In addition to the product, they are also obtaining the status of attending such an event. In these cases a low price might even send the wrong message to the public and discourage attendance.

Combining Pricing Methods

Of course, there is no reason why a cultural organization must use only one approach to pricing. An organization might use cost pricing when deciding what to charge for refreshments. The organization would do so because it does not want to use revenue from fundraising to subsidize the cost of refreshments. It must know the fixed costs to staff the bar and also the variable cost of the refreshments. It can even charge more than the breakeven point to help cover the cost of producing the cultural product. The same is true of any related merchandise such as coffee mugs and t-shirts that are sold. On the hand, the organization might also use competition pricing when deciding upon the regular ticket or admittance price and might then use prestige pricing for special events to maximize revenue.

Differential Pricing

Another way to combine pricing methods is to have different ticket or admittance prices for different segments, times, or events. The organization might have lower prices for students and seniors. It might also institute lower family pricing to encourage more attendance by this segment.

Differential pricing can also be used to price events differentially based on demand. For example, if Thursday is a slow day at the museum, the price can be lower to attract additional demand. This is done because the museum's fixed costs of having the doors open remain, no matter how few

A Wide Range of Prices Keeps Everyone Buying

How do cultural organizations set their prices? Usually by deciding to charge what they have always charged! However, pricing decisions cannot be made without an understanding of consumer motivation. Some people will value the cultural experience highly and be willing to pay more. Pricing some tickets high ensures that there will be available tickets at this price point. Other customers may only be willing to attend at a lower price, which may have nothing to do with their ability to pay. Having lower price tickets ensures that they will also attend. If tickets are not selling at either a high or low price—it may be that the public is not interested in the product, not that the pricing strategy is wrong.

Larson (2011)

people come through the door. So any increase in attendance, even at a lower price, will help to offset costs. The organization might offer different prices for day or evening performances. Lower prices are used to create demand at times when demand is usually low.

Product Introduction Pricing

An additional pricing concept suggests that prices should be adjusted based on where the product is in the product life cycle. All products are introduced to the market, go through a growth stage, mature, and then decline. If they are accepted by the market segment targeted, products go through a growth period as more people purchase. Once the product has been on the market for a period of time, most people in the target market segment are aware of its existence and have either decided to purchase or not purchase. The product is then in the maturity stage. Meanwhile competing products continue to be introduced. If they are more attractive to the target market segment, sales of the original product decrease and the product goes into a decline stage.

Skimming Pricing

If a new product is introduced to the marketplace and it has little competition, the organization can and must price it high. It can price it high because people will be willing to pay as there is no competing products with which to compare the price. If the organization promotes the product effectively as new and exciting, this will explain to consumers why the price is high and why they should be willing to pay. The organization also must charge a higher price if the product is new, because the development costs must be covered in the price. For example, when Apple first introduced the IPad, the price was high. Yet, some consumers were willing to purchase immediately. Apple was not gouging the public because no one needs an IPad to survive. In addition, Apple needed to raise enough revenue to cover the development costs of not just a new product, but a new technological development. Some people were not willing to pay the price, so Apple later came out with lower cost IPads. As the product moves through the product life cycle, the price is decreased.

Penetration Pricing

However, sometimes an organization will take a different approach to pricing a new product. If a new product is entering an already crowded market faced with competition from existing products, the organization cannot charge a high price. It must then take a different approach called penetration pricing. In this approach, the organization tries to steal consumers

Pay What You Can—Or What You Want

Theatres have been concerned that people may not be attending because they cannot afford the price of a ticket. In response "pay what you can" schemes are being tried. Some are tied to specific times and dates such as The Tricycle Theatre in the UK where the offer was available on Tuesday evenings and Saturday matinees. To ensure that it was not exploited by those people who could pay but just didn't want to pay, the scheme was limited to those eligible for concession pricing. At the Riverside Studios the payment scheme is available for everyone but only for previews. The New End theatre in Hampstead has gone a step further by offering the scheme to everyone, at every performance. However, this type of ticket scheme is only possible because the actors are working for half pay and the director is working for free. It may be a great idea to get people in the door, but it can't be a viable business model without outside funding.

Theatre Blog (2011)

from the competing products by pricing low. After all, why should consumers purchase the product when they are happy with the competitor's? Once the product is purchased because of the low price, and the consumer finds it is better than the competitor's, the price can be raised.

Decreasing Price Sensitivity

Some people are bargain shoppers. They look for the best deal online, comparison shop, and clip coupons. However, in difficult economic times, more consumers are said to price sensitive. It makes sense that if consumers are feeling wealthy, they will pay less attention to be the ticket price of an item. However, if they are concerned about possibly losing their job, the level of their retirement income, or unable to find a job at all, they will look for good deals. There are ways for a cultural organization to decrease the price sensitivity of its target market segment. These include product differentiation and complementary product pricing, and pricing promotions.

Product Differentiation

The consumer may view the products of cultural organizations as similar. Consumers may believe that there is not much difference between choral concerts with star performers and their local amateur choir. Of course, they know a star performer is better, but because of the higher price, they may decide to be satisfied with the local choice. The cultural organization must explain to the consumer why and how its product is different and worth the price. To do so it can allow consumers to experience the product

before the purchase, such as through online music files. Or, perhaps, if it is the venue that is unique, the organization might provide an online video tour. Some method must be used to prove to the consumer that the cultural product is superior to the competitor's and, therefore, worth the price.

Complementary Pricing

There is an old saying in business: charge a lot and then give them something free. This means is that if one component of the product is priced lower, consumers become less sensitive to the higher priced component. If free valet parking is included in the price of the concert, people are more willing to pay the full ticket price. This is true even if under normal conditions, they would have parked the car themselves. The opportunity to make use of valet parking offsets the high price ticket. This holds true for discounted refreshments or gift shop products.

Pricing Promotions

Price promotions are tactics that can help lower pricing sensitivity. One is the simple price discount, which is different from permanently lowering the price. Because a permanent price change can have a dramatic effect on revenue, cultural organizations should instead initiate temporary pricing changes. This can be done through a discount offer sent via email or text. Coupons that can be redeemed for lower prices can be left at local hotels. "Two for one" offers can be effective in motivating attendance. Price bundling involves putting separately priced items together with one price. For example, a theatre company could price together the play and intermission refreshments. A gallery showing could include entrance fee plus the catalogue. Price bundling does not mean the second item is free, although a slight reduction in price is usual. The bundling just seems to consumers to offer more for their money than a single price for each item.

Fundraising

Fundraising includes individual gifts, grants from foundations and government sources of revenue. It has traditionally been housed in a separate department within the cultural organization because raising funds is seen as needing people with specialized skills. This is particularly true in a challenging economic environment when it is difficult to know how to ask for support. However, there is a reason why individuals will continue to support an organization even when money is tight. People want to support organizations in their community where they feel they can make a difference (Fredericks 2010).

Every Little Bit Counts

There are a lot more people with small amounts of money than people with large amounts of money and yet development has almost exclusively focused on the wealthy. Crowdfunding is a means of targeting the rest. But crowd-funding is more than just asking for funds, it is a way of letting the public control the budget. How? By giving them a voice in whether a project takes place or not. It works by posting online an idea for a cultural event and how much it would cost to implement. A specific timeframe is posted for raising the funds. People can contribute as much or as little as they want via an online donation link. The amount raised and the remaining time is continually updated. If the budget is reached in the timeframe is designated, the credit cards are charged and the project goes ahead. If it is not reached, the project is dead.

Rothler (2012)

Fundraising has often been seen as a different function than marketing. However, there are strong connections between the two. Both are trying to build a relationship with individuals. The only difference is that fundraising is focused on fewer individuals. Most people who donate money to the arts also attend the venue, however not all people who attend will make additional contributions above the cost of a ticket.

Fundraising must explain in detail how the organization is meeting its mission though programming and events. These are the same programs and events that marketing is developing and promoting. Social media is a perfect forum for soliciting gifts, especially small gifts from younger donors. The method might be as simple as placing a static "Donate Now" button on the organization's webpage. The cultural organization can also use Causes pages on Facebook, which use personal relationships to raise funds (Kanter 2010).

Corporate Sponsorship

Because of the increasing difficulty in obtaining funding, cultural organizations no longer just look to the government for support. Corporate sponsorship has become increasingly important. The cultural organization and corporation negotiate an agreement with benefits for both. The cultural organization provides visibility for the corporate name along with other benefits such as entertainment options for the corporation's employees and guests. In return the corporation provides funding and other support. Not everyone involved with cultural organizations approves of this collaboration between art and business; some see such collaborations as potentially contaminating the mission of the organization. Some believe the danger exists that if corporations sponsor the arts, the corporation will start making demands on what art is presented.

Despite these fears, as government support of cultural organizations has declined, interest in corporate sponsorship has grown. The resulting sponsorship agreements should not be just about gaining funds to cover operational expenses or even special projects. They should be thought of as partnerships in which each partner gains. With the current economic downturn, most businesses are struggling just to keep the doors open. They may not have the additional revenue to donate to nonprofits, but a partnership may be of more interest because it would help the business gain and maintain customers (Alexander 2005).

Benefits for the Corporation

Specific benefits the cultural organization may offer to a corporation would certainly include access to the organization's audience. The corporate world is interested in reaching the audiences of cultural organizations because they consist of the highly sought after cultural "creatives" target segment. This group of individuals is high income and wishes to spend money in ways which confirm their status. This makes them particularly attractive to companies which sell luxury and high technology products.

Of course, the corporation would want tickets to use for corporate hospitality and also may wish to use tickets as part of a benefit package for all employees. In order to promote the corporate name and image, the corporation will want to display the name or logo on the organization's marquee and programs. And finally, the cultural organization can also offer use of their venue and exhibits or performances for corporate events.

If the sponsorship is a long-term arrangement, the corporation may wish to tie its image more closely to the cultural organization by actually having a seat on the board. It may also wish to enhance the relationship by inviting employees of the cultural organization and the artists to visit the corporation's work site. Such visits could include exhibits and/or performances. It may do so in a belief that the artistic creative energy will actually make the employees more creative or simply to enhance the corporation's image.

Benefits for the Cultural Organization

The cultural organization must also determine what it wants to receive from the sponsorship arrangement. Much more than funding can be sought and additional potential benefits should be closely tied to the organization's marketing strategy. Just as the corporation can use the cultural organization to enhance its image so the organization can "piggy-back" onto the corporation's image. Choosing a corporation that is popular with a potential audience segment can help the cultural organization to position the cultural product so that it benefits from the association. And just as the corporation can benefit from access to the cultural organization's

audience, the opposite is also true. The organization can gain access to the corporation's client list as well as to the corporation's employees.

Even a long-term relationship probably will not gain the cultural organization a seat on the corporation's board. However, the organization can gain immensely from the expertise which the corporate employees can offer. For instance, the corporation's marketing department may be able to assist in developing new promotional ideas. Likewise, the strategic planning department may be able to assist the cultural organization in determining its own long-range goals.

Corporate Membership

The traditional arrangement for corporate sponsorship is for the corporation to provide funding in monetary or in-kind donation, in return for which the name of the corporation is prominently (or discreetly) displayed on websites and programs. A new arrangement is to have corporations join as "members" of the cultural organization. In this arrangement the corporation moves from being a passive to an active partner in the relationship.

Membership agreements are negotiated contractual agreements that spell out the benefits that will be provided. The time frame is typically a year and is easily renewable. The fees charged to companies becoming corporate members can provide a predictable source of income to the organization. In return, the cultural organization provides the corporation with "value-added" benefits. These benefits include the ability to meet last-minute requests for tickets to popular events that the corporation needs

You Need the Help of the Board to Raise Money

There are two kinds of boards for cultural organizations. There are the "show" boards with the names of the well-connected and wealthy who will lend their names to the organization and perhaps attend a meeting or two. Then there are the "working" boards. On these boards, members are expected to contribute both treasure and time. But even these board members don't want to assist with raising money because it is hard work. Here are four tactics for getting the board involve in fundraising:

1. Explain that fundraising is a board function.
2. Explain why the money is needed.
3. Give them the information they need to make the sell and train them on how to do it.
4. Have the museum staff follow up with each board member to encourage and support them.

Few people enjoy asking for money but the organization can make the task less onerous.

Garecht (2012)

to entertain clients. The cultural organization can also arrange backstage tours and use of the venue for corporate events. For the corporation, membership also includes intangible benefits such as access to those who create art and manage the organization.

Summary

Most cultural institutions are nonprofits, which exempts them paying part of their revenue to the government in the form of taxes. While exempting it from paying taxes, nonprofit status makes it more difficult to determine if the organization is meeting its mission. Even though the cultural organization cannot support itself on revenue from customers, it still must understand the different pricing methods so that it can minimize its reliance on fundraising. Cost, competition, and prestige pricing can be used in combination depending on the organization and the event. Different types of pricing are also used when introducing a product to the market. In difficult economic times organizations must use various methods to desensitize people to prices they may consider too high. Corporations can be asked for both sponsorship and membership.

References

Alexander, G. Douglas. 2005. *Essential Principles for Fundraising Success: An Answer Manual for the Everyday Challenges of Raising Money.* San Francisco: Jossey-Bass.

Baker, Tim, and Steven Roth. 2012. "Free is a Magic Number?" artsmarketing.org. June 15.

Begos, Kevin. 2012. "Guitar Museum Travels the US, Searching for a Home." Yahoo News. July 7.

Bhrádaigh, E. Ní. 1997. "Arts Marketing: A Review of Research and Issues." *From Maestro to Manager: Critical Issues in Arts & Culture Management.* Dublin: Oak Tree Press.

Burnett, John. 2007. *Nonprofit Marketing Best Practices.* Hoboken, New Jersey: John Wiley & Sons.

Fredericks, Laura. 2010. The Ask: *How to Ask to Support for your Nonprofit Cause, Creative Project, or Business Venture.* San Francisco: Jossey-Bass.

Garecht, Joe. 2012. How to Motivate Your Board to Raise More Money. *The Fundraising Authority.* July 30. http://www.thefundraisingauthority.com/strategy-and-planning/how-to-motivate-your-board/.

Hogwood, Christopher. 1977. *Music At Court.* London: The Folio Society.

Jackson, Sharyn. 2012. "Free Admission is Just the Ticket." StarTribune.com. June 23

Jenson, Joli. 2002. *Is Art Good for Us?: Beliefs about High Culture in American Life.* Lanham, Maryland: Rowman & Littlefield.

Kanter, Beth, and Allison H. Fine. 2010. *The Networked Nonprofit: Connecting with Social Media to Drive Change.* San Francisco: Jossey-Bass.

Larson, Kara. 2011. *Pricing Strategies to Attract Audiences and Keep Them Coming Back for More.* September 14. http://artsmarketing.org/resources/article/2011-09/pricing-strategies-attract-audiences-and-keep-them-coming-back-more.

McCarthy, Kevin F., Elizabeth H. Ondaatje, Laura Zakaras, and Arthur Brooks. 2004. *Gifts of the Muse: Reframing the Debate About the Benefits of the Arts.* Santa Monica, California: Rand Corporation.

Rothler, David. 2012. *The People Formerly Known as the Audience: Participating and Crowdsourcing in Arts and Culture.* January. http://www.scribd.com/doc/97334222/Crowdsourcing-Culture.

Raymond, Susan Ueber. 2010. *Nonprofit Finance for Hard Times: Leadership Strategies When Economies Falter.* Hoboken, New Jersey: John Wiley & Sons.

Solis, Brian. 2012. *The End of Business as Usual: Rewire the Way you Work to Succeed in the Consumer Revolution.* Hoboken, New Jersey: John Wiley & Sons.

Theatre Blog. 2011. Pay What you Can: How Low Can you Go? *Guardian UK*, August 17.

10 Promotion of the Marketing Message

When people are asked to define marketing, they will often describe the promotion of a product. However, the promotion of a product to consumers is actually the final step in the strategic marketing process, not the first. Before promotion can be effective, the cultural organization must first understand the external environment and how it affects the market for the product. It must research its target audience segment to discover the benefits that it desires. It must also understand how to package its product to include the desired benefits, price it correctly, and find the right venue in which to distribute. Only then is the organization ready to put together a promotional campaign. Now it knows to whom it is speaking and what needs to be said. With this knowledge, the cultural organization can design a marketing message that is appealing to its target market.

Once the message is created, the organization then will decide how it should be communicated. The choices of method are advertising, sales incentives, personal selling, public relations, and social media. The current trend is to employ integrated marketing communications (IMC) which uses more than one promotional method and media to deliver the same message and thereby increase the likelihood of being heard.

The Marketing Message

Cultural organizations understand that they need to communicate a message about a product to the public. They also understand they must often communicate messages to raise funds and to advocate for the organization. All of these messages are similar in that they need to be based on the mission of the organization and convey the benefits the organization provides. A survey of nonprofit organizations found that 28 percent do not feel they have enough time to develop a communications strategy with a further 22 percent stating even if they had the time, they didn't have the money to implement the strategy (Durham 2010). Nevertheless, unless a strategy is developed and implemented, the organization cannot compete in today's crowded marketplace.

Since most organizations assume that everyone will be interested in their specific art form, they have traditionally used advertising to broadcast a general marketing message that only provided information on the cultural products features, such as programming and artists. They believed that consumers were already motivated to attend and understood the other benefits that would be received. This type of promotional message communicates to consumers' intellect but not to their emotions.

However, benefits, such as socialization and entertainment, are often emotional in nature. An effective promotional message should communicate both intellectually and emotionally to the consumer. Most of the marketing promotion done by cultural organizations has been designed to make already attending consumers aware of the current programming the organization is offering. The assumption is that the benefits associated with the product are already understood. However, if cultural organizations are marketing to consumers who have limited or no knowledge of the product, the marketing of specific features will have little meaning and, therefore, little ability to motivate them to attend.

A promotional message that merely provides program details is not an effective use of resources. It is a type of "non-marketing" message that feels comfortable to many who work in cultural organizations because it does not appear to "sell." This type of message assumes that the consumer already knows why he or she should be there, and so does not provide information on the benefits that result from attending. However, it is this information on specific benefits that motivates new consumers.

Communication Program

All promotion should be part of a larger communication program that is implemented by the nonprofit (McCleish 2011). With consumers receiving messages through numerous communication channels, a single promotional message will not get and keep their attention. The ways that organizations can communicate, of course, include promotional messages and press releases. They also include annual reports on what the organization accomplished over the past year that can be provided to stakeholders. Specialized communication can be provided on specific programs. A newsletter can be created on an on-going basis to inform the public of what has been accomplished and what is being planned for the future. These communications will be designed with specific target market segments in mind. Public meetings and events are also part of this broader communication process, of which promotion is only a part.

Diffusion of Innovation

Consumers vary in their willingness to try new products (Rogers 1962). When introducing a new cultural product to an established audience or

Improve Your Email Marketing by Not Making These Mistakes

You send out your email to your subscribers and then hope that (1) they receive the email and (2) they read the email. Below are seven actions that can ensure this will happen:

1. Tailor your emails to specific interests and your recipient is more likely to read it.
2. Test different styles of email (plain and fancy) to see which your recipients prefer.
3. Ask those who ask to be unsubscribed why, as the information can help you improve your email marketing.
4. Keep your demands simple by having only one call to action per email.
5. Focus the information on the benefits of your product rather than the features by stating in the subject line how the information contained in the email will help the recipients.
6. More is not better with email, so don't inundate your recipients or they may not read any.
7. Make sure your emails are readable on mobile devices.

Graham (2012)

attracting a new audience to an existing product, the cultural organization must understand the difficulty inherent in motivating individuals to try something new, as many people are averse to taking risks. When promoting a new cultural product, the organization will need a different promotional message depending on whether the individual is risk-adverse or adventurous. The theory of the diffusion of innovation groups the public by their willingness to try new products.

Innovators

Innovators, who make up only 2.5 percent of the total population, are those who are willing to be the first to try a product. Innovators seek

Diffusion of Innovation Theory

Type	%	Description
Innovator	2.5	Younger, financially stable, and well educated
Early Adopter	13.5	Similar but larger group of trend setters, knowledgeable about art form
Early Majority	34.0	Follow trend setters, middle class
Late Majority	34.0	Follow Early Majority, older and more conservative than Early Majority
Laggards	13.5	Possibilities but difficult to reach and motivate
Non-Adopters	2.5	Find culture threatening, attempt to neutralize hostility

stimulation and are attracted to such events as opening nights, new productions, and cutting-edge art. They have enough money to afford to take the risk of trying the unfamiliar. Because innovators are influential and well connected, if they like what they have experienced, they will spread the word to others, who will then be interested in attending.

Early Adopters

Those consumers who follow the example of the Innovators are the Early Adopters. Early Adopters are trend setters who are similar demographically to the Innovators but are not as well connected or knowledgeable and, therefore, are less likely to take risks. They will attend because they have heard that the exhibit or performance is the one that everyone considered "in the know" must see. It is crucial that this group is satisfied with the cultural event or else acceptance of the product will not move on to the larger groups of Early Majority and Late Majority consumers.

Early and Late Majority

The Early and Late Majority groups of consumers are mostly from the middle class and when making decisions follow the advice of other more influential groups. The Early Majority purchase first and the Late Majority take the lead from them.

The Early Majority are not going to take the risk of purchasing anything unknown but will take their lead from the media. If they see that the Early Adopters have made a hit of a performance or exhibit, they will then also attend. The Early Majority are distinguished from the Late Majority by being younger and wealthier.

The Late Majority trusts the word of their friends and neighbors rather than the media. Only if they have had an enjoyable experience will the Late Majority attend. The cultural product is now reaching the mass market. Of course, at this point the Innovators and Early Adopters would no longer be interested in attending.

Royal Ballet Live

You've seen the dancers on stage, but do you know what goes on behind the stage? In the past this would have been a mystery. But the Royal Ballet decided to lift the curtain by live streaming a day at the ballet. Most people do not understand the long days and physical effort that goes into producing a ballet. After all, it looks effortless on stage. The day was streamed on YouTube in real time. The Royal Ballet now has its own YouTube channel where you can watch interviews, performances, rehearsals, and also a video on how ballet shoes are made.

Mackrell (2012) and Royal Opera House (2012)

Go Where the Market Is!

The Sydney Symphony had toured in China. So have orchestras from Europe and the US. But the Sydney Symphony decided to do something different. As part of their Asia strategy they decided to establish a home in China rather than just be a visitor. A three year agreement was signed with Guangzhou in Southern China, which is geographically close and yet culturally far away. Besides performances the agreement calls for the orchestra to train Chinese musicians and also provide marketing expertise. With the largest audience for classical music anywhere, China is the perfect new home for the Sydney Symphony.

Sainsbury (2012)

Laggards and Non-Adopters

The Laggards are those consumers who have no interest in new experiences. In fact, they might find new experiences upsetting, rather than exciting. Laggards lack the confidence to walk into a theatre or museum because they fear they will not know what is going on and might even be ridiculed. In reality, it is very difficult for a cultural organization to motivate this group to attend. They can probably be reached only by bringing the cultural product to a venue in which they are comfortable.

Non-Adopters are not only uninterested but are actually hostile to culture because their sense of self and value system is threatened by any experience with which they are uncomfortable. With this group the most that the cultural organization can hope to accomplish is to try to neutralize the hostility. It is very important to not communicate an image of elitism to Non-Adopters, which would simply antagonize them even more.

Promotional Messages and Diffusion of Innovation

The cultural organization must consider if the target segment is likely to be attracted to new products or would rather wait. For instance, when the organization plans new performance programming or a new exhibit, it may need to communicate a different message to different acceptance types during each stage of the cultural product life cycle. When the product is new, the message should be targeted directly at those selected individuals who are Innovators. Then, advertising for later performances should be aimed at the Early Adopters. As this group wants to feel exclusive and knowledgeable, the advertising message should communicate that this new, exciting experience is being produced for the enjoyment of people such as themselves.

Further into the run of the performance or exhibit, a more broadly based message should be communicated to the Early Majority using reviews and comments made by the Early Adopters. And, finally, in the

last stage of the promotional campaign, the event can be advertised to the Late Majority as "the show that your neighbor has seen and loved."

Promotion Tasks and Methods

Product promotion can be thought of as performing three different tasks: informing, persuading, and reminding. Informative promotion only tells the consumer of the product features. This is a necessary part of the promotional message, but alone, it is not enough to persuade new audiences to attend. The informative task is useful when a new cultural product is being introduced. For example, the opening of a new gallery with visual art by an unknown artist will require that information be provided to the public about both the venue and the artist.

Persuasive promotion seeks to motivate consumers with the benefits of attending. This task is necessary when aiming a message at consumers who may be unfamiliar with the cultural product. The purpose of the message is to present both facts about the product and the reason it should be consumed.

Reminder promotion focuses on reminding current customers of when and where the product is available. This promotion is most useful with consumers who have already consumed the product. They are already familiar with and desire the product features and benefits. The promotional message now just needs to inform them of program, date, and time.

Now that the cultural organization has a message, it must decide how it will be communicated to the target market segment. The methods that can be used are advertising, sales incentives, personal selling, public relations, and social media. Because consumers are bombarded with marketing messages, it is best to use as many of the methods as possible to communicate the organization's message so there is the best chance of being heard.

Promotional media is now being grouped as either traditional or new media (Foote 2011). Traditional media such as advertising, which includes direct mail, is more expensive. However, advertising still has a role to play in communicating the organization's message. The new media is often referred to as social media even though it includes other, older, methods such as websites and email marketing, both of which the organization will still need.

Advertising

Advertising is the word that most people immediately associate with promotion. While the words are often used interchangeably, they are not the same. While advertising is not new, messages for the upcoming bouts of popular gladiators have been found on the walls of Pompeii, modern

advertising campaigns date from the birth of broadcast media, radio and television, to deliver advertisements to a mass group of people.

Advertising may be only one of the methods that can be used to promote a product, but it is probably the most noticeable. Advertising is defined as purchased, non-personal communication that is widely broadcast. The fact that it is widely broadcast is both its strength and also its weakness. It is advertising's strength because its wide dissemination means it will be seen or heard by many people. The weakness results from the fact that it is not personalized to the individual, which makes it difficult to attract attention. Today advertising must compete for attention with all the other media trying to attract the consumer. People have become so deluged with marketing messages that they often "tune out."

Advertising Message

Small cultural organizations rarely have the kind of money to put into TV and radio, but there are also less expensive means that cultural organizations can use such as print advertising through newspapers, magazines, billboards, posters/flyers, and brochures. Static online Internet banners ads are also considered advertising and need to be designed with same three elements that are essential for a successful print advertisement:

- The marketing message must be crafted into a memorable word or phrase;
- The design must be creative and appealing to the target market segment;
- The necessary factual information, such as when, where, and what, must be provided.

Alternative Forms of Advertising

Advertising seems to be everywhere, from the back of ticket stubs to the seat backs in public buses. Advertisements can be found on video screens in elevators and even in light on floors and walls using floodlights. Today's consumer receives information from a variety of media sources. Because of this "media multitasking," the use of alternative media is an essential component of advertising campaigns (Blakeman 2011). More creative forms include coffee cup sleeves, sidewalk street art, and vacant storefront windows.

Sales Incentives

An area of promotion that is growing in favor among businesses is sales incentives. Sales incentives are a promotion method that is used to

They May Not Read Your Ad, But They Will Watch Your Video

A 2012 study found that the average video viewer watches 22 hours a month. Of course, this is not all in one sitting. In fact, the average person consumes many short videos. Because of this phenomenon, for profit companies are posting more videos about their products online. Cultural organizations should think of doing the same. Letting the consumer view a bit of the performance or exhibit will help to motivate attendance.

The video content should be designed not to sell the cultural product but instead to engage the potential audience. YouTube is not the only platform that can be used, though it is one of most popular. Once the video is on YouTube, it can then be linked to the organization's website and social media site. The organization can even have its own channel on YouTube. The Colorado Ballet Association has 39 videos posted on its channel. Topics covered include announcements of the season's performances, videos of rehearsals, gala events, and even how to construct the classic ballet hair bun.

Sheldon (2012) and Colorado Ballet Channel (2012)

stimulate product trial among non-purchasers and to increase demand or purchase frequency among current customers. While advertising uses the marketing message to provide facts about the product and the benefits that will result from its consumption, sales incentives communicate the marketing message along with an incentive that provides a very specific motivation for buying now. Sales incentives are of growing importance in the field of promotion for three reasons:

- They can be carefully targeted to encourage attendance by specific market segments or for a specific art event;
- They can be relatively inexpensive compared with advertising;
- Some methods, such as contests, allow the organization to gather customer information.

Creativity is the key to a successful sales incentive promotion. Common sales incentives include discounts, coupons, premiums, contests, and samples. However, there are many more sales incentive methods used by profit businesses that could be adapted for use by cultural organizations. Of course, the availability of these incentives must be communicated via advertising and social media.

Discounts

A discounts is a temporary price reduction. The reduction might be offered to help fill seats when demand is low or to introduce a new product to

consumers. Everyone loves the sense of getting a good deal. Even people with large incomes like to feel that they are being smart consumers. Discounts also add excitement to the purchase process by giving a compelling reason to "buy now" (Hine 2002). An example of a discount would be 25 percent off the purchase price of a second ticket for a limited time period. Such a discount can be planned and promoted or it can be instituted at the last moment for events that are selling slowly. A discount might also be used to encourage sales for a less popular or new arts event by offering tickets at a discount if the consumer is purchasing a full price ticket to a more popular show.

Other ideas include having seasonal discounts for periods of time when attendance is slow, such as during the holidays. Discounted gift certificates might be sold for Mother's Day, Christmas, or any other special occasion. Tourists might be targeted with discounted prices during the summer. Group discounts can be offered to clubs, service organizations, or churches as a means to encourage attendance.

Coupons are similar to discounts but are usually in print or electronic form and target a specific product rather than time period. Coupons are usually used for the consumer goods market, but there is no reason why they cannot be adapted for arts promotion. A coupon offering two-for-one tickets could be sent to subscribers on their birthdays. Or coupons could be included with all new single ticket purchases to encourage a return visit. If the coupon is not used, nothing is lost by the organization except a small printing cost. If it is used, it will fill a seat that might have otherwise gone empty.

Cross-Promotions

Cross-promotions are collaborations between two or more organizations. The idea is to encourage the customers of one business to patronize another related business. This could be a collaboration between two cultural organizations where one ticket purchase will allow entry to both venues. The price is usually less than it would be if the tickets were purchased separately.

However, cross-promotions can also be used between cultural organizations and profit businesses. A ticket might include both the price of the ticket and the cost of dinner at a local restaurant. For those travelling to the event from out of town, it might include a package that includes the ticket and hotel stay. The business is interested in the partnership to increase revenue as well as in associating its brand with the brand of a nonprofit whose image is attractive to the potential customers (Kunitzky 2011).

Premiums

Premiums are gifts that are given free or at a very low cost to ticket purchasers. They are usually targeted at a specific group or for a specific

event. Of course, cost is an issue, but an organization can help to defray the cost of the premium by using something they already have or by having the gifts donated to the organization. For example, a choral group might provide a free copy of its CD to all new ticket purchasers. For the organization, the cost to produce each additional CD is low. New ticket purchasers may be unfamiliar with the group's music and therefore unlikely to buy the CD on their own. Meanwhile, the organization sells additional tickets based on the promotion and the consumer will, hopefully, enjoy the CD and return for another performance. Another idea for a premium might be copies of posters that are paid for by a local business, which would then receive free publicity.

Contests

Contests are another way to encourage sales while adding a bit of excitement to the purchase process. They are also an excellent method of collecting consumer data. The easiest is to simply have a drawing by asking people when purchasing their tickets to provide their business card or fill in an entry blank. This can be done via paper or online. The purpose of this type of contest is to attract entries from as many people as possible as a means of gathering names and demographic data. Asking for this information online works well. It is simple for the customer, and the organization can gather additional information such as attendance frequency and favorite artist or performer. In addition, the organization collects address or emails as these are necessary to notify the winner. Because of privacy issues the entry form can include a box that can be checked requesting that the customer not be added to any email list.

The prize for the drawing can be for anything from a free mug to a free season ticket. Different audience segments can be encouraged to complete a form by changing the prize to something that will be of special interest. To keep costs down the prize can be an experience rather than a product. Culture participants want to be involved rather than passive, so a prize such as the opportunity to be in the green room with the actors or to "guest" conduct the orchestra would be very attractive. Because these are very exciting prizes, entry to the contest can be restricted to those who purchase a certain level of tickets.

Contests can also be used as a method of conducting quick and easy research on the targeted group. On the entry form it might ask a simple question such as "Would you attend a concert of Russian choral music?" or "Which of the following plays would you be interested in seeing?" The results will not be statistically valid but it's always a good idea to get information when possible.

Samples

Samples are common sales incentives for consumer products such as toiletries and food. Sampling involves giving away a bit of the product in the hopes that consumers will be so impressed they will decide to purchase. It is a common experience to receive a free sample size tube of toothpaste or to be offered a taste of a dessert at the grocers. If the consumers like the product, they may purchase it on the spot.

Samples can also be used by cultural organizations. It is very difficult to attract attendance if the cultural organization's targeted market segment is totally unfamiliar with the art product. Such a group will ignore the organizations advertisements, if they notice them at all. The only means of familiarizing them with the product may be to give them a sample. This will involve bringing the art to the targeted group. This is essentially what arts organizations are doing when they bring music or art to schoolchildren. Such sampling can also be targeted at adults by bringing a bit of the music, play, or visual art where the target market is located such as places of employment, churches, or other leisure venues such as restaurants. Electronic samples may also be provided. For example, video clips can be placed on YouTube and then linked to the organization's website. Podcasts can also be linked to either the website or social media sites.

While it might seem that these tried and true sales incentives are old-fashioned in the age of social media, they are even more popular now. This is because all of these ideas can be promoted on the organization's social media site. In fact, even more excitement can be generated by having a contest online and then featuring comments and video of the winner on the organization's webpage.

Personal Selling

Personal selling is informing the consumers of the benefits of the product one at a time. The traditional view of personal selling is the salesperson going door-to-door which, of course, is not how arts have been sold. However, personal selling is not just the job of a professional salesperson. Personal selling can be done by every member of the organization, using every opportunity to inform each member of the public with whom they come into contact about the benefits the organization provides. For example, ticket sellers, when they sell a ticket for one performance should recommend another that might be of interest. Even the ushers can inform people of the products on offer in the gift shop. To be able to sell, the people in the organization must understand all aspects of the product and be able to communicate it to anyone with whom they may come into contact.

Public Relations

Broadly defined, public relations is about maintaining a favorable public image. It is a necessary tool when countering negative information about the organization that may appear in the news media. While this is an important function of public relations, it is not how it is usually used by cultural organizations. They tend to focus more on the publicity component of public relations. Publicity is the creation of positive information on the organization in the news media. The purpose of the publicity is to generate positive coverage in the news media that will then be read by the public who will, hopefully, be motivated to attend. The principle tools used in generating publicity are news releases, press conferences, photographs, and feature articles.

Publicity

For an organization to use publicity effectively it must have a good working relationship with the local media. Newspapers, radio stations, and magazines work on tight time schedules and with specific production guidelines. If the news release or feature article is timely, in correct format, and aimed at the media's target audience, it has a much greater chance of being published. In addition, it must be interesting. Newspapers, radio, and other media are businesses that live or die by whom is reading, listening, or watching. These media companies will use the news release not to help sell tickets, but because the information provided will be of interest to their audience.

Once the appropriate media vehicle for publicity has been decided and a relationship with the media has been established, the next step is to write a press release, article, or provide a photograph that will be used. All the public relations material can also be posted on the organization's website and social media site. Therefore, the efforts of the organization in preparing this material can be doubly effective.

PR and Social Media

Today, there is a strong connection between the public relations and social media components of a nonprofit's promotional strategy (Madia 2011). Although it is still necessary for nonprofits to prepare and send in news releases, a majority of journalists also use social media sites and blogs to find content for news stories. The social media press release (SMPR) is becoming a staple. It differs from a traditional press release in that in addition to the traditional written content, it also provides links to additional resources and is designed to be shareable. The SMPR is emailed to the usual news organizations used by the cultural organization. It is also placed on the organization's social media site and website. It will have a

Your Website is Always a Work in Progress

Ever organization now understands that a website is as important as having a street address or a phone number. The website is where people go to find information. However, it also reflects the brand of your organization. If the website does not engage the user, the question might be asked if the organization will be any more interesting. Here are five rules any organization can use to review their website:

1. Use your homepage to highlight what is important. If my attention isn't caught, I won't use any of the links.
2. Keep it fresh. Update frequently so I have a reason to come back and look again.
3. Multimedia is a must. Even if you can't provide professional quality videos, show me what is going on behind the scenes with videos shot using your cellphone.
4. Dual use. I want to be able to access your site on my computer, my phone and my tablet.
5. Action Oriented. If you want me to do something—ask!

Dadisman (2012)

unique URL that will make it easy for readers to share via email. The written copy is kept to a minimum of just a few sentences or bullet points. Other information is provided in the links. These links can include content from other organizations that validate what the organization is trying to accomplish.

Social Media and Direct Marketing

Direct marketing serves two purposes. It promotes the product to a specific market segment by asking for immediate feedback through purchase or through a request for more information. And it is used to maintain a database on the targeted customers so that future communications will be more focused on meeting the market segment needs. Direct marketing can be done via mail, phone, or computer. Cultural organizations have in the past relied on the phone and mail, but more are becoming sophisticated users of direct marketing using social media and email. This makes sense as the average arts attender is well educated and in a professional occupation. Being online is a routine part of their lives. The same is true of younger potential audience members.

Websites and Social Media

Cultural organizations may feel that they do not know where to get started in implementing social media. However, it was not that long ago that the

same would have been said about creating a website. Cultural organizations quickly learned that websites were a necessary tool to provide information to the public on the features and benefits of their product. They are now learning that social media sites are as necessary as a website. A well-designed social media site can communicate to the public the brand image of the organization and the art form itself. Providing online video allows the public to view the dancing, see the art, and hear the music without stepping foot into the venue. While the same information should be posted on the website, the social media site allows the consumer to interact with the organization and with other consumers.

While the website can provide information on the what, when, and where of the cultural product, the social media site allows the public to communicate with the organization. The most popular social media sites vary by country. They will also continue to evolve as technology changes. What is important to understand is not the technology but the *use* of the technology.

The growth of social media use is the result of a profound cultural change. These changes can be summarized as the new power of consumers, the desire for authentic organizations, and the ability to co-create (Hollman and Young 2012). Therefore, the social media site should be used to listen to both the positive and negative comments customers provide on the organization's product. The organization must present itself honestly. The days of products claiming to be the "greatest" have gone. And, lastly, the consumers must have the ability to affect the organization's product is some way. For museum's this might be allowing the consumer to be part of the curating process. For performance companies, it might be allowing the consumer input into the programming. Social media means that the day of top down control is gone. If the cultural organization laments this control, it is useful to remember that the advent of the Gutenberg press caused Martin Luther to lament that now everyone would think that had written something worth publishing (Shirky 2010). Before Gutenberg, only the most important books were hand copied. After Gutenberg, people had easier access to both good books and also poorly written ones. The same is true with social media because when everyone can hit the "publish" button both the best and worst will appear.

Email and Social Media

While social media may garner most of the attention in marketing meetings, email is still an excellent means of sending regular promotional information to consumers. Email can also be used to target specific market segments who want specific types of information. Effective marketing programs do not blast emails to everyone but instead focus on specific groups that have already requested information. This information may have been requested on a social media page, during the ticket booking process,

Pre-Visit Emails

You know that when you have a reservation booked at a hotel, you will receive an email a few days in advance reminding of your visit. You will also receive information on how to get to the hotel, where to park, and any special events that are taking place. Well, cultural organizations can do the same. Jacobs Pillow Dance sends an email to ticket purchasers with information on directions and parking. They also have suggestions for those who want a meal along with the performance. Details of a pre-performance talk are provided. Finally, an invitation to partake in a special event is included. But the email does more. Now that the ticket purchaser is excited about the upcoming performance, the email provides information on how to attend more events.

Geane (2012)

or even in person at the venue. The customer is giving up a bit of his or her privacy in return for information of value. Therefore, email marketing should always be useful to the recipient.

Creating an email list has a number of marketing advantages. Not all consumers have the time to follow many organizations on Facebook or other social media sites. The simple email is a means of reminding the consumer of the organization's existence. The email list can be used to provide information on upcoming programming, promotional offers, and special events.

When sending out direct email to consumers that request information, it should be personalized and customized. Most email is read quickly so the organization must get to the point quickly. For example, the reason for the email message must be stated at the beginning. Customizing the subject line is also very important. The subject line of an email is the envelope the message comes in and must identify the topic. If the subject line is not interesting, the email might not be opened. For example, if the offer is geared toward families or the email contains information on a pricing discount the subject line should say so. There is software available that will allow the busiest and most stressed cultural organization employee to generate professional looking email newsletters easily and quickly.

The organization can't send the emails if they don't have the addresses, so it is very important to use every means possible to collect this information. Some ideas are:

- Guest books or customer registration forms on the website;
- Including a line for email addresses on ticket order forms;
- Contests and promotions;
- Collecting at the box office;
- Lobby signup sheets;
- Inserts in programs.

When gathering email addresses online, the cultural organization should offer the customer signing up the ability to control the type and amount of information that is received. No one will read emails in which they have no interest. In addition, to reward the consumer for signing up, a special gift might be given.

Developing a Personal Relationship

Using technology, vast quantities of information can be gathered on current and potential customers. Databases allow information to be collected and processed about what art events consumers purchase. This data, along with information on the consumers' demographics and consumer behavior, can assist the marketing department in segmenting their audience.

The focus for cultural organizations may be to reach the largest number of individuals with their cultural product. However, there remains the fact that their product may be of deep interest to only a small percentage of the population. Using databases, the cultural organization can separate out these individuals and use fewer resources to communicate their promotional message. The organization's marketing strategy needs to differentiate between the more dedicated enthusiasts and groups of culture consumers. Separate direct marketing messages can then focus on each group's interests.

It may be even more effective to further subdivide these groups into very small and specialized segments that can be targeted for exactly the programs or events they wish to attend. The organization can then use databases to target participants on how they can be more involved with the organization.

Social Media is Fine, But Direct Mail Still Pulls in the Money

The workhorse of fundraising continues to be direct mail. How you design the letter, including both wording and layout, can be the difference between success and failure. The sad truth is that almost all receivers of direct mail will look at your mailing for the 10 seconds it takes to walk to the trash can. A few will scan the headlines and images for 20–30 seconds. These readers may be interested in your organization or are just the careful types who read everything they receive. The smallest number will spend one to two minutes reading. What does this mean in regard to design? There is not much that can be done about the receivers that automatically throw out the mail. However, your direct mail piece will have a better chance of motivating the people who spend 20–30 seconds to spend more time if headlines and bolded and italicized words are used to communicate your mission and your need.

Garecht (2012)

Databases help to make this possible, and, if used well, the message can be personalized so that a relationship is established between the cultural organization and the audience members. This personal relationship will stress not only the cultural product that they enjoy, but it will also stress how they can become involved with the organization. For the cultural participant, the association with the values of the cultural organization is critical.

Summary

Promotion is not the start of the marketing process but rather the last step in the strategy. The organization must develop a message that will be of interest to a specific target segment. This message may vary depending on the stage of the product life cycle. Promotion can be used to inform, persuade, or remind consumers. The methods used include advertising, sales incentives, public relations, personal selling, and social media. Social media is unique in that it involves two way communications with the organization.

References

Blakeman, Robyn. 2011. *Strategic Uses of Alternative Media: Just the Essentials*. New York: M.E. Sharpe.

Colorado Ballet Channel. 2012. YouTube. July 24. http://www.youtube.com/user/thecoloradoballet?feature=results_main.

Dadisman, Ceci. 2012. "Five Rules for Arts Organization Websites." *ArtsMarketing.org*. April 4. http://www.artsmarketing.org/resources/article/2012-04/5-rules-arts-organization-websites

Durham, Sarah. 2010. *Brandraising: How Nonprofits Raise Visibility and Money Through Smart Communications*. San Francisco: Jossey-Bass.

Foote, Cameron S. 2011. *The Creative Industries Guide to Marketing: Selling and Branding Design, Advertising, Interactive, and Editorial Services*. London: W.W. Norton.

Garecht, Joe. 2012. 4 Tips for Designing Fundraising Mail that Works. *The Fundraising Authority*. July 31. http://www.thefundraisingauthority.com/fundraising-by-mail/designing-fundraising-material/.

Geane, Katryn. 2012. "Pack Your Shorts: Using Email to Prepare Audiences for Their Arts Experiences." *Artsmarketing.org*. January 5. http://artsmarketing.org/resources/article/2012-01/prepped-and-ready-using-email-prepare-audiences-their-arts-experience.

Graham, Charlie. 2012. "Email Marketing: 7 Mistakes Not to Make." INC.com. May 12. http://www.inc.com/charlie-graham/email-marketing-mistakes.html.

Hine, Thomas. 2002. *I Want That! How We All Became Shoppers: A Cultural History*. New York: Perennial.

Hollman, Christer, and Simon Young. 2012. *The Social Media MBA: Your Competitive Edge in Social Media Strategy Development and Delivery*. Chichetser, West Sussex, UK: John Wiley & Sons.

Kunitzky, Ron. 2011. *Partnership Marketing: How to Grow Your Business and Transform Your Brand Through Smart Collaboration.* Mississauga, Ontario, Canada: John Wiley & Sons.

Mackrell, Judith. 2012. "Royal Ballet Live: Our Behind-the-Scenes Dance Stream." *The Guardian.* March 22.

McCleish, Barry. 2011. *Successful Marketing Strategies for Nonprofit Organizations: Winning in the Age of the Elusive Donor.* Hoboken, New Jersey: John Wiley & Sons.

Sheldon, Kerrin. 2012. "Why Short-Form Video is the Future of Marketing." July 23. http://www.fastcompany.com/node/1843289/print.

Rogers, Everett. 1962. *Diffusion of Innovations.* New York: The Free Press.

Sainsbury, Michael. 2012. "Guangzhou Base Bid to Cement SSO in Region." *The Australian.* July 31.

Royal Opera House. 2012. YouTube Channel. August 14. http://www.youtube.com/user/RoyalOperaHouse.

Shirky, Clay. 2010. *Cognitive Surplus: How Technology Makes Consumers into Collaborators.* New York: Penguin Books.

Marketing Plan Worksheet

Having a plan and timeline is important to keep you on track as you start developing a new marketing strategy. Be realistic when assigning responsibilities and deadlines. If you achieve your goal early great! If you fall behind you might become discouraged.

Who is available to assist in the development of a marketing strategy?

_____ _____

_____ _____

Task	Person Responsible	Completion Date
Internal and Customer Analysis		
External Analysis		
Competitor Analysis		
Buyer Analysis		
Purchase Process		
Segmentation Analysis		
Research Proposal		
Product Analysis		
Distribution Analysis		
Pricing Analysis		
Promotion Analysis		

Internal and Customer Analysis Worksheet

The first steps in the marketing process are to state your mission and to examine the resources of your organization. After filling in your mission, answer the questions on your organization's internal and customer environment.

Our organization's mission (or reason we exist) is:

Internal Factor	Question	Answers
Current Marketing Strategy	What is being done and is it successful? If not, what should be done?	
Financial Resources	Is there money for product improvement and marketing? If not, where can money be found?	
Human Resources	Do our people have the necessary marketing skills? If not, what training do they need?	
Organizational Culture	Is the organization ready for new ideas? If not, how can the culture be changed?	
Current Customers	Who is purchasing our product?	
Potential Customers	Who is not purchasing but might do so?	
Product Use	How do customers use our product?	
Purchase Motivation	Why do customers choose our product?	

External Analysis Worksheet

The next step is to analyze the external environment.

External Factor	Questions	Answers
Competition	Who is our competition, both non-profit and for profit?	
Economic Issues	Are our customers able to afford our product? Is our funding in danger?	
Legal/Political Issues	How do these impact our organization?	
Technology	What do we need to add to satisfy our customers?	
Socio-cultural	What trends are affecting our customers?	

List below the organization's competitive advantage:

Now state the marketing goal and objectives to reach the goal:

Goal: _____

Objective 1: _____

Objective 2: _____

Objective 3: _____

Competitor Analysis Worksheet

List three organizations your customers view as your competitors:

1.

2.

3.

Visit them and then use the table below to list what they offer that you don't:

Marketing Mix Factor	What Our Competitors Offer that We Don't
Customer service— attitude, ideas, services?	
Products—availability, quality, benefits?	
Pricing—level, specials, variations?	
Location—convenience, access, parking?	
Promotion—type, amount, creativeness?	
Purchase—convenience, online ticketing?	

After you have studied the competition, use the scale below to rank yourself in comparison to what else is available to your customers. Now you know what you need to improve.

Overall Product Attractiveness

Excellent									*Poor*
1	2	3	4	5	6	7	8	9	10

Promotional Effectiveness

Excellent									*Poor*
1	2	3	4	5	6	7	8	9	10

Acceptable Pricing Level

Excellent									*Poor*
1	2	3	4	5	6	7	8	9	10

Buyer Motivation Worksheet

Besides the opportunity to experience art/culture, what else do you believe motivates your customers to attend? There can be more than one reason.

Motivation	Yes/No	Describe the Motivation in Detail
Values		
Beliefs		
Personality		
Education		
Family		
Social Class		
Ethnicity		

Purchase Process

How can we motivate the customer during each stage of the purchase process?

Stage	Marketing Action
Need/Problem Recognition	
Information Search	
Evaluation of Alternatives	
Product Purchase	
Post-Purchase Evaluation	

Segmentation Worksheet

Segment your typical audience member and a segment you would like to attract.

Variable	Our Current Audience	Our New Target
Demographic: (age, gender, income, ethnicity, social class, family)		
Geographic: (neighborhood, city, region, or tourists)		
Psychographic: (values, beliefs, lifestyles)		
Benefit: (fun, socialization, status)		
Usage: (new, infrequent, frequent)		

Answer these questions about your typical audience member. The more "yes" answers, the more important to keep them attending even while you attract a new audience

Usage questions	Yes	No	?
Do they attend frequently?			
Are they members of your organization?			
Do they volunteer?			
Do they provide additional financial support?			
Are they loyal to your organization vs. competition?			
Are they interested in new products?			
Are the numbers in this group increasing?			

Research Proposal Worksheet

The first step in research is to define your research question. The more specific, the more successful will be your research. Answer the question: What do I want to learn?

These additional questions will help you to plan your research effort.

Task	Answer	Person Responsible	Date to Complete
What will I do with the information? (research objectives)			
Where can I find existing information? (desk research)			
What method will I use? (primary research type)			
How will I ask? (method selection)			
Who will I ask? (sample definition)			
Where will I ask? (site selection)			
What will I do with the information? (analysis and reporting)			

Product Worksheet

We offer the following art/culture product:

Product	Description	Benefits Offered

Our core product is packaged as the following events to attract different target markets (i.e., singles nights, family activities, educational opportunities)

Event Description	Market Segment Targeted	Benefits Offered

The packaging of our product (venue) includes:

	Description of Current	Suggested Improvements
Comfort		
Design		
Cleanliness		
Sound quality		
Furnishings		
Lighting		

Our product is unique because:

Distribution Worksheet

Answer these questions on your venue:

Question	Description of Current	Suggested Improvements
How does our location affect our attendance?		
How does the appearance of our building affect attendance?		
What is the public transportation/parking situation?		
What cross-promotions with neighboring business or organizations can we do?		
How can walk- and drive-by traffic be attracted?		
How does our website provide location information?		
Where else can we distribute our product?		

Pricing Worksheet

Use the checklist on this worksheet to help determine the effect of raising ticket prices. Then, answer the additional questions to help design a pricing strategy.

(*The more "yes" answers, the more freedom to raise prices.*)	*Yes*	*No*	*?*
Do our customers seem to be unaware of price increases?			
Is our customer base expanding?			
Does our status or reputation increase our value?			
Are we an established organization?			
Do we have many repeat customers?			
Are we selling out often?			

1. What is our revenue from ticket sales of admission?

2. What other sources of revenue in addition to ticket sales do we have?

3. What are our expenses?

4. What do our competitors charge?

5. What is the price range our customers expect?

6. How can differential pricing be used to increase revenue from existing customers?

7. How can differential pricing be used to attract new customers?

8. How can pricing be used as a sales incentive?

Promotion Plan Worksheet

Use this worksheet to develop your promotional strategy. Once you state your message and your target market, design an integrated marketing communications (IMC) plan that will communicate the same message using different messages.

Our target market is:

Our marketing message is:

How can we use the promotional methods in the table below to communicate our message?

Method	Idea	Cost	Responsibility
Advertising (print, broadcast, flyer, brochure, alternative)			
Public Relations (press releases, feature articles, photographs)			
Personal Selling (staff training, box office workshops)			
Sales Incentives (coupons, discounts, premiums, contests)			
Social Media (site, email, twitter, blog, video)			

Index